From Star Wars to Indiana Jones

FROM STAR WARS

BY MARK COTTA VAZ & SHINJI HATA

TO INDIANA JONES

THE BEST OF THE LUCASFILM ARCHIVES

CHRONICLE BOOKS

SAN FRANCISCO

To Olga with love

—M.C.V.

TM & © 1994 by Lucasfilm Ltd.

First published in the United States by Chronicle Books.

Printed in China

Library of Congress Cataloging-in-Publication Data available.

ISBN 0-8118-0997-8
 0-8118-0972-2 (pbk)

Written by: Mark Vaz and Shinji Hata
Original Japanese editions by: Bungeishunju'
Produced by: Shinji Hata, Masayuki Likubo, and Chikako Narita
Coordinated by: Tamae Kobayashi and Eri Brevig
Art Direction and Design by: George Tsuru
Photographs by: Tomohiko Hayashi and Tatsuo Harada

Original American editions by: Chronicle Books
Coordinated by: Lucy Autrey Wilson
Edited by: Allan Kausch and Charlotte Stone
Design Direction by: Michael Carabetta

Distributed in Canada by Raincoast Books,
8680 Cambie Street, Vancouver, B.C. V6P 6M9

10 9 8 7 6 5

Chronicle Books
275 Fifth St.
San Francisco, CA 94103

Contents

Foreword

THE ARCHIVES OF LUCASFILM came into being out of practical necessity. After eight years of producing the *Star Wars* trilogy, there was an accumulation of "stuff," which had been stored wherever storage could be found—a closet here, a warehouse there, cubbyholes at England's Elstree Studios, inaccessible corners of Industrial Light & Magic (ILM). It was all the physical things needed to make the movies and their extraordinary effects, ranging from simple pencil sketches to elaborate models of space vehicles and grotesque creature heads. No one referred to this "stuff" as artifacts, and no one thought about museums. The dilemma was storage.

That changed on a spring day in 1983, just before the release of *Return of the Jedi*. Someone had the idea to take a publicity shot of George Lucas amid a sea of models and miniatures used to make the trilogy. ILM then added a starfield with the ominous Death Star under construction hovering overhead. It wasn't until that day on the gigantic ILM soundstage that we had seen all of these pieces in one place. We were stunned by the volume of it. George turned to me and said, "You know, we need to save all this stuff. We need to start an archive. You're in charge of it."

Suddenly the focus shifted from storage to preservation, and we began to realize that the products of the enormously talented designers and craftspeople who helped make the films were objects of artistic, cultural, and historical significance. The phenomenal success of the films had made many of these objects into popular icons. We commenced the task of cataloging and photographing each item, still an ongoing process, with more than ten thousand pieces of artwork alone. An environmentally controlled Archive building was constructed at Skywalker Ranch and opened in November 1991, a giant two-story barn that houses both a film vault and an archive for models and other physical artifacts. Our goal is to preserve, protect, and document these pieces by the same standards used by museum curators.

The selection of art and artifacts displayed in this book represents a significant proportion of the archive in terms of models but only a fraction of the art work and costumes in our total collection. These items were selected for the first major exhibit of our archive, The George Lucas Exhibition, which toured several cities in Japan in 1993-94, organized and presented by Hata International of Tokyo. The selection covers primarily the *Star Wars* and Indiana Jones trilogies.

The Lucasfilm Archive contains the following elements:

MODELS These include mainly spaceships, miscellaneous vehicles, miniatures of sets, early prototypes, and robots, all designed for use in special effects sequences.

CREATURES These include hand puppets, articulated full-head masks to be worn by actors, full creatures in miniature scale used in stop-motion photography, and others. These are usually made of foam latex.

PROPS Props are most commonly hand-held items, and include weapons, clothing accessories, and other objects that often play a central role in a story, such as a sacred artifact that is the object of a quest.

COSTUMES Most of the costumes worn by the principal actors in Lucasfilm's productions have been preserved, as well as selected costumes worn by extras. These can range from traditional clothing and uniforms to the intricately constructed, full-body suits worn by Ewoks.

MATTE PAINTINGS Most often these paintings are done on glass, about three feet by six feet in size. They are designed to create the illusion of a large set or exterior location which would normally be too costly for actual filming. Clear spaces are left in matte paintings where live-action photography is composited with it. There are larger backdrop paintings also, either on board or canvas, used as complete scenic backgrounds for special effects photography.

ART WORK Art is created at every stage of production, from beginning concept sketches and drawings to finished production paintings. Art includes storyboards for action and effects sequences, all costume and set designs, and full set blueprints. During postproduction, publicity art is also created, in poster designs and other special art used in the merchandising of licensed products.

Movie memorabilia has been around as long as the movies themselves, yet historically the film industry has had a sad record of not preserving its own artifacts. With the boom in the merchandising of characters and trademarks from

films in recent years, a new appreciation of the value of the originals, and an increasing trade in them, has also materialized. Moreover, with the technology of computer graphics rapidly taking over the special effects industry, the era of traditional model work and matte paintings is coming to an end. The artifacts from that era are fast becoming antiquities, part of the archaeology of the cinema. Museums devoted to the history of film are currently sprouting up in several cities, which gives hope that there will be more homes for film-related art in the future.

Lucasfilm has made a concerted effort to save its history. George Lucas has committed substantial resources to this preservation. We hope our example will inspire others to do so as well.

DEBORAH FINE
Director of Research and Archives
Lucasfilm Ltd.

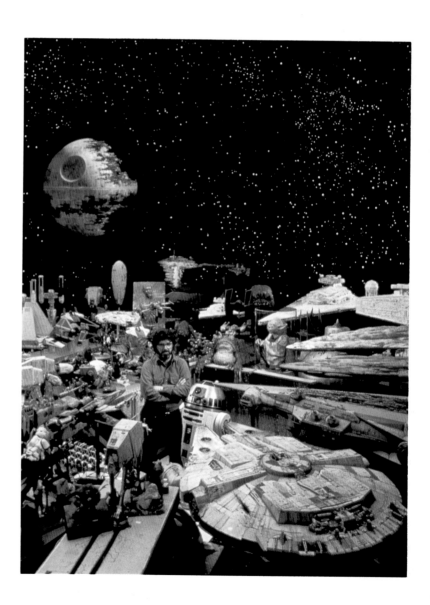

George Lucas has produced some of the most popular movies in film history, among them the classic *Star Wars* and Indiana Jones trilogies. Thanks to Lucas's foresight, and the dedication of Lucasfilm archivists, the artifacts used in the making of his films have been preserved.

DAWN OF DREAMS

George Lucas's creation of the *Star Wars* universe and of Indiana Jones's world of adventure has made his name synonymous with movie magic. The popularity, and resulting financial success, of Lucasfilm is the stuff of movie legend. The *Star Wars* trilogy alone has collected more than $1.3 billion in worldwide box office revenue, with an additional $2.5 billion in merchandising sales.

But the Lucas impact goes deeper than the business of selling tickets. Beginning with *Star Wars*, a new kind of movie spectacle was created, one in which character and story were advanced with astounding visual effects. Lucas resurrected the dying art of motion picture effects, which had been withering away in the decades following the breakup of the old Hollywood studio effects departments, when he established Industrial Light & Magic (ILM) to create his *Star Wars* universe.

With the record grosses of *Star Wars*, Lucas began to realize his dream of Skywalker Ranch, a creative environment located in Marin County north of San Francisco, on thousands of acres of pastoral countryside where dairy cattle once grazed. In the nearby town of San Rafael, Lucas located his ILM department, which continues to advance the state of the art in motion picture effects.

The Lucas success goes to the heart of the American dream, a story rooted in his early life in the agricultural cradle of Northern California.

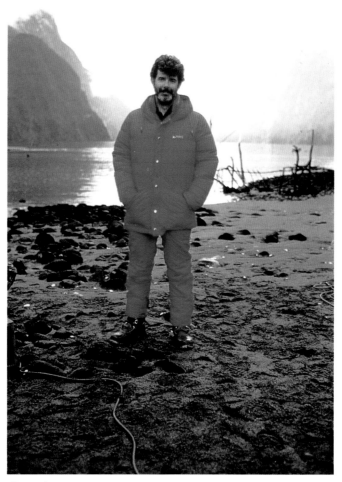

George Lucas

RITE OF PASSAGE

George Lucas was born in 1944 in Modesto, California, a small town set in the farmlands of the San Joaquin Valley. His father owned a small stationery store in Modesto and later, during George's teenage years, acquired a ranch outside town where he grew walnuts, peaches, and grapes. Lucas's mother tended to the home, raising him and his three sisters.

Lucas's boyhood was an idyll of simple pleasures during a time when children mounted their own neighborhood carnivals and pretend circuses, played in homemade forts and tree houses, and raced in their own soap box derbies. His interests also included comic books (from Walt Disney's *Uncle Scrooge* to *Superman*) and classic fantasy literature such as *Treasure Island* and *Robin Hood*. Other diversions included the two movie theaters in town, one of which Lucas recalls as an "A" list theater, the other a more "B" picture venue, where his boyhood imagination was sparked by *Flash Gordon* and other adventure serials. (Lucas's earliest movie memory was the adventure classic *King Solomon's Mines*.)

As a teenager, Lucas was a budding carpenter and a helping hand during harvest time on the family ranch, but he was an admittedly poor student in school. His consuming passion in those days was building, racing, and cruising hot-rod cars. His pride was a souped-up Fiat racer outfitted with a roll bar and special, four-inch-thick nylon seat belts.

One twilight, two days before his high school graduation, an eighteen-year-old Lucas was driving the flat country road that led back to the family ranch. As Lucas began to make the right turn into his driveway, a classmate, who had been driving behind him at eighty to ninety miles an hour with his headlights off, tried to gun past Lucas on the right, hitting the Fiat broadside. The crash sent Lucas's car turning over and over until it plowed into one of the family walnut trees. Ironically, the special seat belts broke, throwing Lucas free before the impact with the tree.

While his classmate was unhurt, Lucas lay on the dirt unconscious and without a pulse, his lungs collapsed and numerous bones crushed. For two days the hot-rodding teenager was in a coma, hovering in the tenuous space between the material world and eternity.

Lucas regained consciousness and during the coming weeks of convalescence contemplated the miracle of his escape: if his safety belt hadn't broken, he surely would have died when his car crashed into the tree. Fate had sent him to the brink of death and brought him back, an ordeal Lucas recalls as his personal "rite of passage."

Thereafter, Lucas began to broaden his horizons, entering Modesto Junior College and studying anthropology, mythology, and philosophy (subjects that would be reflected in his filmography to come). During junior college he also began experimenting with 8-mm and 16-mm cameras and stop-frame animation, which led to his ultimate passion for filmmaking.

The sixties were an era of experimentation for a new generation of filmmakers which, in addition to Lucas, includes Steven Spielberg, Brian DePalma, and Martin Scorsese. As Lucas began his filmmaking career, his path crossed that of Francis Ford Coppola, another leading light of the new wave of young moviemakers.

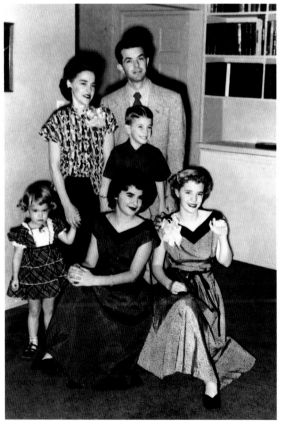

The Lucas family, 1950

THX 1138

A twenty-seven-year-old Coppola was directing film legend Fred Astaire in *Finian's Rainbow* when he met twenty-three-year-old Lucas. Coppola acted as mentor and guide during Lucas's introduction to the inner sanctum of big-studio moviemaking. In 1969 Lucas and Coppola, filled with idealism and wary of Hollywood ways, moved to San Francisco to create American Zoetrope Studios. Their major collaboration under the production umbrella of Zoetrope was *THX 1138*, a movie Lucas had conceived during his University of Southern California days.

The 1971 film, about a man mistakenly granted free will in a police state of the future, was a seminal effort for a number of budding talents, including Lucas as director, Coppola as executive producer, actor Robert Duvall, and composer Lalo Schifrin. The production itself was full of experimental, film-school energy, as Lucas was able to conjure up the futuristic world of *THX* on locations that included the subway tunnels of the Bay Area Rapid Transit system then under construction, the Frank Lloyd Wright-designed Marin County Civic Center, and the atomic energy facilities at the Lawrence Livermore Lab.

THX was released by Warner Brothers although the studio disliked the film, which met with dismal box office and a mixed critical response. Lucas gained some satisfaction six years later when, hard on the global phenomenon of *Star Wars*, the studio re-released the film.

THX was a turning point for both Lucas and Coppola. As business partners they were polar opposites: Coppola's hell-bent-for-leather management style did not mesh with Lucas's fiscally conservative approach. Lucas left the partnership to form Lucasfilm Ltd. while Coppola forged ahead with Zoetrope, beginning production on a film called *The Godfather*.

The film also provided a springboard for another Lucas project, a personal film based on his teenage years called *American Graffiti*. When *THX* was entered in the Director's Fortnight program at the Cannes Film Festival, Lucas, down to his last $2,000, decided to strap on his backpack and attend the fabled French Riviera festival. Lucas's arrival was hardly triumphant as he lacked a festival pass and had to sneak into the screening of his own film. He did, however, strike a $10,000 deal with a United Artists (UA) representative to develop his *American Graffiti* script.

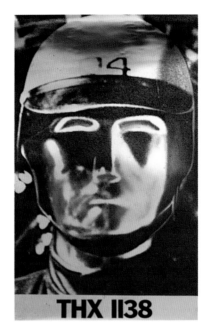

THX 1138, poster, 62 x 99 cm.

George Lucas working with Francis Ford Coppola's crew on *The Rain People*

THX 1138, production photo

AMERICAN GRAFFITI

The preproduction period for *American Graffiti* was a time of trouble and testing for Lucas. In the weeks following the festival United Artists had rejected several drafts and his bank account quickly dwindled.

Lucas was tempted with an offer of $100,000 plus a profit percentage to direct a movie called *Lady Ice*, an assignment that would have required him to abandon *American Graffiti*. Lucas declined, disliking the idea of coming in as hired gun to direct someone else's project. It was another near miss with disaster for Lucas: the film bombed, leaving the filmmaker forever convinced that if he'd done the movie his career would have been finished.

Then fate began to smile on Lucas and *American Graffiti*. Coppola, with the weight of *The Godfather* success behind him, came on as producer and steered the project from UA to Universal. The writing team of Willard Huyck and Gloria Katz, Lucas's classmates from USC, helped coauthor the final script.

Although the film would be produced under the aegis of a big studio, it was another shoestring effort with a $700,000 budget and a twenty-eight-day shooting schedule. But Lucas turned adversity to advantage, filming in continuity his tale of one long, fateful summer night in the lives of his teenage characters. By the end of nearly a month of all-night shooting the cast had the naturally burned-out pallor called for in the script. Lucas often filmed when his cast was unawares, capturing action with an almost documentary-style realism. When the shooting wrapped, Lucas was able to indulge his love of editing to craft his final film.

As with *THX*, studio executives disliked the finished product and cut five minutes from the film. But unlike *THX*, Lucas had the last laugh at the domestic box office as the film generated more than $100 million.

American Graffiti, French poster, 118 x 158 cm.

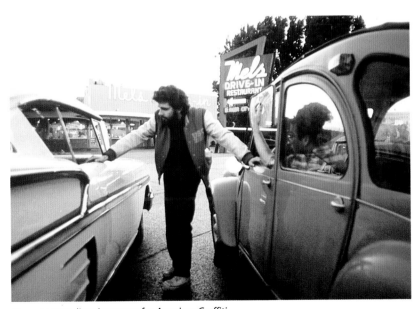

George Lucas directing scene for *American Graffiti*

STAR WARS

Several studios passed on *Star Wars* before Alan Ladd, Jr., head of production at 20th Century Fox, decided to gamble on the film.

Lucas envisioned spaceships presented in realistic scale, flying through starfields at super speeds, as well as complex battles in space, designed with all the fighting realism he had witnessed in World War I and II aerial dogfight footage. However, the technology of space-age effects in the 1970s hadn't progressed too far beyond shooting models on wires. And Lucas only had a total budget of $9.5 million with which to conjure up his universe.

Lucas formed his own visual effects outfit, Industrial Light & Magic, which set up shop in an old warehouse in Van Nuys, California and began to create a new kind of movie magic. ILM's breakthrough technology was computerized motion control photography.

Lucas also contracted the services of key people along the way, such as George Mather, an old Hollywood hand who made sure that the lab processing ILM's daily production footage delivered the all-important dailies in a timely fashion, the equivalent, according to ILM veteran Lorne Peterson, of "making the trains run on time."

Design artists Ralph McQuarrie and Joe Johnston helped keep the *Star Wars* dream alive at the studio with their concept sketches and paintings of Darth Vader, the droids, and other key characters. "Early on we did five to ten *Star Wars* paintings for presentations around the conference tables at Fox, to convince the studio to do the film," Ralph McQuarrie observes. "Neither George or myself thought they'd be finals, we were just working on atmosphere and feeling. As it stood, the paintings were impressive to people at the time so we went ahead with those designs for the film."

The preproduction stage also included the work of the unsung Colin Cantwell, who produced the earliest prototypes for Luke Skywalker's landspeeder, the Imperial Star Destroyer, and the sandcrawler of the Jawas.

By 1991 an Archives building was constructed on the sprawling grounds of Skywalker Ranch to professionally store the thousands of Lucasfilm artifacts. Constructed as a barn-like building, the facility sits near a horse corral in a little valley below rolling hills. Once through the Archive doors the visitor enters an enchanting environment where the entire pantheon of Lucasfilm creatures, models, paintings, and props are on display in the open spaces and shelf-lined places of a temperature-controlled bay.

There R2-D2 sits in silent greeting near the life-size landspeeder once driven by Luke Skywalker across the sands of Tatooine, while the slab of an agonized Han Solo frozen in carbonite is set near the Ark of the Covenant. One can see the furry forms of the Ewoks of Endor, the ominous helmets of the Imperial stormtroopers, the torture rack used by Indiana's foe Mola Ram to lower his latest victim into lava pit fire, Indy's signature outfit (fedora, leather jacket, and whip), various lightsabers, model ships of every scale, alien creatures, even the Holy Grail.

One Lucasfilm employee likened an Archive visit to spending time in the ultimate grandmother's attic. If so, this is an attic stuffed with rare icons of popular culture, objects familiar to moviegoers worldwide—through movie magic these sleeping creatures have come to life, the model spaceships have assumed gargantuan scale and blasted through the universe at super speed, lightsabers have glowed with energy, the Ark of the Covenant has exploded with supernatural power.

This book is an exclusive tour, and celebration, of the treasures of Lucasfilm created during the making of the *Star Wars* and Indiana Jones trilogies. They represent the highest levels of the art of moviemaking, artifacts from films that have been thrilling the planet's moviegoers for generations. They are the stuff that movie dreams are made of.

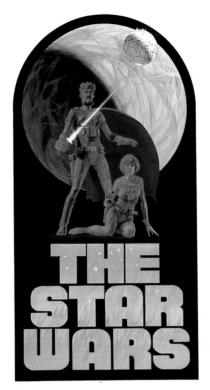

Star Wars, early poster concept art

George Mather's *Star Wars* storyboard "bible"

I

"A LONG TIME AGO
IN A GALAXY FAR, FAR AWAY..."

STAR WARS

(Lucasfilm/20th Century Fox) 1977

MYTHIC VISION

Lucas's goal for *Star Wars* was to create a new mythology for the space age. The epic story Lucas wrote (which he soon realized would require many movies to tell) reflected the new horizons the Modesto kid had been intellectually exploring for years, the myths, fables, and fairy tales of world cultures.

The western had been the last great myth, but with the wilderness long since settled, the power of frontier reflections had dimmed. Still, the classic themes of the western—the lure of wild places, the face-off between good and evil—endured. In the endless, starry universe Lucas would find a stage big enough for his mythic tale.

The story, set "a long time ago in a galaxy far, far away," went through many evolutions before settling on the now-familiar cast of characters: Darth Vader and the other evil leaders of the Empire who hold sway over the cosmos, freedom-fighting Princess Leia and the forces of the Rebellion, the young hero Luke Skywalker and his mystical teacher Obi-Wan Kenobi, the rogue adventurer Han Solo and his sidekick Chewbacca, and the lovable droids R2-D2 and C-3PO.

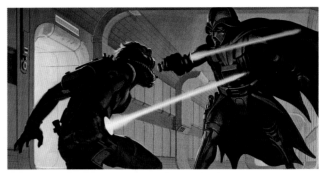

Darth Vader and Luke Skywalker's lightsaber battle, production painting, 18 x 41 cm.

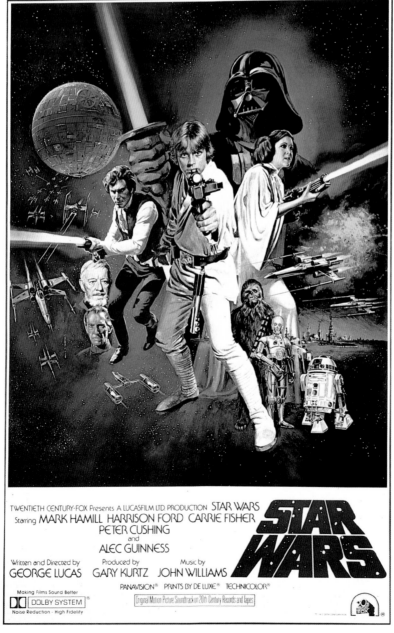

Star Wars, release poster, 61 x 91 cm.

SHIPS IN SPACE

One technique Lucas uses in his cinematic storytelling is to open with a dramatic shot that will pull an audience into the thick of the action: in the first scene, a Rebel Blockade Runner carrying Princess Leia is pursued by Darth Vader's Star Destroyer, which descends from overhead. The opening was a revelation—audiences had never before seen space ships of such speed and scale on a movie screen. (In what would become a tradition of moviemaking in-jokes by Lucasfilm folks, a tiny *Star Wars* poster and a *Playboy* centerfold were hung on the cockpit wall of the model ships, out of camera eye.)

ILM model making is a meticulous process beginning with detailed blueprints and prototypes. Since the final model ships (which are each usually made in different sizes) had to withstand hours of handling, they were built with metal frames to provide support. The interiors included electronics and lighting, such as bundles of fiber optics for the Rebellion's X-wing and Y-wing fighters. To keep the models from melting due to stage lights and interior wiring, compressed air hoses and other systems were used to cool off the over-heated model interiors.

The Star Destroyer, envisioned as a monster ship a mile in length, was constructed as a three-foot model. To capture the huge scale of the ship required surface detailing as small

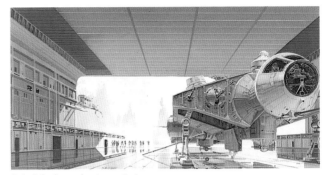

Rebel dock, production painting

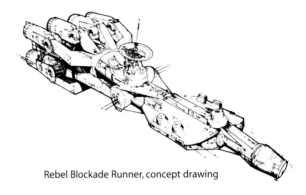

Rebel Blockade Runner, concept drawing

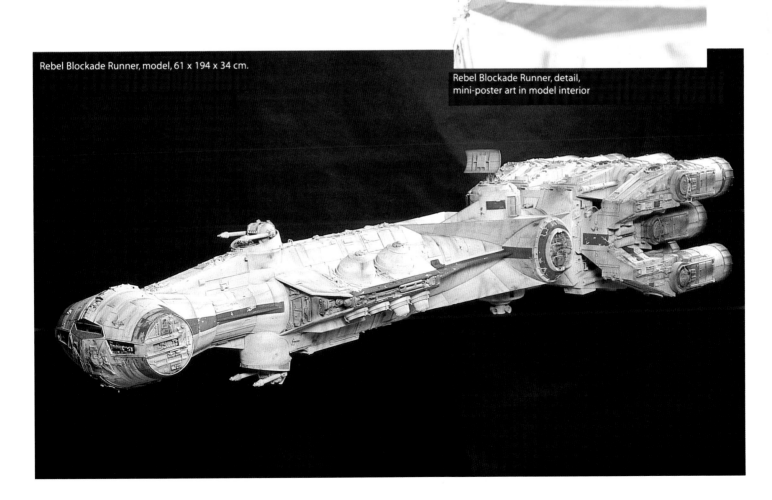

Rebel Blockade Runner, model, 61 x 194 x 34 cm.

Rebel Blockade Runner, detail, mini-poster art in model interior

as a sixteenth of an inch thick. The model making often involved the use of what model maker Lorne Peterson calls "found objects." The three Star Destroyer thrusters, for example, were made of egg-shaped plastic containers, used to package women's stockings, molded in high-heat aluminum epoxy to withstand the heat of the three, two-inch-wide halogen projection lamps built into the model.

A major innovation for all the space ships was that, unlike the shiny spacecraft of bygone science fiction films, *Star Wars* craft would show the physical wear of space travel, the battle-scarred hulls of space combat.

The detailing of the models also allowed for scale references, unlike the smooth, featureless surfaces of the old movie ships. "We created the space ship models with what we called 'boiler plate technology,' like how battleships are made, with quarter-inch steel sections riveted together," explains Lorne Peterson. "The idea was to get at what George Lucas called 'a used universe,' the idea that in the future things wouldn't be perfect and shiny, there'd be texture, you'd get used to your technology. Some things would be kept in shape, others would get junky and biodegraded."

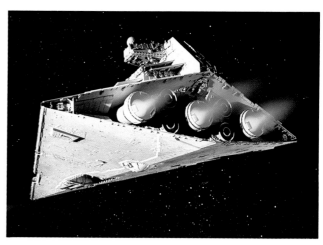

Imperial Star Destroyer, still from film

Imperial Star Destroyer, concept sketches

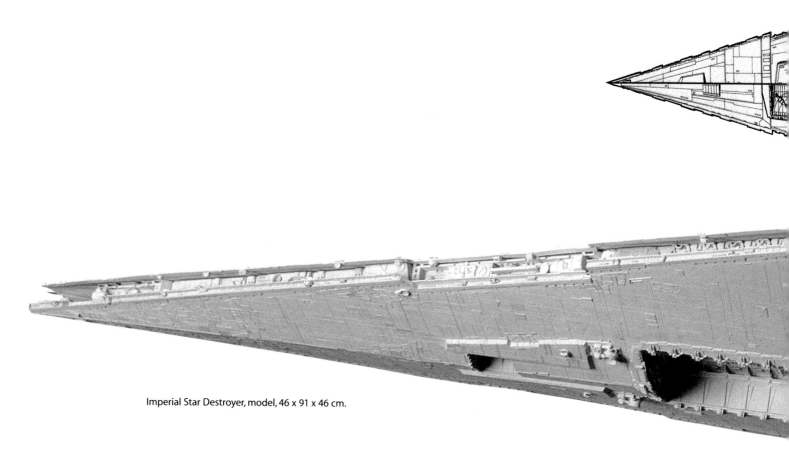

Imperial Star Destroyer, model, 46 x 91 x 46 cm.

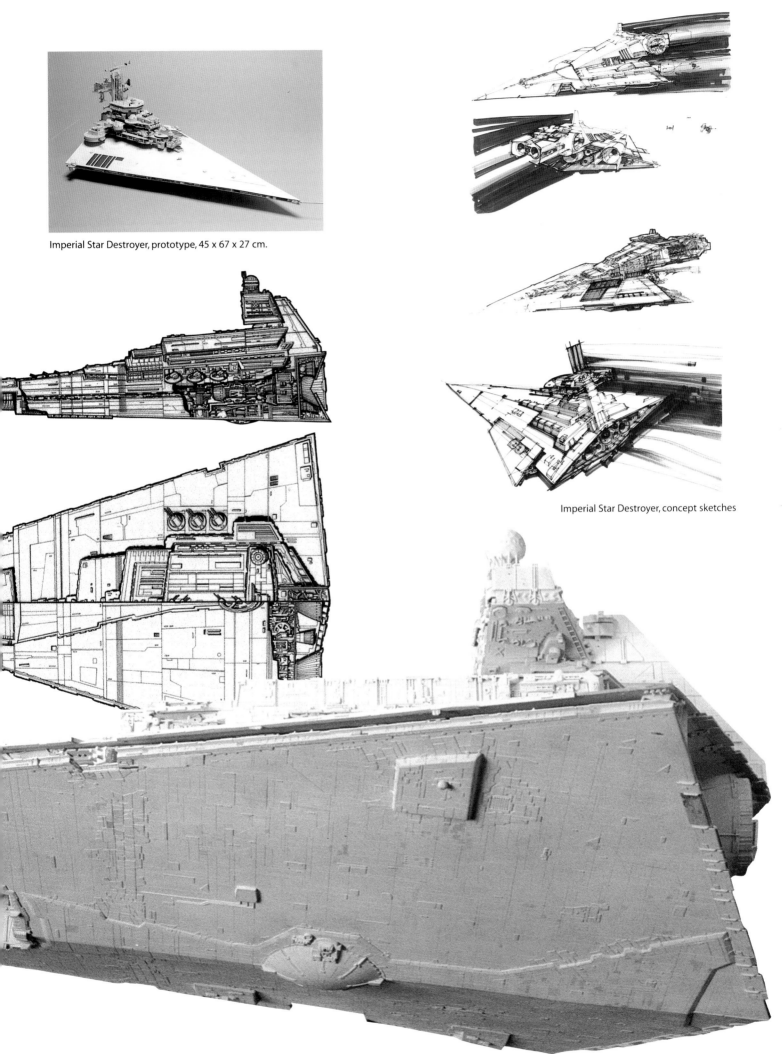

Imperial Star Destroyer, prototype, 45 x 67 x 27 cm.

Imperial Star Destroyer, concept sketches

THE DROIDS

The robots (or "droids"), C-3PO and R2-D2 are one of the great teams in the movies, a bickering yet lovable pair with a talent for placing themselves in the most precarious predicaments.

R2-D2 and C-3PO, coming across the desert sands of Tatooine, were the first *Star Wars* characters visualized and painted by artist Ralph McQuarrie. The painting was produced not only to convince Fox executives to do the film, but to stimulate Lucas's imagination. An early "Artoo" design by McQuarrie, depicting the droid perched on a large ball bearing, did not look right to Lucas, and the now-familiar tripod base was substituted. C-3PO was originally conceived with a more humanoid appearance before McQuarrie's final concept illustration, which recalled the art deco lines of the robot in the classic 1927 film *Metropolis*.

Although many of the nonhuman characters populating the *Star Wars* universe would be realized as articulated puppets, the droids were designed as costumes worn by actors. Hours of sound effects experimentation were required to nail down the unique beeping sounds of the squat little Artoo (played by three-foot, eight-inch tall actor Kenny Baker). C-3PO (played by actor Anthony Daniels) went through a major personality shift: Lucas initially imagined the droid as the stereotype of a fast-talking used-car salesman before deciding on the cultivated voice and manner of a proper English butler.

C-3PO and R2-D2, production painting

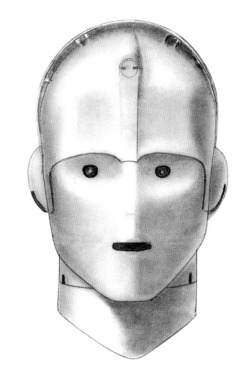

C-3PO, concept sketches

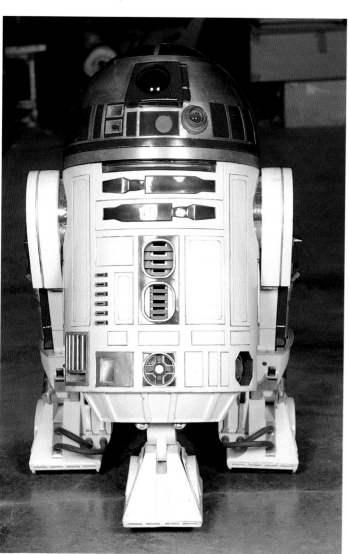

R2-D2, mechanical suit, 61 x 46 x 110 cm.

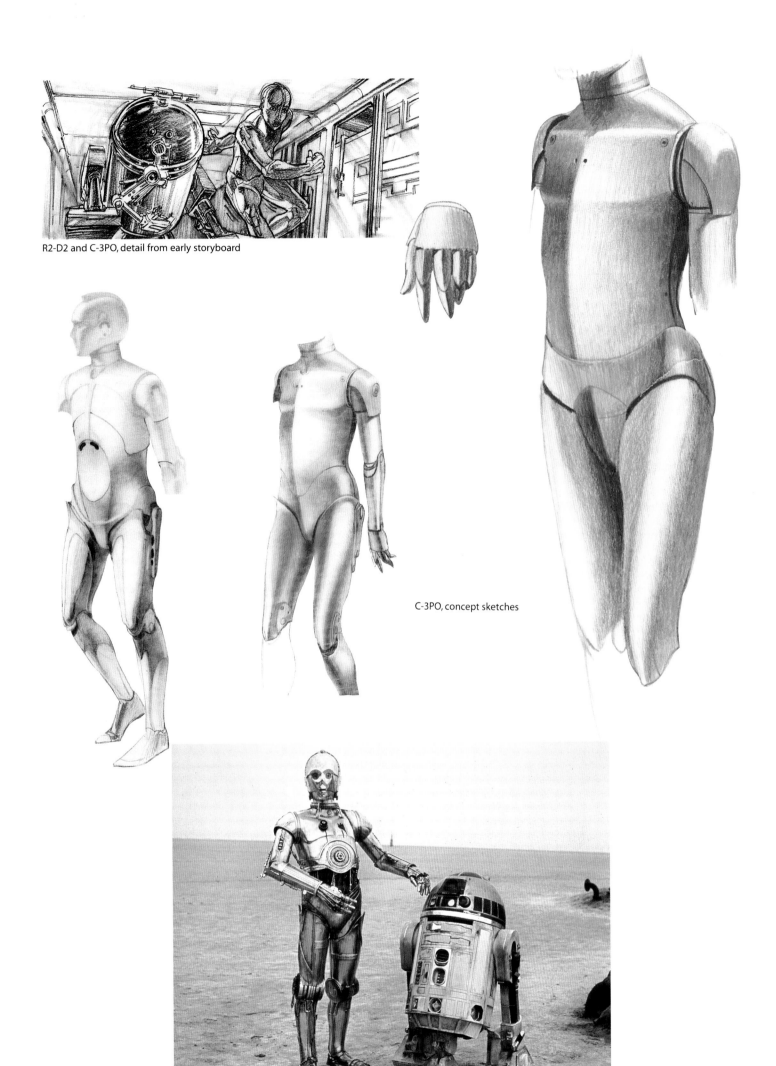

R2-D2 and C-3PO, detail from early storyboard

C-3PO, concept sketches

DARTH VADER: FIGURE OF EVIL

Darth Vader represents one of American film's unique villains, his aura of omnipotent power underlined by the opening shot of the Star Destroyer at his command. Vader was one of the first characters conceived by Lucas and artist Ralph McQuarrie to interest Fox in the film. "George asked me to create a guy with a cape that fluttered in the wind, with a wide brim helmet like the headgear of a medieval samurai," McQuarrie recalls. "Early in the script there was a description of Vader crossing between two ships in space so I created this mask so he could breathe in space, with a suggestion of teeth in the mask's grill work. George loved it."

The mask and helmet were so distinctive it was decided they would be a permanent feature of the character, incorporated into the saga as being protective equipment for lung and other injuries suffered by Vader during a battle with Obi-Wan Kenobi.

Although actor David Prowse filled the black Vader costume, the evil personality of the character was enhanced in postproduction with a dubbed-in voice by veteran character actor James Earl Jones. To create the labored breathing from Vader's tortured lungs, sound effects expert Ben Burtt, Jr., first tried to synthesize more than eighteen types of human breathing, but they proved unsatisfactory, so he used a scuba regulator for the final effect.

Faceoff, production painting

Darth Vader, early character sketches

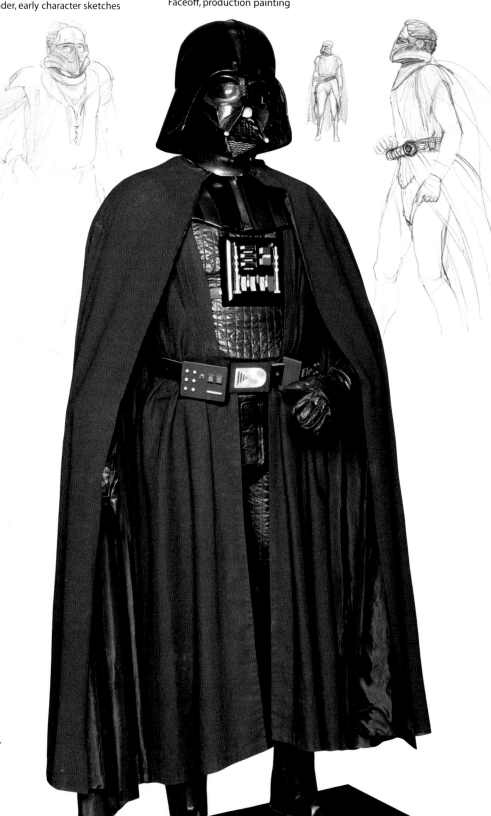

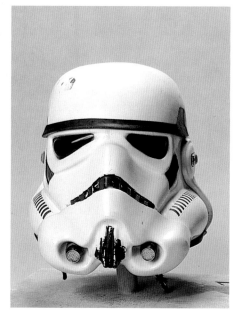

Imperial Stormtrooper's helmet,
costume headgear, 35 x 35 x 48 cm.

Darth Vader, costume, 97 x 46 x 204 cm.

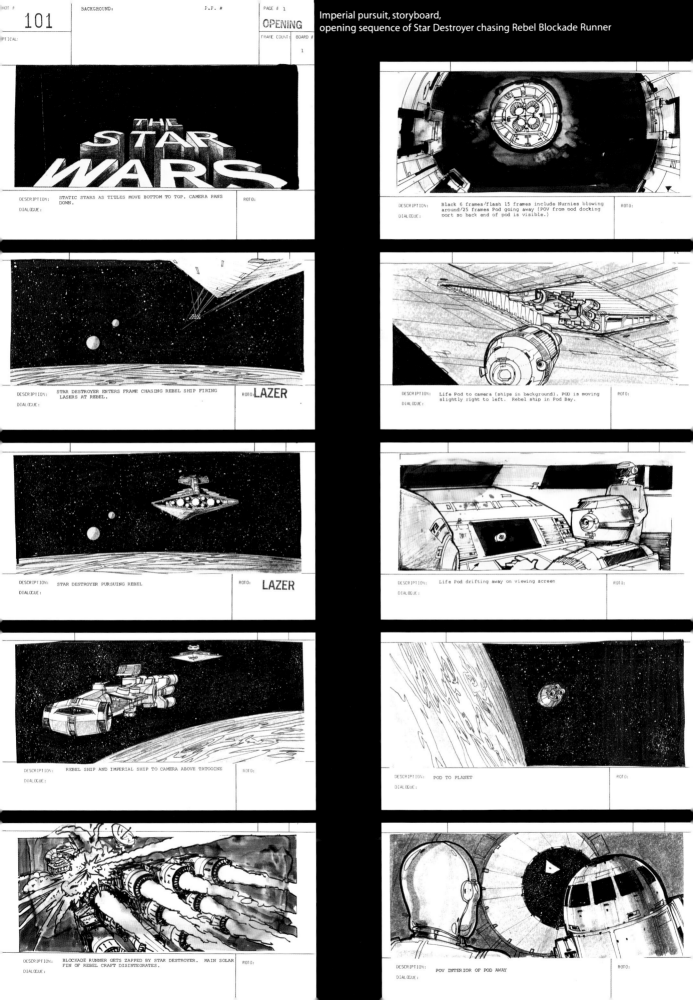

SHOT #	BACKGROUND:	F.P. #	PAGE # 1

OPTICAL:

101

OPENING

FRAME COUNT: | BOARD #
1

DESCRIPTION: STATIC STARS AS TITLES MOVE BOTTOM TO TOP. CAMERA PANS DOWN.
DIALOGUE:
ROTO:

DESCRIPTION: Black 6 frames/flash 15 frames include Nurnies blowing around/25 frames Pod going away (POV from pod docking port so back end of pod is visible.)
DIALOGUE:
ROTO:

DESCRIPTION: STAR DESTROYER ENTERS FRAME CHASING REBEL SHIP FIRING LASERS AT REBEL.
DIALOGUE:
ROTO: LAZER

DESCRIPTION: Life Pod to camera (ships in background). POD is moving slightly right to left. Rebel ship in Pod Bay.
DIALOGUE:
ROTO:

DESCRIPTION: STAR DESTROYER PURSUING REBEL
DIALOGUE:
ROTO: LAZER

DESCRIPTION: Life Pod drifting away on viewing screen
DIALOGUE:
ROTO:

DESCRIPTION: REBEL SHIP AND IMPERIAL SHIP TO CAMERA ABOVE TATOOINE
DIALOGUE:
ROTO:

DESCRIPTION: POD TO PLANET
DIALOGUE:
ROTO:

DESCRIPTION: BLOCKADE RUNNER GETS ZAPPED BY STAR DESTROYER. MAIN SOLAR FIN OF REBEL CRAFT DISINTEGRATES.
DIALOGUE:
ROTO:

DESCRIPTION: POV INTERIOR OF POD AWAY
DIALOGUE:
ROTO:

TRIP TO TATOOINE

The desert planet of Tatooine was conceived as a forsaken place, where the burning heat of its twin suns forces settlers such as Luke Skywalker (played by Mark Hamill) and his uncle and aunt to live underground. Dangers lurk on Tatooine as well: in the arid wastelands prowl the armed and dangerous Tusken Raiders and the three-foot-tall Jawas, a semihuman species who dress in monkish robes.

The creation of the *Star Wars* universe, from alien creatures to fantastic planet environments, was always first visualized in production sketches, illustrations, and paintings. "My job, as George defined it, was to capture the grand theme, the scale, the complexity of structures," artist McQuarrie notes. "After that, they'd worry about the effects and whether it could be built or not."

The planet was created with a combination of live-action location work in the Tunisian desert, miniature sandcrawler scenes shot in the California desert (at a spot where mine tailings had settled in sediments, forming a miniature Grand Canyon), and matte painting effects.

The escape pod used by the droids to reach Tatooine, an eighteen-inch final model, is another example of "found object" model making: the pod was created with two throwaway paper paint buckets, one whole and one truncated, joined together and covered with laminated plastic and

detailing. (According to Lorne Peterson, the time and expense estimated by the shop head for a model dictates the effort that goes into it. The escape pods were, as Peterson recalls, "a five-day wonder.")

Luke's landspeeder was realized as both a miniature model and a full-scale, three-wheeled motorized vehicle built for the first-unit work in England. When the full-scale land-

Luke and the twin suns of Tatooine, production painting

Luke Skywalker, costume sketches

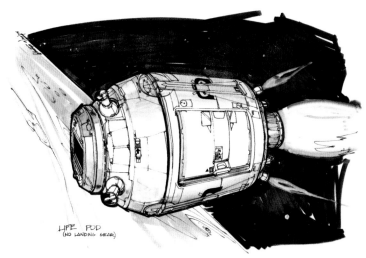

Rebel Blockade Runner Escape Pod, concept design

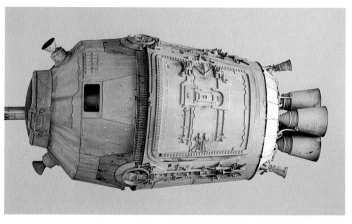

Rebel Blockade Runner Escape Pod, final model, 21 x 21 x 44 cm.

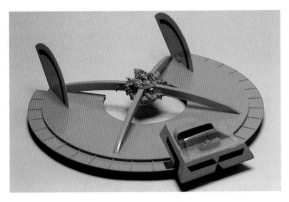

Landspeeder, early prototype, 37 x 9 x 40 cm.

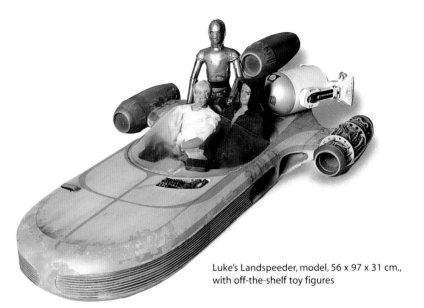

Luke's Landspeeder, model, 56 x 97 x 31 cm., with off-the-shelf toy figures

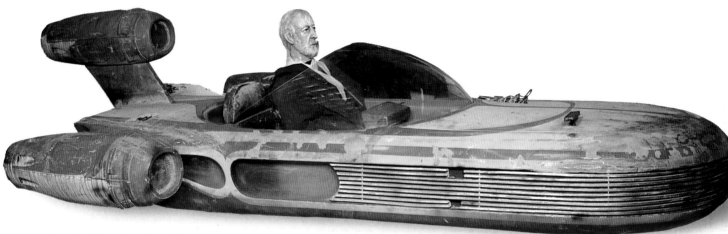

Luke's Landspeeder, full-scale mechanical prop, 217 x 402 x 114 cm. with Obi-Wan figure

Tatooine, matte painting, 127 x 86 cm.

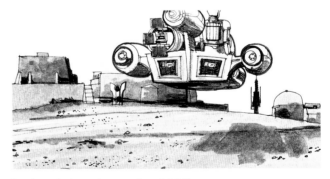

Landspeeder in motion, storyboard detail

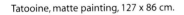

speeder was shipped to the states, some ILMers took the vehicle out for a spin around Van Nuys, drawing stares from passing motorists who didn't know they were witnessing a piece of movie history driving by. The miniature landspeeder model, which developed from a Colin Cantwell disc-shaped prototype, was built nearly three feet long to handle the foot-tall, store-bought action figures made up to look like Luke and the sage Ben (Obi-Wan) Kenobi.

Off-the-shelf parts are an important part of big-movie model making.

The sandcrawler craft, used by the Jawas to scour the flatlands for minerals and plunder, utilized four store-bought panzer tank tracks at its four corners. The final sandcrawler model was a fully motorized, radio-controlled vehicle three feet long and constructed of birch plywood covered with plastic and detailing. It was built with such powerful motors that its radio operators could make the sandcrawler pop a wheelie, although when the cameras rolled the miniature vehicle only had to lumber over the Tatooine wasteland.

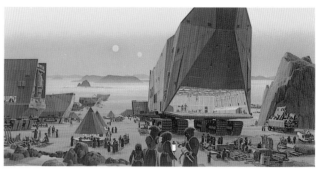

Jawa Camp, production painting

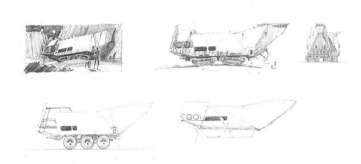

Sandcrawler, concept sketches

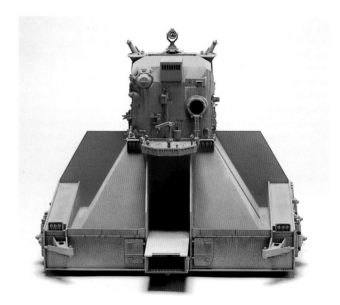

Sandcrawler, early prototype, 33 x 40 x 28 cm.

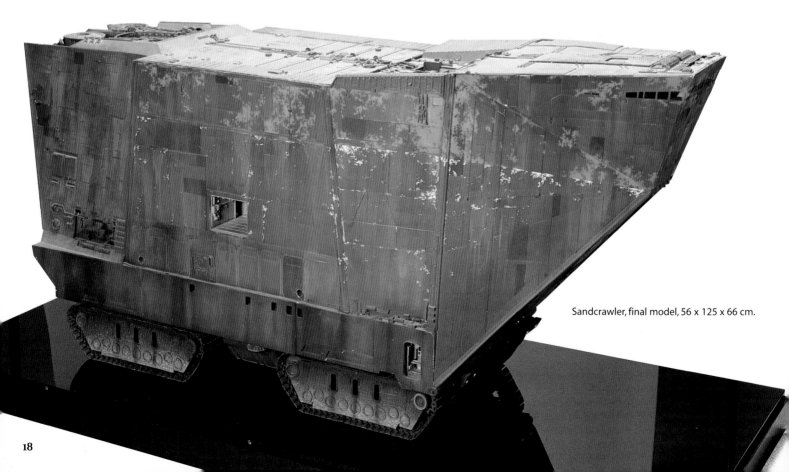

Sandcrawler, final model, 56 x 125 x 66 cm.

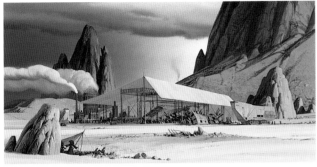

Jawa Camp, distant view, production painting

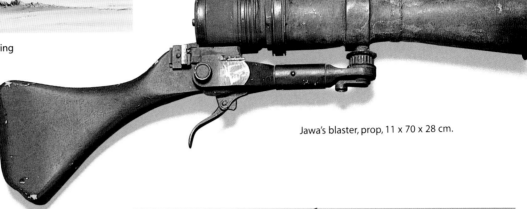

Jawa's blaster, prop, 11 x 70 x 28 cm.

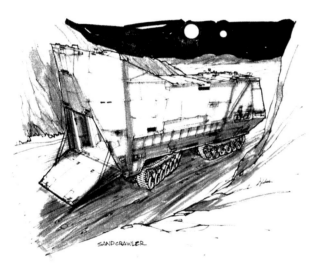

Sandcrawler, production sketch

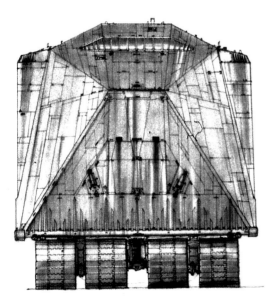

Sandcrawler, production sketch

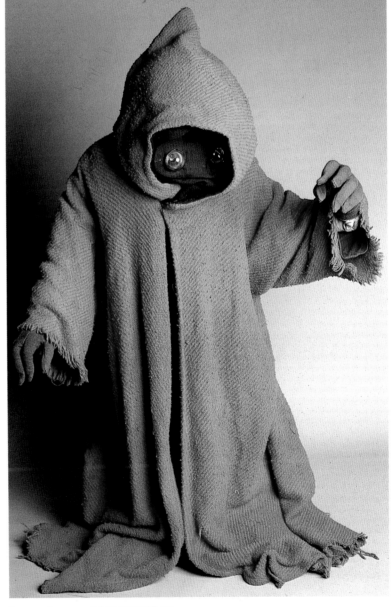

Jawa, costume, model, 46 x 23 x 97 cm.

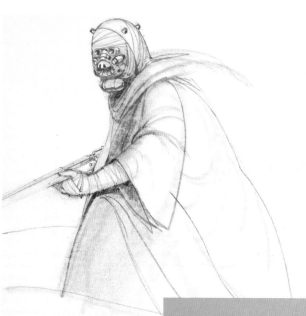

R.M.Q./75

Tusken Raider, production painting

Tusken Raider, costume sketch

Tusken Raider, full-head mask

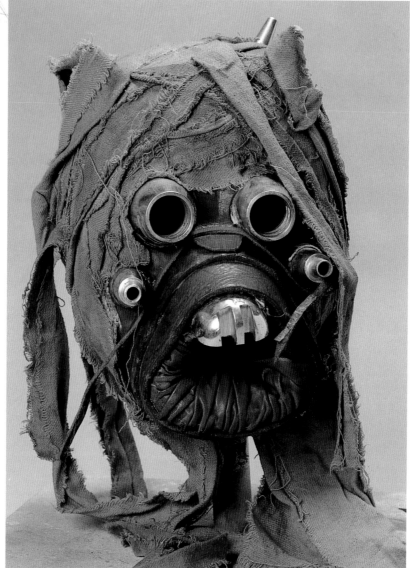

Gaffi Stick, weapon of the Tusken Raiders, prop, 21 x 121 x 12 cm.

HOT RODDER IN SPACE

Before he crosses paths with Princess Leia (played by Carrie Fisher) and Luke Skywalker, Han Solo (played by Harrison Ford) successfully avoids taking sides in the great struggle between the Rebels and the Empire. He is content as a mercenary, piloting through space with his partner, the towering Wookiee Chewbacca (played by Peter Mayhew).

The design of Solo's hot-rodding *Millennium Falcon* stalled after several versions, from an elongated prototype to a design for what eventually became the Rebel Blockade Runner. Then Lucas had another quirky design inspiration for the *Falcon*—the shape of a hamburger he had for lunch. That basic shape was developed with what model maker Peterson calls "guts on the outside," glued-on details meant to provide realistic scale. Off-the-shelf *Falcon* detailing

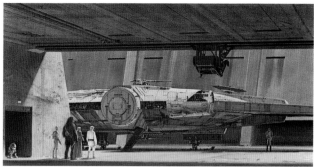

Millennium Falcon in hangar, production painting

Han Solo, photo of actor Harrison Ford

Han Solo's blaster and holster, prop, holster, 6 x 30 x 18 cm.

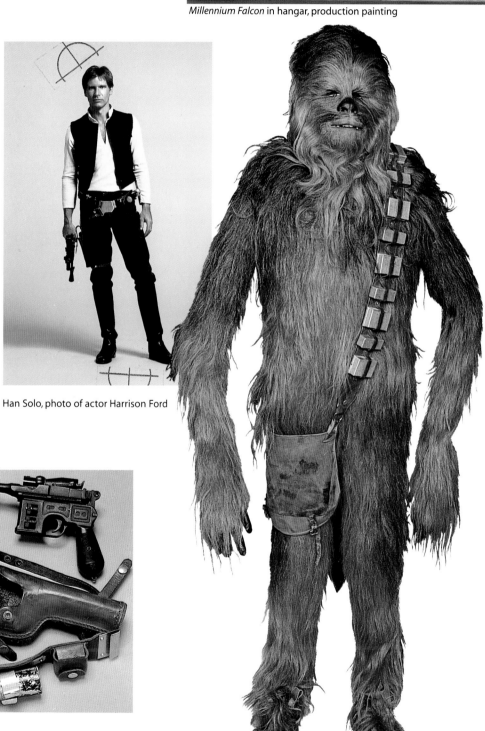

Chewbacca, costume suit, 82 x 38 x 219 cm.

included engine parts from Formula-1 race car and motorcycle model kits.

Since the *Falcon* figured in so much action, both as a bluescreen model effect and as a live-action prop, its importance necessitated many designs. Lucas even considered having the ship fly vertically through space. Although the ship became a horizontally powered craft, there are occasions in the trilogy when the *Falcon* is piloted as originally conceived, such as the flight through the Death Star tunnel in *Return of the Jedi*. Even the ship's hatch, which would figure in some key action sequences, went through more than ten basic configurations until a final was accepted.

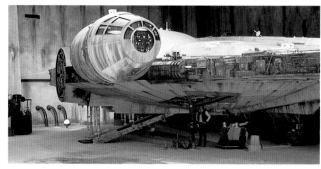

Millennium Falcon, with Han Solo, production photo

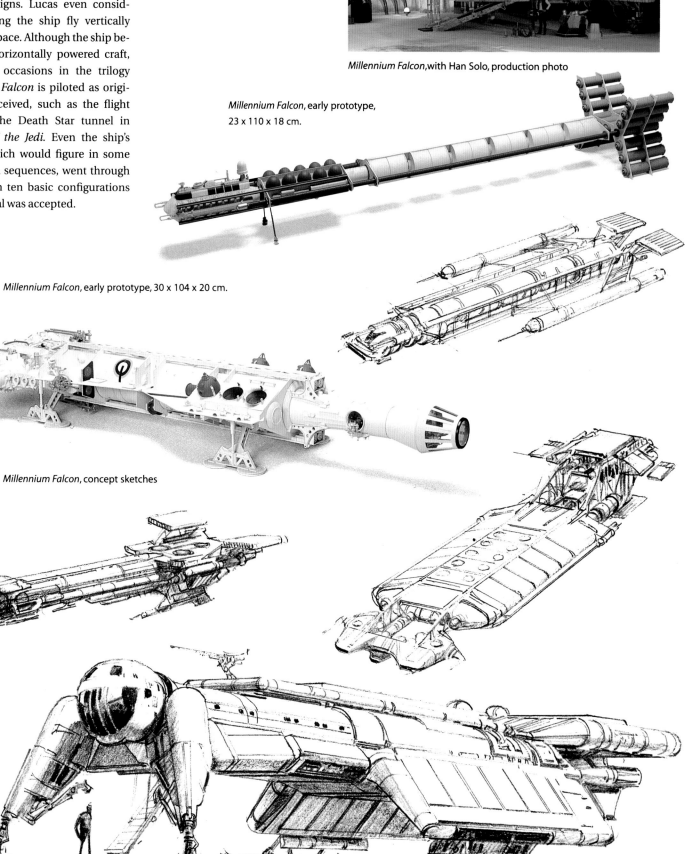

Millennium Falcon, early prototype, 23 x 110 x 18 cm.

Millennium Falcon, early prototype, 30 x 104 x 20 cm.

Millennium Falcon, concept sketches

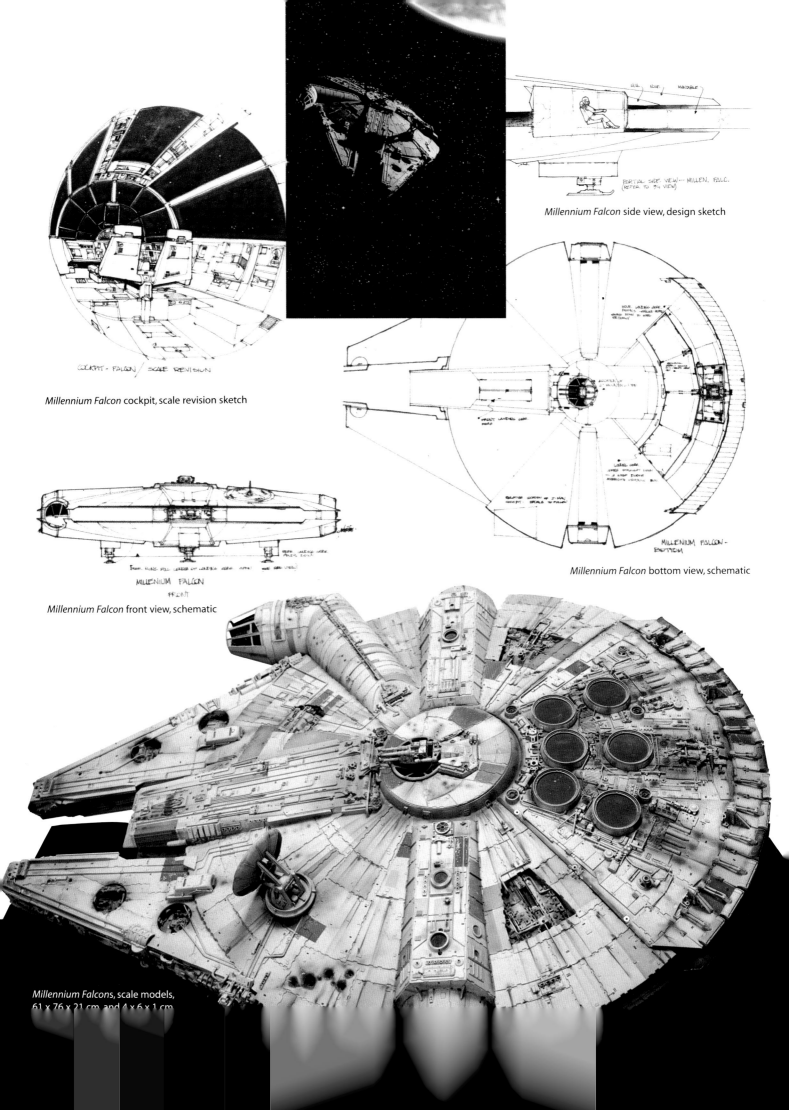

Millennium Falcon side view, design sketch

Millennium Falcon cockpit, scale revision sketch

Millennium Falcon bottom view, schematic

Millennium Falcon front view, schematic

*Millennium Falcon*s, scale models,
61 x 76 x 21 cm and 4 x 6 x 1 cm

STAR WEAPONS

Although the weaponry used in battles between Rebels and Empire includes different classes of blaster guns, such as Han Solo's laser pistol, modeled after a German Mauser, the greatest weapon of the *Star Wars* universe is the lightsaber of the Jedi Knight tradition. To Jedi Knights a blaster is a random, clumsy weapon while the lightsaber represents the Zen-like elegance of the civilized age when the Old Republic reigned with peace and justice for all. To use the lightsaber properly is to be at one with the Force, described by Obi-Wan as "an energy field created by all living things…[that] binds the universe together."

Different styles of lightsaber props were constructed from old-fashioned press photography camera flash bars, with additional parts machined on. The saber's laser-light glow was achieved by filming the actors holding stick swords wrapped with highly light-reflective material. In subsequent installments the lightsaber glow effect would be created as animation laid frame by frame over prop swords used by the actors.

The Jedi training remote, used by Obi-Wan to test Luke Skywalker during an early lightsaber training session, was called the "seeker ball" by the model crew. The turnaround for the model was a mere two days. (Note the chrome wheel rims from an off-the-shelf model truck kit that decorate the orb's surface.) The remote was shot as a bluescreen element for later optical compositing, but instead of programming a computerized motion-control move, artist Joe Johnston manually manipulated the model from its bottom with a quarter-inch rod as the camera rolled.

Imperial Stormtrooper with lightsaber, production painting

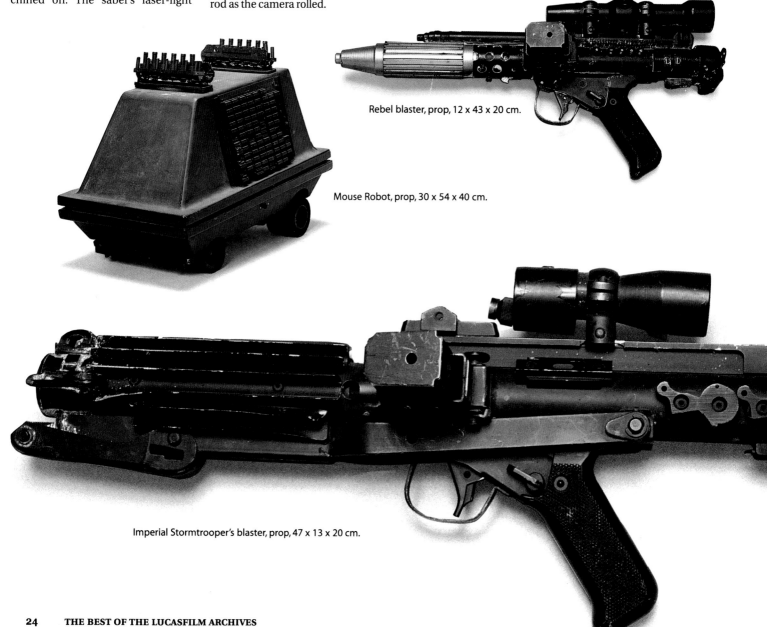

Rebel blaster, prop, 12 x 43 x 20 cm.

Mouse Robot, prop, 30 x 54 x 40 cm.

Imperial Stormtrooper's blaster, prop, 47 x 13 x 20 cm.

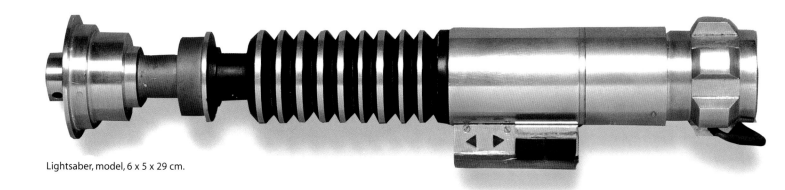

Lightsaber, model, 6 x 5 x 29 cm.

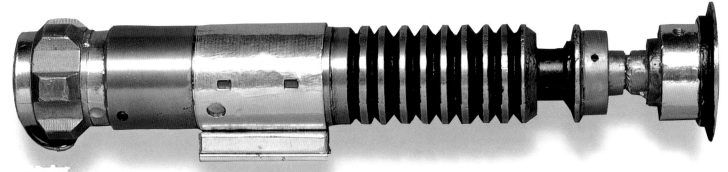

Lightsaber, model, 6 x 5 x 29 cm.

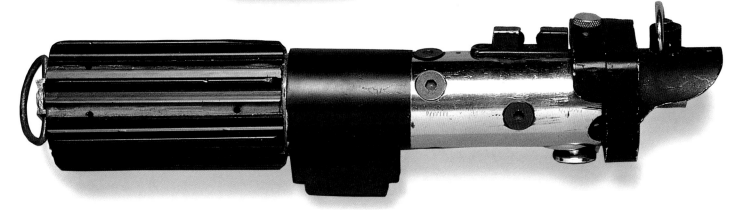

Lightsaber, model, 5 x 5 x 28 cm.

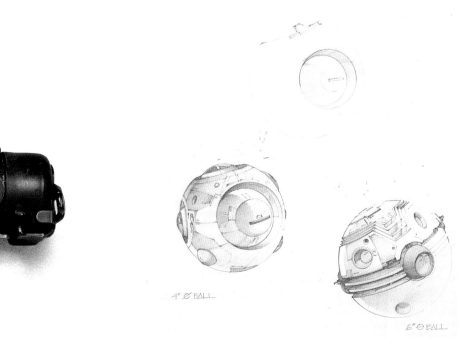

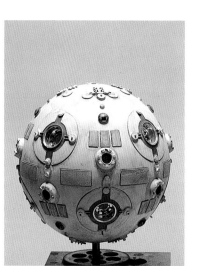

Jedi Training Remote, model, 15 x 15 x 15 cm.

Jedi Training Remote, design sketches

BATTLE AT THE DEATH STAR

The climax of the film, the battle between Rebel X-wing and Y-wing fighters and Empire TIE fighters along the trench of the Imperial Death Star, was a fighting sequence inspired by the World War I and II aerial dogfight footage studied by Lucas.

The Death Star, the citadel of the Imperial force, was written as a planet-sized structure, protected by Imperial TIE fighters and laser towers (which Joe Johnston called the "ack-ack" guns for the pump-action report of the model's firing system).

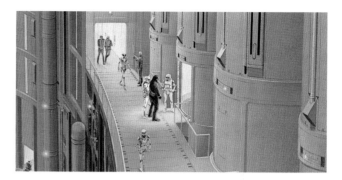

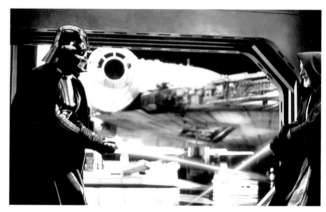

Death Star interior, production painting (above)
Darth Vader and Obi-Wan face off with lightsabers, still from film (below)

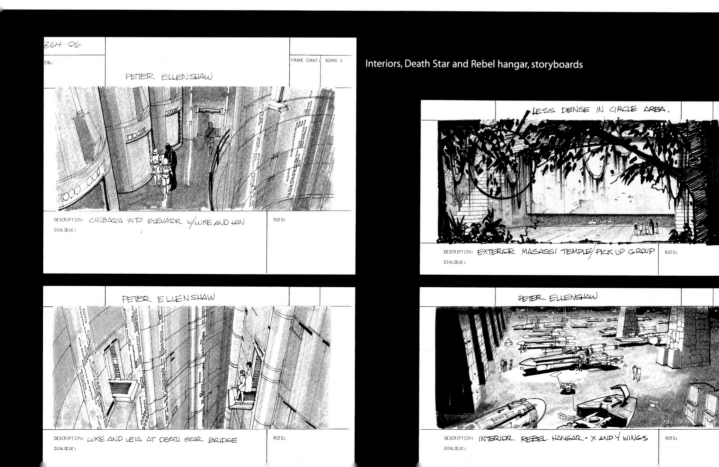

Interiors, Death Star and Rebel hangar, storyboards

PETER ELLENSHAW

DESCRIPTION: CHUBACCA INTO ELEVATOR W/LUKE AND HAN
DIALOGUE:

LESS DENSE IN CIRCLE AREA.

DESCRIPTION: EXTERIOR MASASSI TEMPLE/PICK UP GROUP
DIALOGUE:

PETER ELLENSHAW

DESCRIPTION: LUKE AND LEIA AT DEATH STAR BRIDGE
DIALOGUE:

PETER ELLENSHAW

DESCRIPTION: INTERIOR REBEL HANGAR - X AND Y WINGS
DIALOGUE:

The TIE fighter models, which ranged in size from two feet across to several inches, were named after the "bow ties" some ILMers said they resembled.

The Rebel X-wing and Y-wing fighters were named for their respective shapes. Once again, off-the-shelf and found objects were used to build the models: the Y-wing fighters utilized both glued-on model kits of Saturn rockets and egg-shaped stocking containers used, as noted earlier, for the Star Destroyer thrusters. (For rough size approximations of *Star Wars* ships and vehicles see

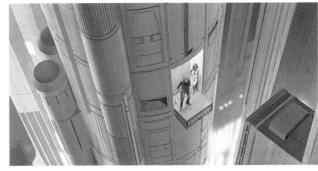

Luke and Leia in Death Star reactor chamber, production painting

Death Star trench, design sketch

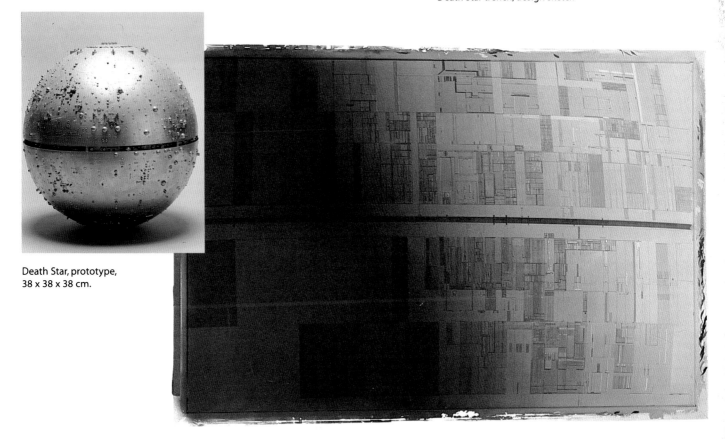

Death Star, prototype,
38 x 38 x 38 cm.

Death Star surface, matte painting, 127 x 86 cm.

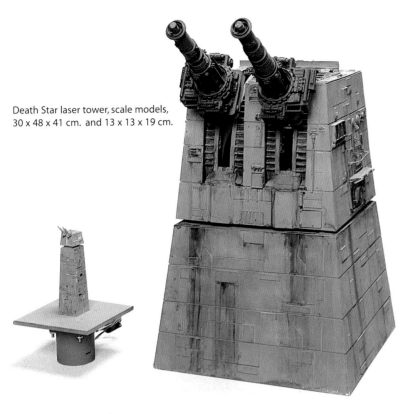

Death Star laser tower, scale models,
30 x 48 x 41 cm. and 13 x 13 x 19 cm.

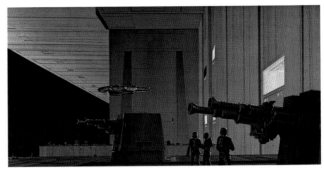

Millennium Falcon flying into Death Star hangar, production painting

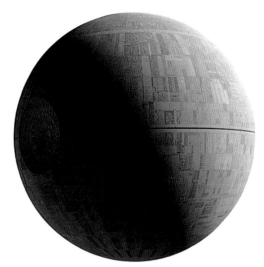

Death Star, matte painting, 127 x 86 cm.

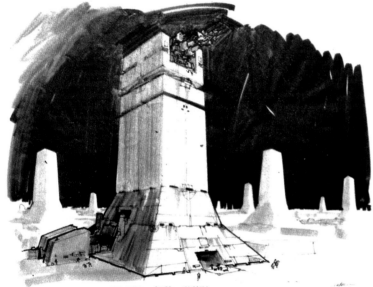

DEATH STAR LASER CANNON

Death Star laser tower, production sketch

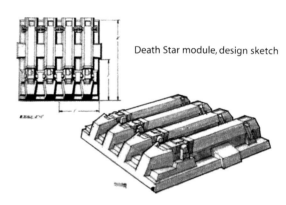

Death Star module, design sketch

DEATH STAR MODULE - 3

Death Star surface module, model, 65 x 150 x 15 cm.

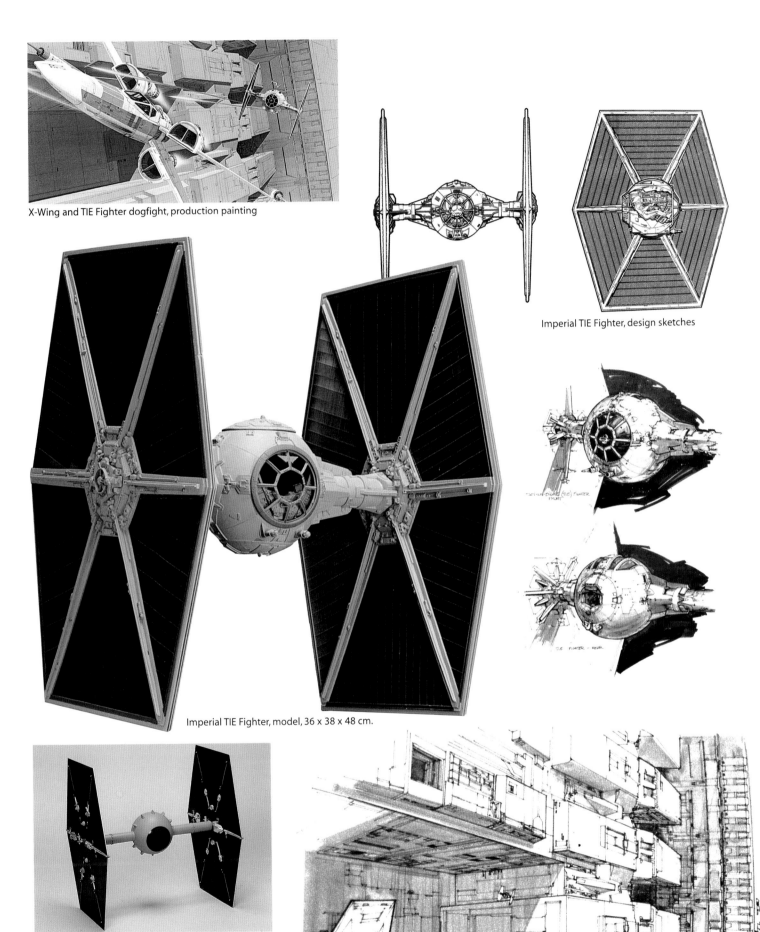

X-Wing and TIE Fighter dogfight, production painting

Imperial TIE Fighter, design sketches

Imperial TIE Fighter, model, 36 x 38 x 48 cm.

Imperial TIE Fighter, prototype, 34 x 30 x 37 cm.

TIE Fighter over Death Star equator

the Joe Johnston schematics on the final page of this chapter.)

In the film, Luke Skywalker is able to bomb and destroy the Death Star because it has a deadly weakness: a breachable trench opening to the citadel's exposed reactor core.

The Death Star trench was created as a miniature, sixteen-hundred-square-foot set that was filmed outdoors, in natural sunlight, on the ILM lot. The motion-control Dykstraflex camera was suspended in the trench and reeled across to give audiences a pilot's eye view of the attack. (Pyrotechnic effects for the explosive fire along the trench required filming at speeds of more than three hundred frames per second.)

Rebel X-Wing in Death Star trench, production painting

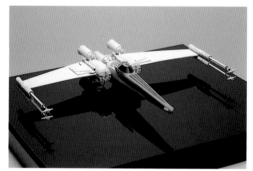

Rebel X-Wing Fighter, early prototype, 48 x 41 x 6 cm.

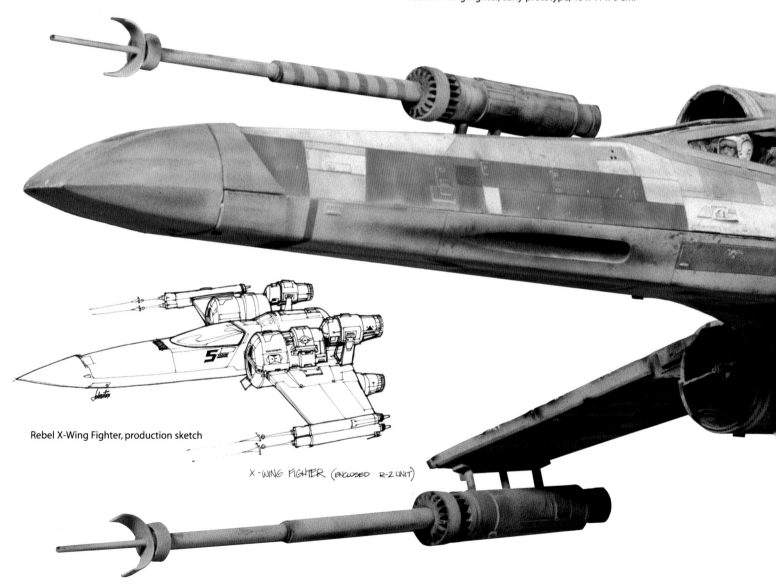

Rebel X-Wing Fighter, production sketch

X-WING FIGHTER (ENCLOSED R-2 UNIT)

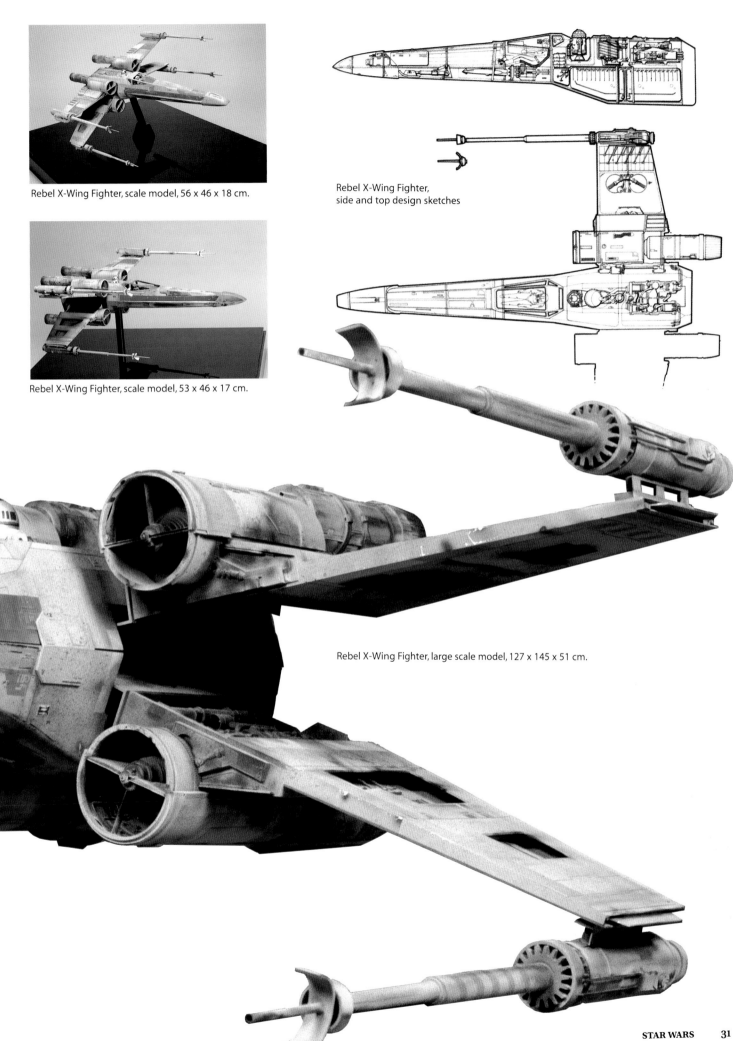

Rebel X-Wing Fighter, scale model, 56 x 46 x 18 cm.

Rebel X-Wing Fighter, scale model, 53 x 46 x 17 cm.

Rebel X-Wing Fighter,
side and top design sketches

Rebel X-Wing Fighter, large scale model, 127 x 145 x 51 cm.

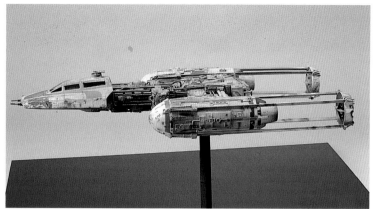

Rebel Y-Wing Fighter (Red), model, 38 x 10 x 71 cm.

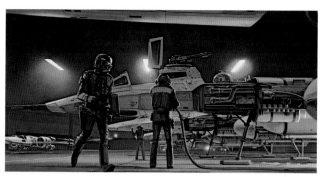

Rebel Y-Wing hangar, production painting

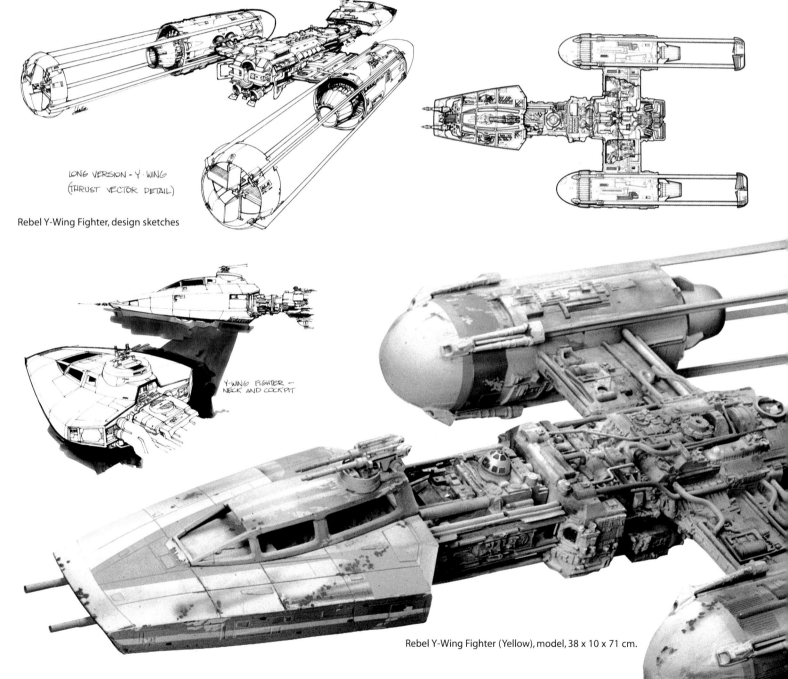

LONG VERSION - Y-WING
(THRUST VECTOR DETAIL)

Rebel Y-Wing Fighter, design sketches

Y-WING FIGHTER -
NECK AND COCKPIT

Rebel Y-Wing Fighter (Yellow), model, 38 x 10 x 71 cm.

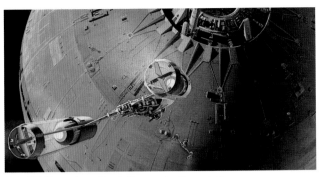

Rebel Y-Wings above Death Star, production painting

Darth Vader's damaged TIE wing, model, 22 x 6 x 31 cm.

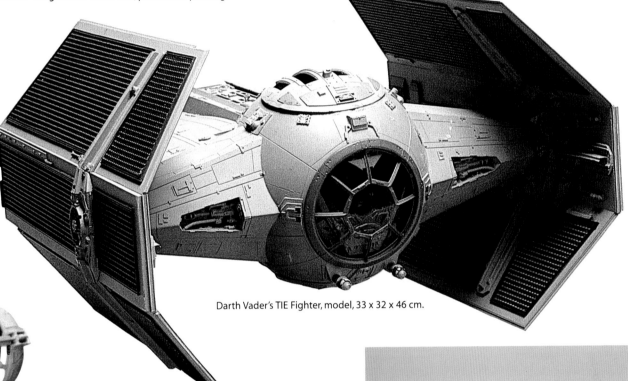

Darth Vader's TIE Fighter, model, 33 x 32 x 46 cm.

Rebel Y-Wing Fighter, design sketch

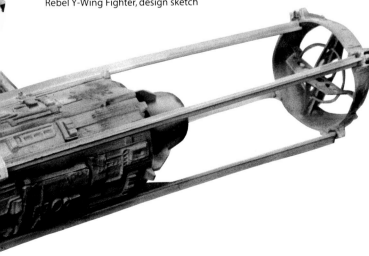

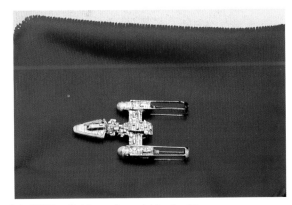

Rebel Y-Wing Fighter, prototype, 30 x 46 x 10 cm.

Rebel Y-Wing Fighter, scale model, 2 x 3 x 0.3 cm.

HAPPY ENDINGS

In the film's finale, Skywalker, Solo, and Chewbacca are honored by an assembly of the victorious Rebel forces. It would be a short-lived celebration—by the next chapter the Empire would be regrouped and, once again, the Rebels would be on the run.

When *Star Wars* opened at Hollywood's fabled Mann's Chinese Theater, there were lines around the block, eight or nine people deep, forcing one lane of traffic to be closed off. Lucas himself, dining at a nearby restaurant, saw what he recalls as "a mob scene" and was astounded when he realized his film was the cause of the commotion. During a vacation to Hawaii later in the week he received reports that his movie was breaking box office records. (During that fateful trip, at which he was joined by his friend Steven Spielberg, Lucas advanced his concept of an adventuring archaeologist named Indiana Jones.)

For years *Star Wars* would rank as the number one box office attraction in movie history (nearly twenty years later it still ranks third on the all-time list). The film would be nominated for Best Picture and win six Oscars, including Best Visual Effects.

In his first flush of major success Lucas shared profit percentages with key cast and crew and began to funnel his grosses into building Skywalker Ranch and maintaining Industrial Light & Magic as a fully operating effects unit. But with worldwide audiences impatiently awaiting the next chapter in the saga, the creative forces of Lucasfilm knew they would have to outdo themselves in the sequel.

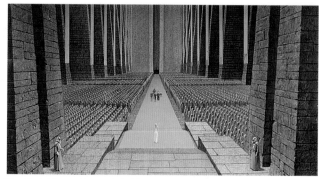

The Main Throne Room, Rebel base on Yavin Four, production painting, with still from film below

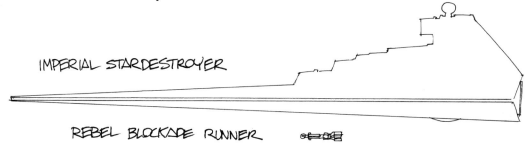

Star Destroyer to Sandcrawler, images drawn in approximate scale to each other

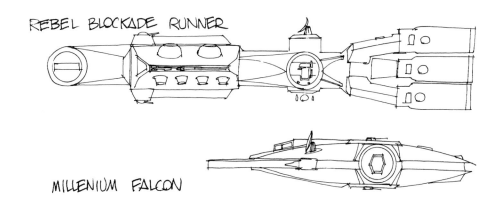

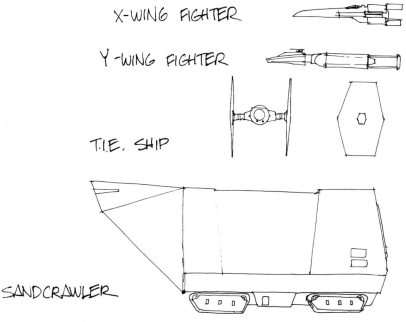

IN THE CLUTCHES OF DARTH VADER

THE EMPIRE STRIKES BACK

(Lucasfilm/20th Century Fox) 1980

THE ICE PLANET

It was a long way from the old Zoetrope studio, a warehouse on San Francisco's Folsom Street that housed what Lucas recalls as a "loose confederation of radicals and hippies," to his 1978 purchase of seventeen hundred acres of former ranch land in Marin County.

Lucas, laying the foundation for Skywalker Ranch, also relocated his ILM effects unit from Van Nuys to nearby San Rafael. Ralph McQuarrie even created a whimsical change of address card featuring *Star Wars*

Industrial Light & Magic, setting up shop at San Rafael facility

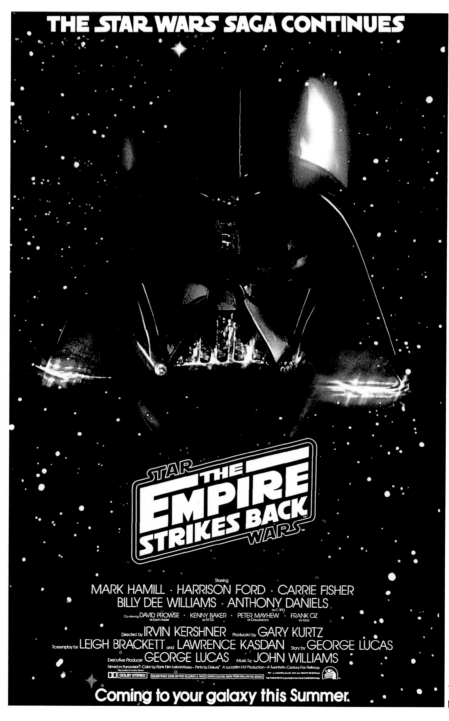

The Empire Strikes Back release poster, 61 x 91 cm.

characters in a landspeeder, followed by a huge sandcrawler, making their way out of Hollywood.

But Lucas's dreams of expansion, as well as future *Star Wars* episodes, were predicated on the success of *The Empire Strikes Back*.

ILM had to hit the ground running on production for *Empire*, forced to work their movie magic while the facility around them was still full of the noise and dust of construction. The soundstage work would, once again, be staged at Elstree Studios in England. A new character would also be introduced, the wise, elfin Jedi master, Yoda.

The major location shoot for *Empire* was Finse, a region of Norway that would serve as the ice planet of Hoth. The freezing location, which in the past had served explorers and military forces training for polar expeditions, required constant vigilance by the crew, who had to contend with frostbite, avalanches, blizzards, whiteouts, and gale force winds.

The film opens as Vader, searching for Luke Skywalker, dispatches from his Star Destroyer an Imperial probe robot (nicknamed "probot"). The probot lands on the planet Hoth and is spotted by Skywalker through his special binoculars.

The floating probot, built by model maker Paul Huston and duplicated in England as a full-scale replica, was inspired by an image created by visionary graphic artist Jean "Moebius" Giraud (who gave permission to develop the strange contraption for *Empire*). The eighteen-to twenty-inch-tall probot model was designed with all the hammered steel and rivets of the model shop's "boiler

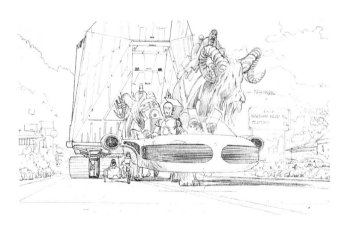

Ralph McQuarrie concept sketch which became Lucasfilm change-of-address card

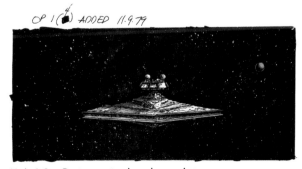

Vader's Star Destroyer, storyboards, opening scene (with in-house crawl gag)

plate" approach to model making. The probot miniature was shot on a motion-control rig as a bluescreen element with the spidery, mechanical legs animated stop-motion.

Like Luke's home planet of Tatooine, the ice planet of Hoth is populated by strange creatures such as the tauntauns, which can stand on their two legs and be ridden like horses, and the wampa, an ice creature who captures Luke and hangs him upside down in his icy lair.

The tauntaun design sketches were followed closely in creating a final puppet of the creature and rider for the time-consuming, precise art of stop-motion animation. Many of

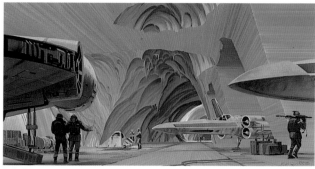

Rebel Base on Hoth, production painting

Millennium Falcon in hangar, matte painting, 191 x 84 cm.

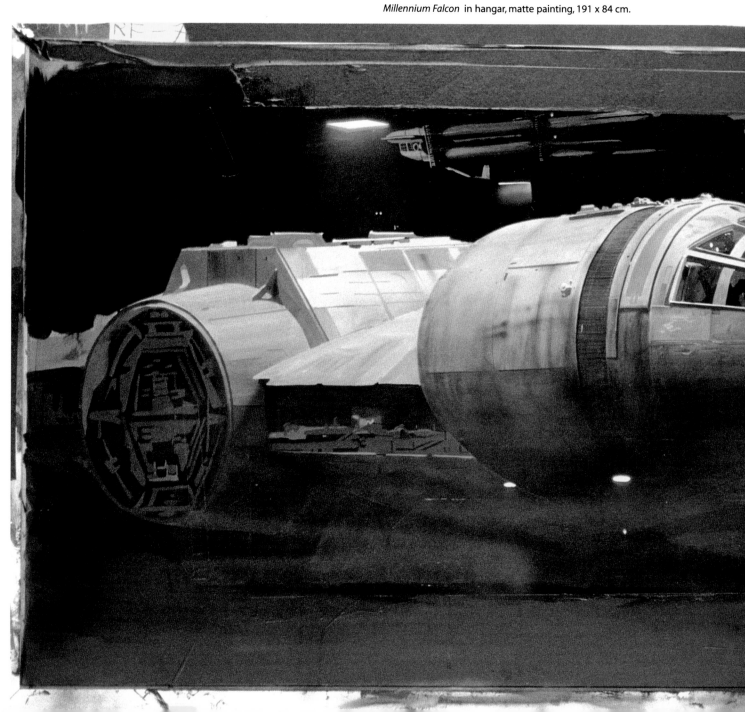

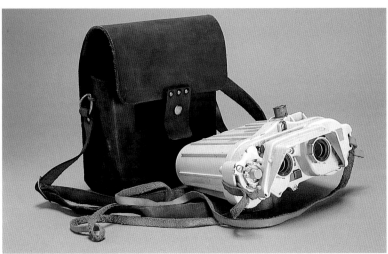

Macrobinoculars with case, prop, case size, 30 x 30 x 10 cm.

Rebel locator box (Rebel sensor pack), prop, 22 x 14 x 50 cm.

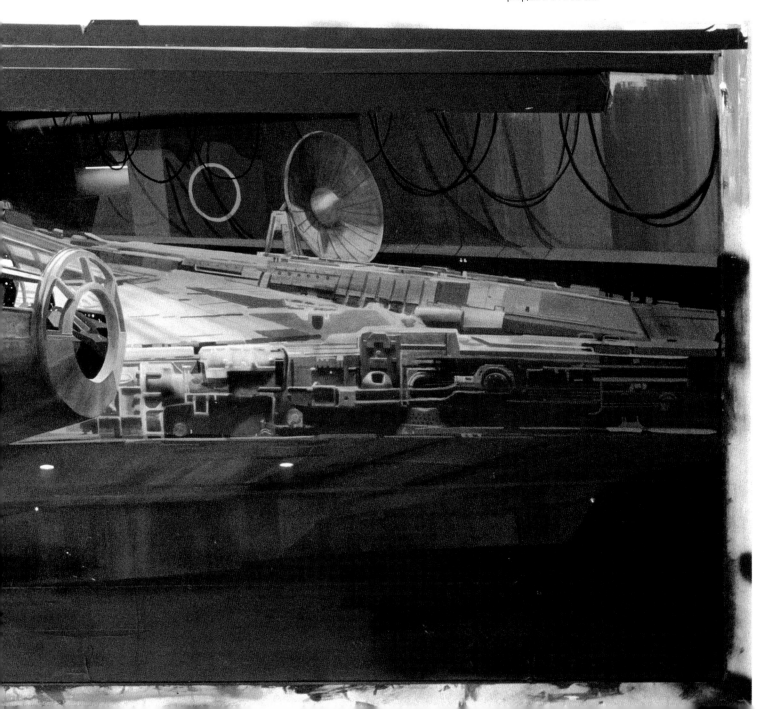

the creatures, even such mechanical contraptions as the four-legged Imperial walkers, were realized as puppets manually manipulated frame by frame. Even though the technique exerts the inevitable wear and tear on puppets (which are usually made of foam latex or similar material), molds of each puppet allow a creature shop to make duplicates as needed. The most important part of a stop-motion puppet is the machined, steel ball-and-socket armature skeleton that, hinged at pivot points, allows the figure to be manipulated by animators.

Probot scouts the Ice Planet, production painting

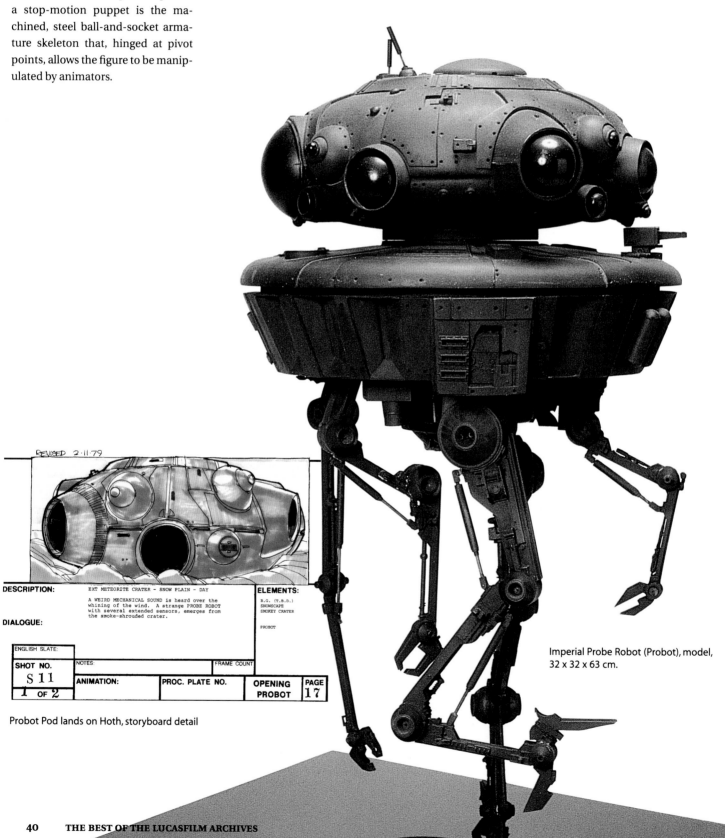

REVISED 2·11·79

DESCRIPTION: EXT METEORITE CRATER - SNOW PLAIN - DAY

A WEIRD MECHANICAL SOUND is heard over the whining of the wind. A strange PROBE ROBOT with several extended sensors, emerges from the smoke-shrouded crater.

DIALOGUE:

ELEMENTS:

B.G. (T.B.D.)
SNOWSCAPE
SMOKEY CRATER

PROBOT

ENGLISH SLATE:

SHOT NO.	NOTES:		FRAME COUNT	
S 11				
1 OF 2	ANIMATION:	PROC. PLATE NO.	OPENING PROBOT	PAGE 17

Probot Pod lands on Hoth, storyboard detail

Imperial Probe Robot (Probot), model, 32 x 32 x 63 cm.

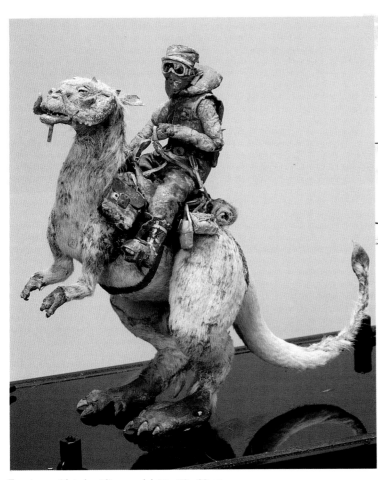

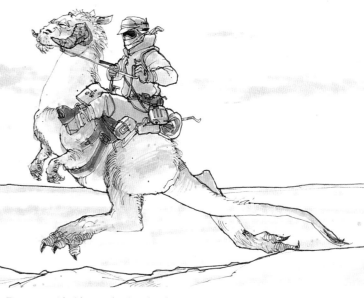

Tauntaun with rider, production sketches

Tauntaun with Luke riding, model, 10 x 28 x 33 cm.

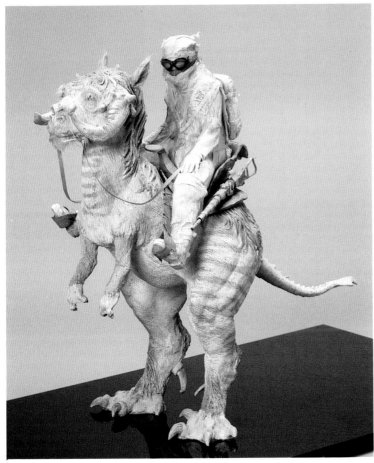

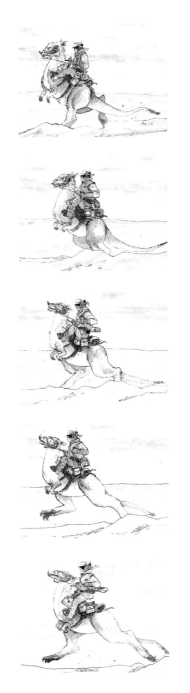

Tauntaun with rider, prototype, 15 x 41 x 34 cm.

Unlike the time-consuming demands of a stop-motion figure, the wampa, created as a hand puppet made by Jon Berg and animated by Phil Tippett, was on screen for less than a second. Other than that close-up, in which the monster roars out of the snow and swats down Skywalker, the wampa never again shows its face (although audiences hear the monster's terrifying roar and see the hairy arm sliced off by Luke's lightsaber).

After Luke is rescued by Han Solo, aided by a locator box tracking device, the young Rebel leader is tended to by 2-1B, a medical droid.

Luke in the healing chamber, production painting

Wampa Snow Creature, puppet, 51 x 31 x 31 cm.

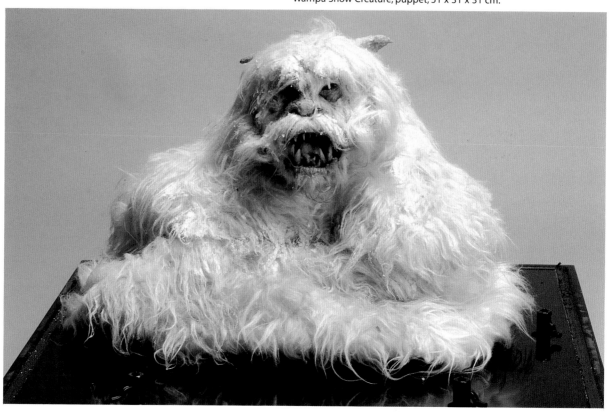

Hoth, the Ice Planet, matte painting, 190 x 83 cm.

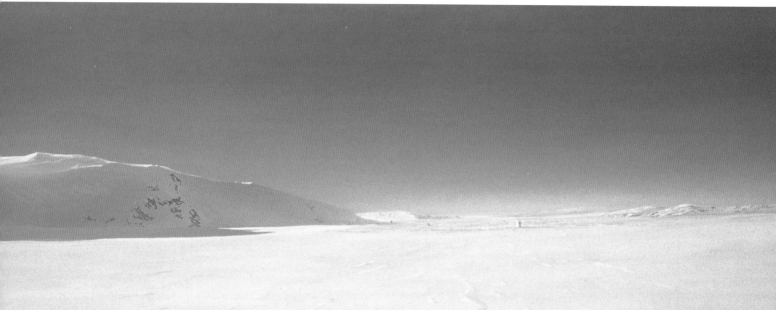

Dolly →

more ends to reveal –

action cuts.

Luke trapped in Wampa's cave, storyboards
(with Luke reaching for lightsaber)

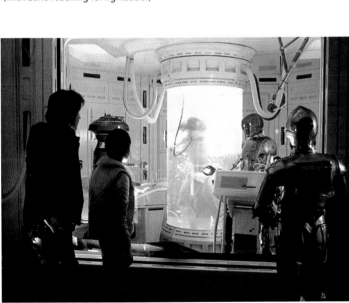

Luke in the healing chamber, still from film

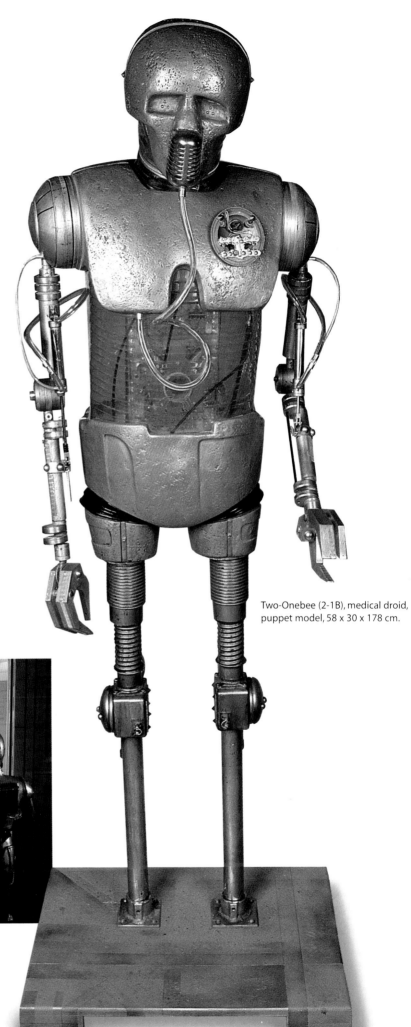

Two-Onebee (2-1B), medical droid,
puppet model, 58 x 30 x 178 cm.

VADER'S STAR DESTROYER

The Imperial Star Destroyer *Executor*, the flagship of Darth Vader, was conceived as eleven times the size of the original Star Destroyer of *Star Wars*. (For a reference, the conning tower that rises from the *Executor* was supposed to be as big as the original Destroyer's conning tower.) The interior action on the *Executor* was often shot as an effect, such as the ship's matte-painted bridge where live action of Vader and his crew were optically composited.

The *Executor* model was the first ship made out of strong, but lightweight, honeycombed aluminium, an eighth-of-an-inch-thick sandwich of two thin layers of aluminium skin with a honeycombed sheet in between. The ten-foot-long model was full of detailing, including little glued-on balconies. And whereas the original Star Destroyer was lit from within by bundles of fiber optics, the *Executor* had an internal neon lighting system that shone through an estimated 250,000 separate light portals, achieved by using a photo-graphic etching process to create pinprick holes through brass plates.

The flagship was originally conceived for use in a few establishing shots, but once the production team saw the completed, ten-foot model, new storyboards were prepared to accommodate additional *Executor* shots.

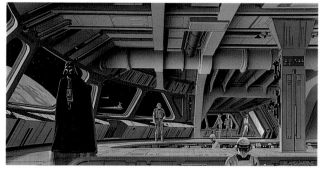
Vader walks the bridge, production painting

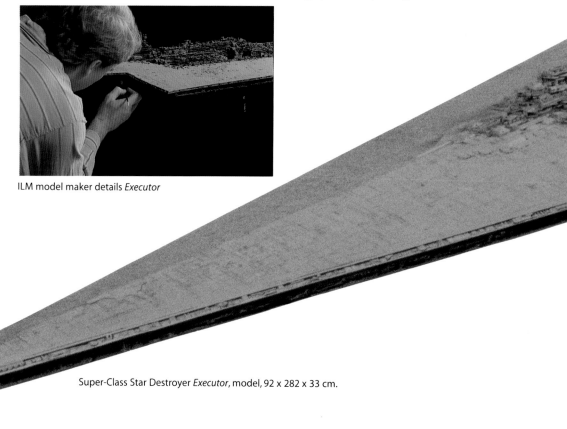
ILM model maker details *Executor*

Super-Class Star Destroyer *Executor*, model, 92 x 282 x 33 cm.

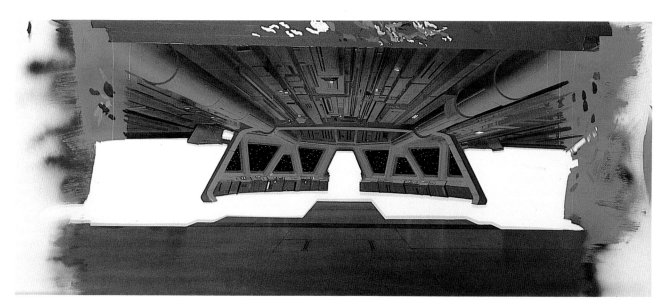
Executor bridge, matte painting, 191 x 84 cm.

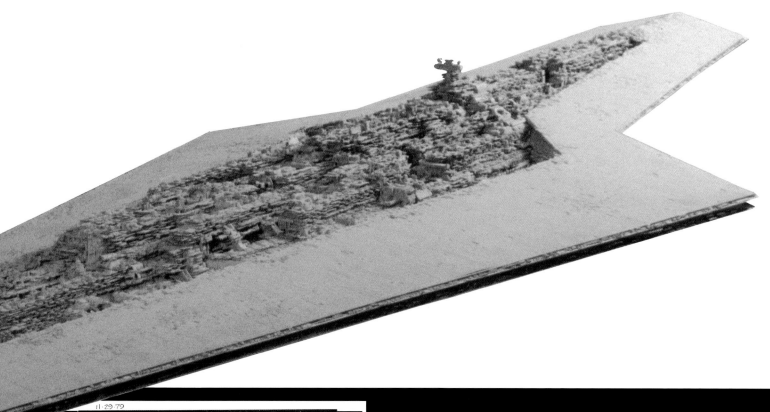

Imperial Fleet assembles, storyboard sequence

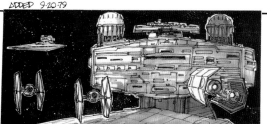

11·29·79

DESCRIPTION:
EXT. SPACE - IMPERIAL FLEET
Fleet assembles.

DIALOGUE:

SCENE NO. 54				
SHOT NO. **VH 1**	NOTES		FRAME COUNT 183	
OF	ANIMATION:	PROC. PLATE NO.	VADER - HOTH	PAGE 43

ELEMENTS:
3 Stardestroyers & Lights
3 Tie Ships
Stars

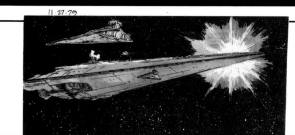

11·27·79

DESCRIPTION:
EXT. SPACE - IMPERIAL FLEET.
Vader's huge Stardestroyer eclipses a sun as the fleet assembles.

DIALOGUE:

ELEMENTS:
Vader's Stardestroyer
3 Stardestroyers & Engine
Ties - If Possible
Stars
Sun

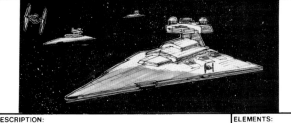

ADDED 9·20·79

DESCRIPTION:
EXT SPACE - IMPERIAL FLEET
Fleet assembles. A giant shadow crosses the conning tower of one of the Stardestroyers.

DIALOGUE:

ELEMENTS:
2 Stardestroyers
3 Tie Ships
Stars

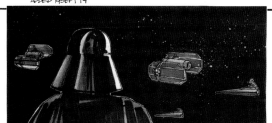

ADDED 19SEPT 79

DESCRIPTION:
INT. BRIDGE - MAIN CONTROL DECK - VADER'S STARDESTROYER
CU of Vader looking out the window at the Imperial fleet.

DIALOGUE:

ELEMENTS:
Eng. F.G.
Stardestroyer No. 1
Stardestroyer No. 2
Stardestroyer No. 3
Chili Tie No. 1
Chili Tie No. 2

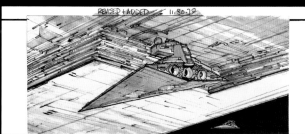

REVISED + ADDED 11·30·79

DESCRIPTION:
EXT. IMPERIAL FLEET - SPACE
The fleet assembles.

DIALOGUE:

ELEMENTS:
Vader's Stardestroyer & Lights
2 Stardestroyers & Engine
Stars

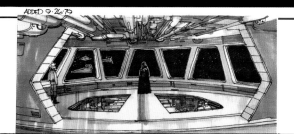

ADDED 9·26·79

DESCRIPTION:
INT. BRIDGE - MAIN CONTROL DECK - VADER'S STARDESTROYER
Vader at bridge window.

DIALOGUE:

ELEMENTS:
Stardestroyer No. 1
Stardestroyer No. 2
Stardestroyer No. 3
Matte Painting - Ceiling
Stars

RETURN OF THE FALCON

Han Solo's *Millennium Falcon*, half of which had been built full-size for the first film's live-action sequences, was constructed as a complete, full-scale ship for *Empire*. Built by a manufacturer in Wales, the *Empire Falcon* was a multiton ship sixty feet long and sixteen feet high. The full-scale ship had to be separated into sixteen sections for transportation and final assembly at the *Star Wars* production facility at Elstree Studios outside London, where the principal photography was staged (as was the first episode).

Several days before the *Falcon* made its trip, the soundstage (at which Stanley Kubrick was then shooting *The Shining*) burned during a mysterious fire. Twentieth Century Fox, however, came to the rescue, remodeling the soundstage to even better accommodate the new *Falcon*. The stage, which had previously been known as the "Third Stage," was later dubbed "*Star Wars* Stage."

Model maker Mike Fulmer also built several scaled models, from a two-foot *Falcon* to a miniature several inches long. The tiny *Falcon* would be attached to the ten-foot-long *Avenger* model for a shot in which Han Solo, in a daring move to avoid sensor detection, hides his ship on the side of the Imperial Destroyer.

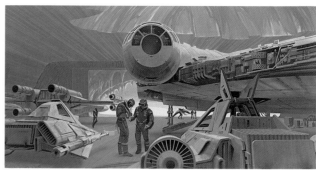

Millennium Falcon in Hothian hangar, production painting

Miniature *Millennium Falcon*, model, 15 x 20 x 3 cm.

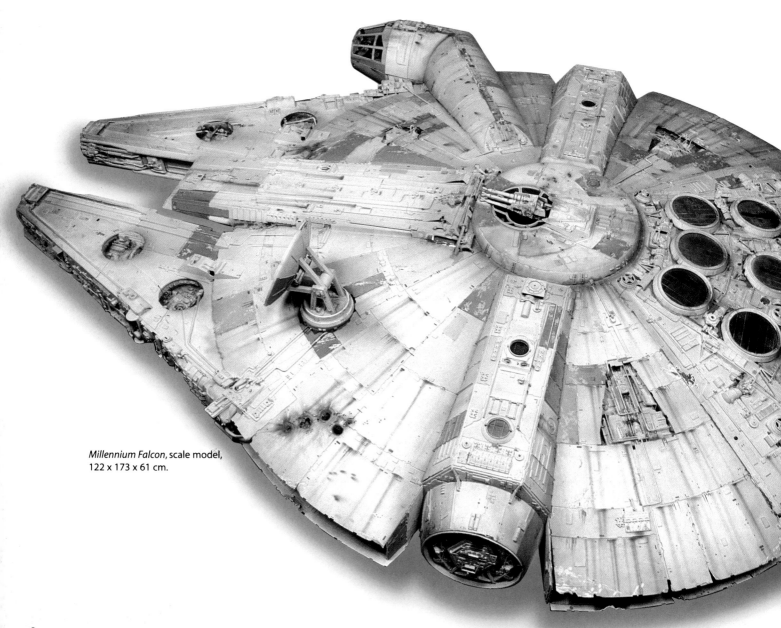

Millennium Falcon, scale model,
122 x 173 x 61 cm.

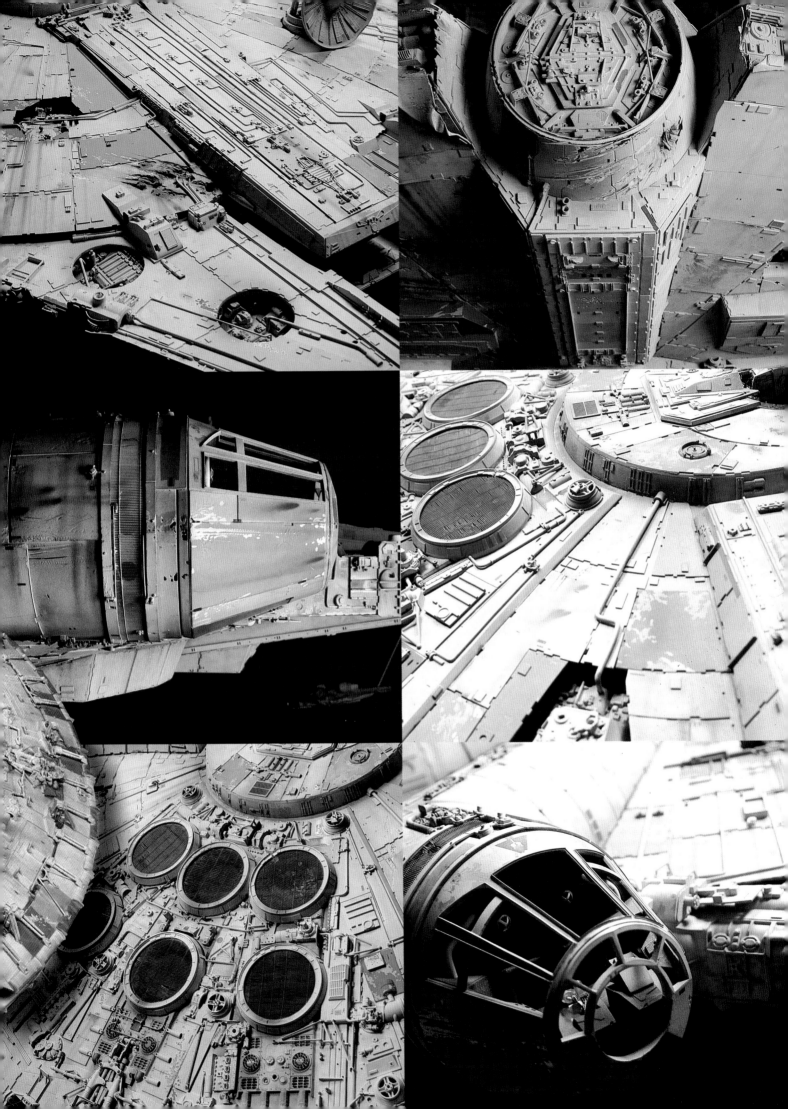

THE IMPERIAL WALKERS

Richard Edlund, visual effects supervisor for *Empire*, once described effects work as a double-edged sword that can cut both ways: the final result has to be perfect because a single mistake can destroy the illusion of the entire shot.

A complex, ten-minute scene of Rebels battling Imperial Walkers (or All Terrain Armored Transport, AT-ATs) on a snowy Hothian battlefield required absolute perfection to maintain its realism. The white, snowy background would be especially unforgiving if multiple-element shots (which often required live action, miniatures, and models) were not perfectly composited in opticals. The *Empire* demands necessitated new technology, so Edlund and his crew developed "the Quad," a breakthrough, computer-driven optical com positing printer with a custom-designed lens capable of producing the sharpest images then possible.

The creation of the Imperial Walkers was the result of innovative ILM preproduction design work. Originally, the Imperial attackers were to take the form of Norwegian army tanks shot on location. But de-

signer Joe Johnston developed the visual look for the walkers as four-legged mechanical monsters that would be created by Jon Berg and Tom St. Amand as puppet models and filmed stop-motion.

The stop-motion work for the walkers required precision detail by the animators. Since the walkers were

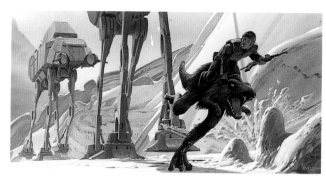

Imperial Walkers attack Tauntaun rider, production painting

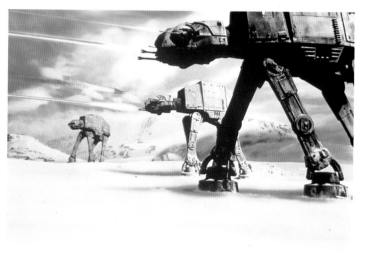

Walkers attack, still from film

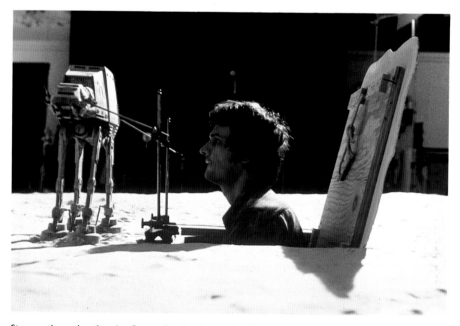

Stop-motion animation, Jon Berg animating Imperial Walker model from below planet Hoth set, production photo

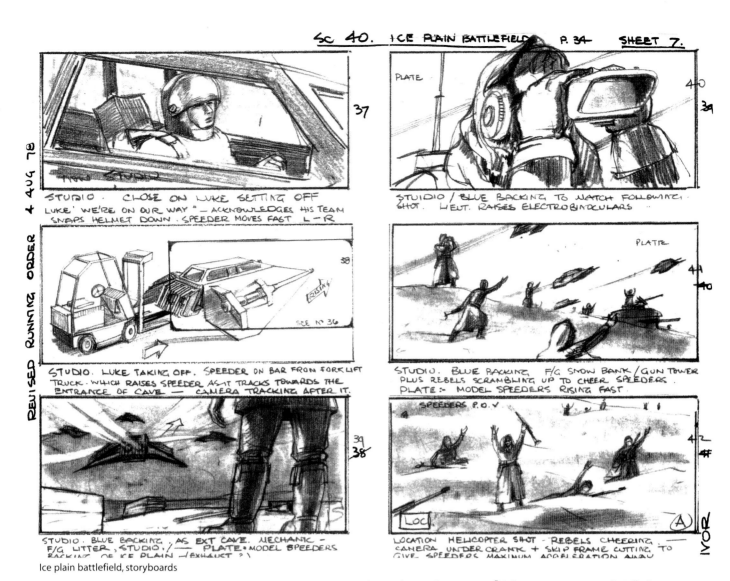

REVISED RUNNING ORDER 4 AUG 78

STUDIO. CLOSE ON LUKE SETTING OFF
LUKE' "WE'RE ON OUR WAY" — ACKNOWLEDGES HIS TEAM
SNAPS HELMET DOWN. SPEEDER MOVES FAST L—R

STUDIO / BLUE BACKING TO MATCH FOLLOWING
SHOT. LIEUT. RAISES ELECTROBINOCULARS

STUDIO. LUKE TAKING OFF. SPEEDER ON BAR FROM FORKLIFT
TRUCK. WHICH RAISES SPEEDER AS IT TRACKS TOWARDS THE
ENTRANCE OF CAVE — CAMERA TRACKING AFTER IT.

STUDIO. BLUE BACKING, F/G SNOW BANK / GUN TOWER
PLUS REBELS SCRAMBLING UP TO CHEER SPEEDERS.
PLATE:- MODEL SPEEDERS RISING FAST

STUDIO. BLUE BACKING., AS EXT CAVE. MECHANIC —
F/G LITTER, STUDIO./ — PLATE: MODEL SPEEDERS
BACKING OF ICE PLAIN (EXHAUST?)

LOCATION HELICOPTER SHOT - REBELS CHEERING.
CAMERA UNDER CRANK + SKIP FRAME CUTTING TO
GIVE SPEEDERS MAXIMUM ACCELERATION AWAY

Ice plain battlefield, storyboards

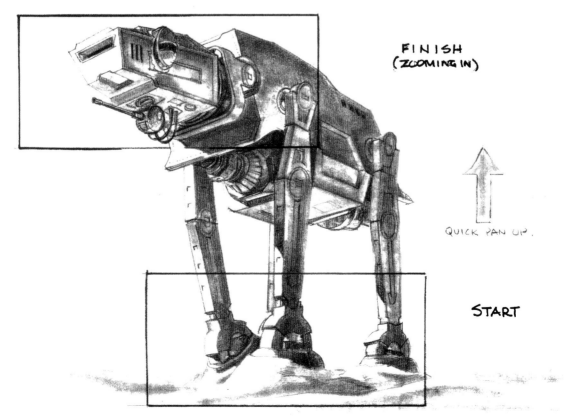

REVISED RUNNING ORDER. 11. AUG 78

FINISH
(ZOOMING IN)

QUICK PAN UP.

START

SC 44. ALTERNATIVE START. BEGIN CLOSE ON FEET OF WALKER / MODEL /
PAN-UP QUICKLY TO HEAD, SHOOTING UP, TO ESTABLISH INT. / OR BEGIN →

IVOR

giant metallic machines equipped with laser weapons and metal feet capable of crushing anything in their lumbering paths, the animators had to give weight to their puppets.

The Imperial Walkers were animated on a special miniature ILM set complete with a painted, cloudy blue sky backing and a battlefield dressed with a baking soda snowfield. In order not to disturb the baking soda effect, key animator Jon Berg had to do his work perched on supports or from trapdoors built into the set. The time-consuming process required Berg and other animators to place steel pointers around an object to mark its starting position. After moving the animated parts to a new position the artist would remove the pointers, and the crew would determine if the snowfield had been disturbed. An animation video recorder also tracked the frame-by-frame

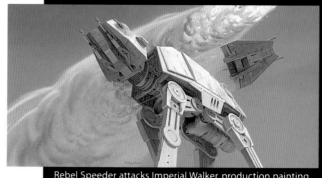

Rebel Speeder attacks Imperial Walker, production painting

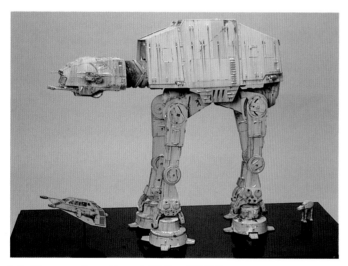

Rebel Snowspeeder and Imperial Walkers (AT-ATs),
models, left: 12 x 19 x 4 cm.;
middle: 24 x 53 x 48 cm.;
right: 2 x 6 x 5 cm.

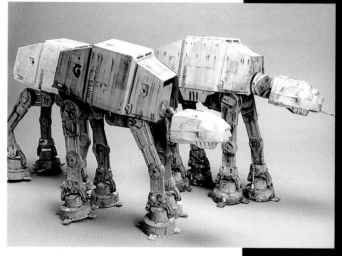

Imperial Walkers (AT-ATs), models, 24 x 56 x 48 cm.

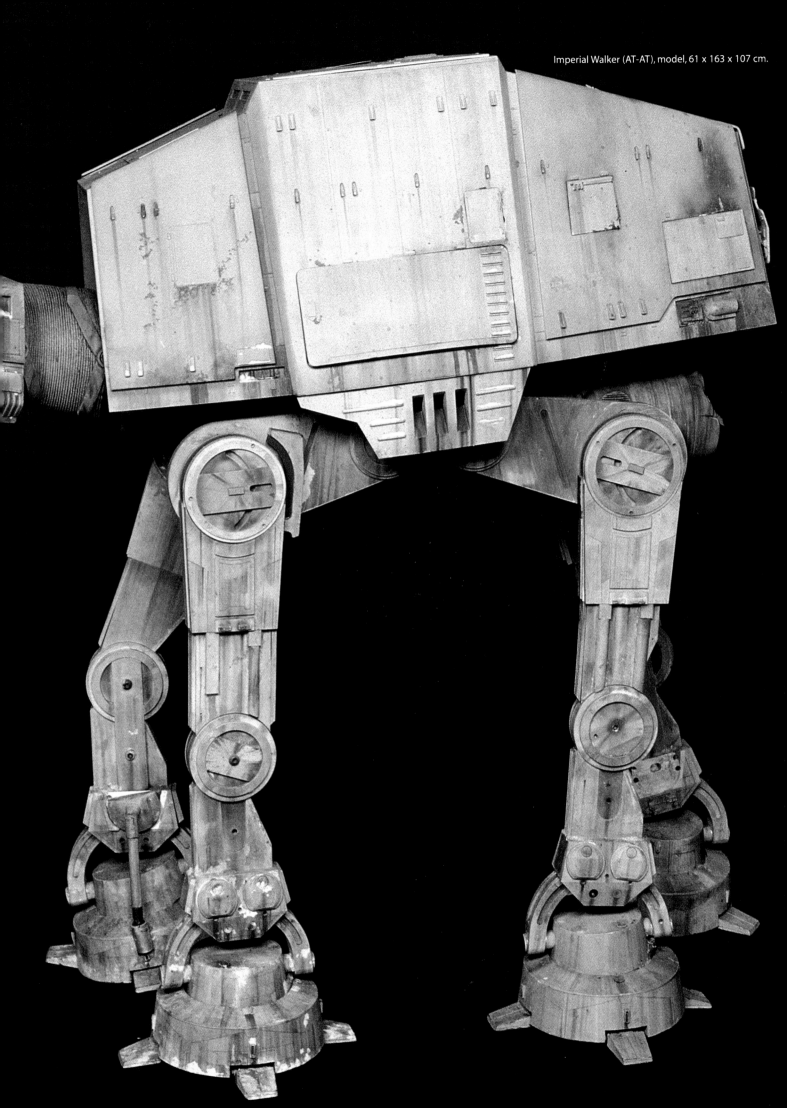

Imperial Walker (AT-AT), model, 61 x 163 x 107 cm.

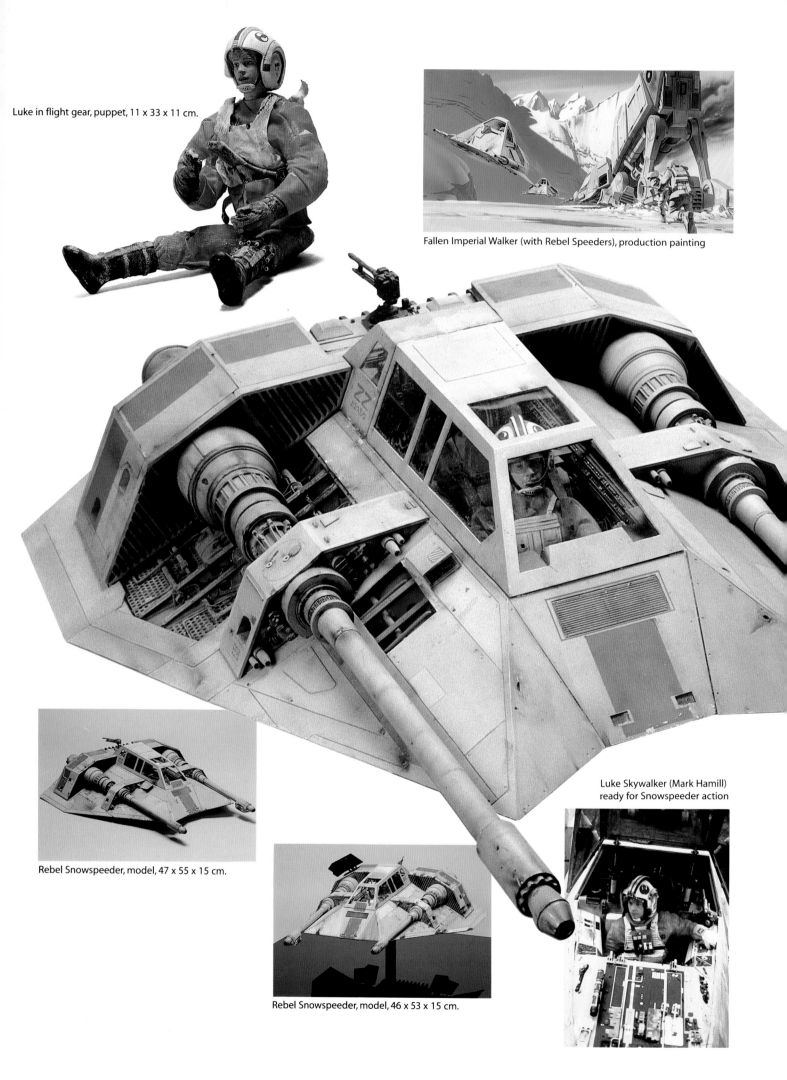

Luke in flight gear, puppet, 11 x 33 x 11 cm.

Fallen Imperial Walker (with Rebel Speeders), production painting

Rebel Snowspeeder, model, 47 x 55 x 15 cm.

Rebel Snowspeeder, model, 46 x 53 x 15 cm.

Luke Skywalker (Mark Hamill) ready for Snowspeeder action

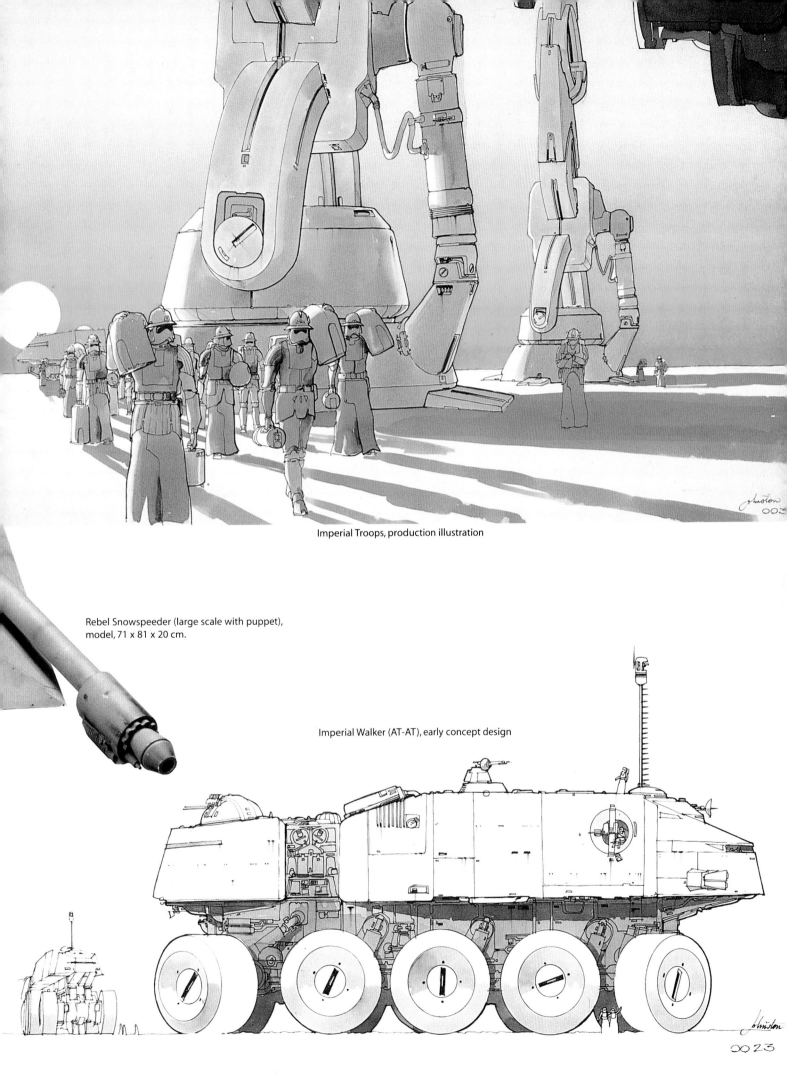

Imperial Troops, production illustration

Rebel Snowspeeder (large scale with puppet),
model, 71 x 81 x 20 cm.

Imperial Walker (AT-AT), early concept design

progress so the crew could check if their work was translating into realistic movement when filmed out. When it was decided the scene was ready for film, the motion-control camera would expose a single frame of film, a process repeated twenty-three additional times to produce one second of screentime. Additional effects, such as frame-by-frame bolts of walker fire, would be added later in the creative process. The stop-motion animation and filming for the walkers required a fifteen-month work schedule.

Storyboards were key to plotting all the animation, live action, and effects for the battle sequence. The sequence boarded here, in which a Rebel speeder wraps a cable around the mechanical legs of a walker, was particularly complex, requiring intercutting from live-action views of the speeder cockpits (with additional elements composited in the window) to detailed looks at the stop-motion animation.

The boards for this sequence are masterpieces of storyboard art. The storyboard team for *Empire* took six months to go from draft images to finished boards. More than a mere guide, storyboards are a literal blueprint for how a scene should look.

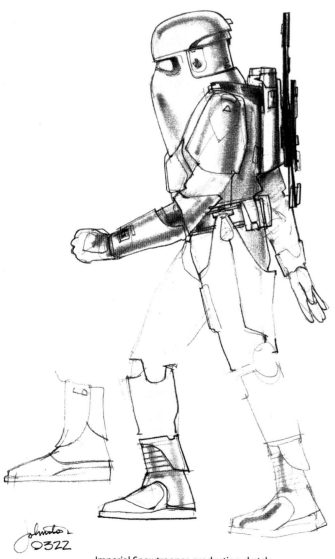

Imperial Snowtrooper, production sketch

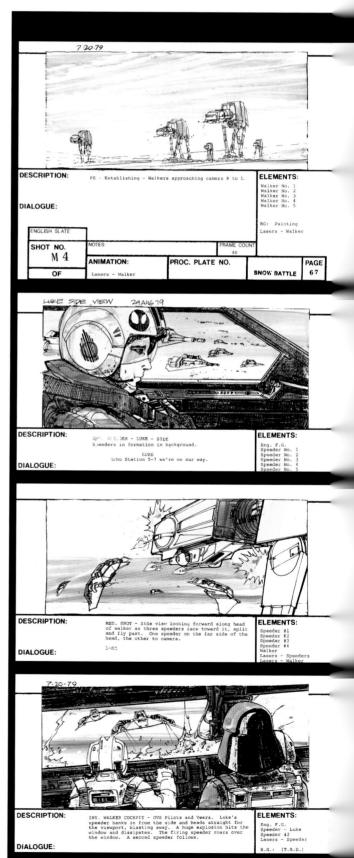

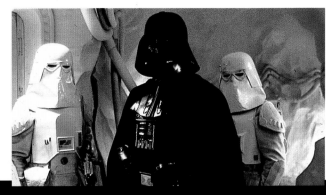

Darth Vader and Snowtroopers, still from film

Rebel Snowspeeder trips up Imperial Walker,
storyboard sequence

DESCRIPTION: INT. COCKPIT - GUNNER'S POV. Harpoon rope flashes out toward walker legs.

DIALOGUE:

ELEMENTS:
Eng. F.G.
Walker Leg
Harpoon & Cable EFX

B.G.: (T.B.D.)

DESCRIPTION: INT. COCKPIT - WEDGE - FRONT. Walker legs go by.

WEDGE
One more pass, come on.

DIALOGUE:

ELEMENTS:
Eng. F.G.
Walker legs

B.G.: (T.B.D.)

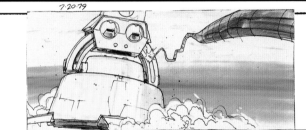

DESCRIPTION: MEDIUM FULL SHOT - Harpoon and cable over camera and impacts on giant foot.

DIALOGUE:

ELEMENTS:
Walker Foot
Harpoon & Cable

B.G.: (T.B.D.)

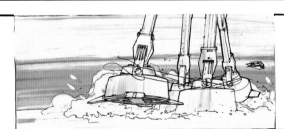

DESCRIPTION: CU CABLE RELEASE on back of the speeder as it snaps loose and the cable drops away.

DIALOGUE:

ELEMENTS:
Eng. F.G.

(OR)

Miniature Speeder cable release

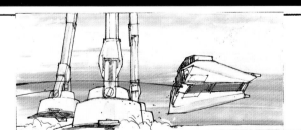

DESCRIPTION: FULL SHOT SPEEDER as it races L to R around one of the giant walker feet, trailing the cable behind it. The speeder continues around the back foot going R to L. Truck with the walker No. 3.

DIALOGUE:

ELEMENTS:
Speeder w/ cable
Walker #3 Legs

Shadow

B.G.: (T.B.D.)

DESCRIPTION: EXT BATTLEFIELD - HOTH
MED SHOT of the tangled legs and feet of Walker No. 3 coming to camera. The monster begins to stumble.

DIALOGUE:

ELEMENTS:
Walker #3 Legs
Speeder
Speeder cable

B.G.: (T.B.D.)

DESCRIPTION: HIGH OVERHEAD MOVING SHOT of speeder as it circles the walker moving around the tail end. A second speeder passes in the foreground with the cable in tow.

DIALOGUE:

ELEMENTS:
Walker #3
Speeder w/ cable
Speeder #2

B.G.: (T.B.D.)

DESCRIPTION: EXT BATTLEFIELD - HOTH
EXTREME LONG SHOT OF WALKER NO. 3 through the legs of a foreground walker. The giant Imperial assault machine stumbles and starts to fall to the ground. Side angle roving right to left.

DIALOGUE:

ELEMENTS:
Walker #3 w/ cable
Walker Legs - F.G.

Shadow

B.G.: (T.B.D.)

EMPIRE COMPOSITES

Empire required 400 to 500 optical composites, as compared to 380 effects shots for *Star Wars*. To handle the production pressures, ILM developed new optical compositing printers (such as the Quad) capable of creating the dreamed-of effects.

Optical printers, developed during the twenties, allow for separately filmed elements to be rephotographed and combined on one strip of negative film. The design of a basic printer consists of one or more projectors and lamphouses facing a recording (or "taking") camera loaded with negative film. The elements already recorded on exposed film can then be projected into the eye of the taking lens.

In the case of the Quad, four projectors were built into the printer (although two of the projectors would be removed years later, cannibalized to provide parts for another printer). The Quad was also equipped with a cubic beam splitter, a light reflector that allowed the camera to record two separate images simultaneously.

The Quad was valuable when compositing a scene in which the *Millennium Falcon*, four Imperial TIE fighters, and an eight-foot Star Destroyer model nearly collide. (In addition to the eight-foot Destroyer, the model shop created a fourteen-inch miniature and scale detail of the Destroyer conning tower measuring ten feet tall by fifteen feet across.) Although a mere three seconds on

screen, the shot, even with the high-tech Quad, required film to be processed ninety-five times through the printer before a final picture was achieved.

And when space in the *Star Wars* universe became particularly crowded, distant ship elements were sometimes created as miniature photographs pasted to glass programmed to move in front of a bluescreen.

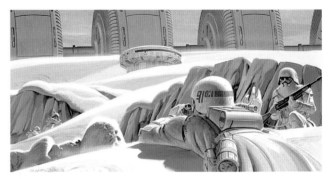

Imperial Troop Scouts, production painting

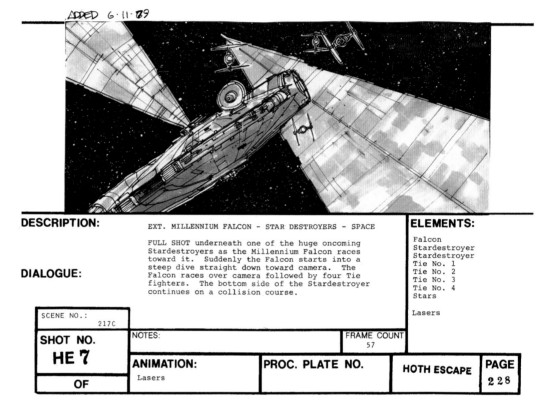

DESCRIPTION: EXT. MILLENNIUM FALCON - STAR DESTROYERS - SPACE

FULL SHOT underneath one of the huge oncoming Stardestroyers as the Millennium Falcon races toward it. Suddenly the Falcon starts into a steep dive straight down toward camera. The Falcon races over camera followed by four Tie fighters. The bottom side of the Stardestroyer continues on a collision course.

DIALOGUE:

ELEMENTS:
Falcon
Stardestroyer
Stardestroyer
Tie No. 1
Tie No. 2
Tie No. 3
Tie No. 4
Stars

Lasers

SCENE NO.: 217C			
SHOT NO. **HE 7**	NOTES:		FRAME COUNT 57
	ANIMATION: Lasers	PROC. PLATE NO.	HOTH ESCAPE PAGE 2 28
OF			

Escape from Hoth, storyboard of *Millennium Falcon* dodging Destroyers, with TIE Fighters in pursuit

Rebel Transport, model, 25 x 79 x 11 cm.

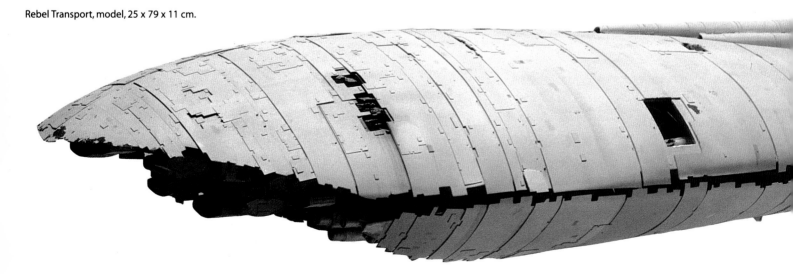

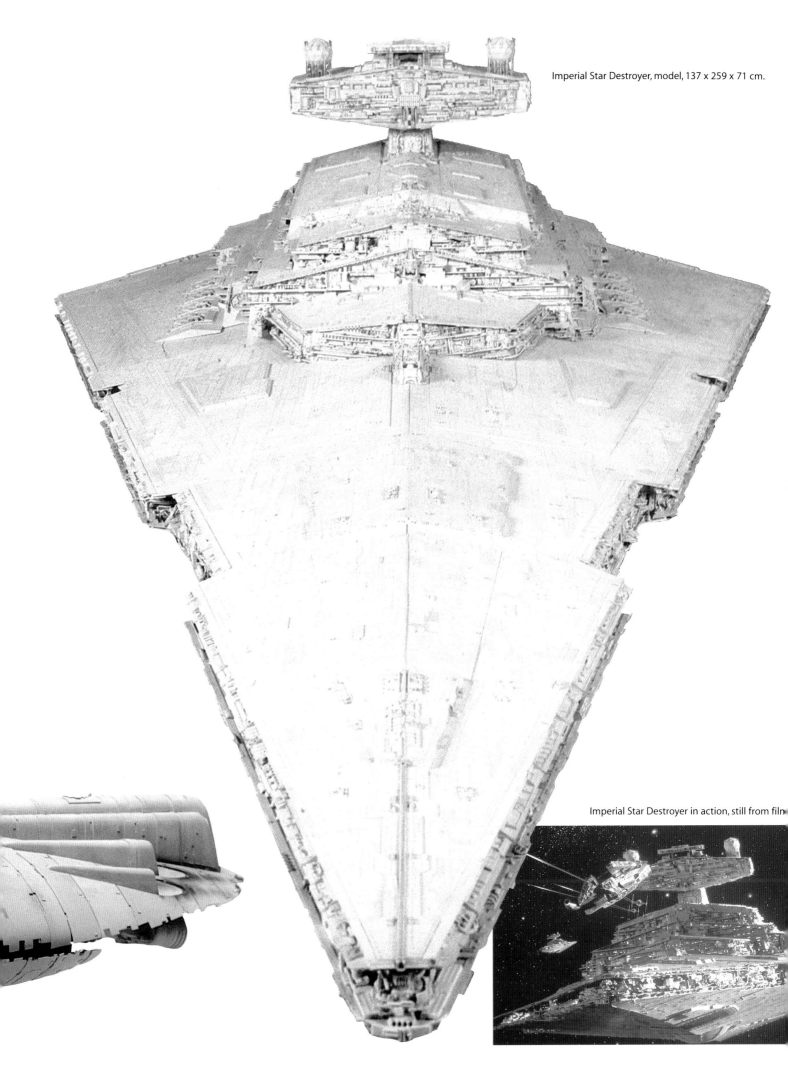

Imperial Star Destroyer, model, 137 x 259 x 71 cm.

Imperial Star Destroyer in action, still from film

YODA AND THE SECRETS OF THE FORCE

One of the most compelling ideas of the *Star Wars* series is the notion of the Force, the cosmic life energy mastered by the fabled Jedi Knights. As with the rest of the mythic underpinnings of the series, the Force can be recognized in other cultures, particularly in the Chinese concept of the universal energy force of Chi.

Young Luke Skywalker, eager to master the mysteries of the Force, is visited by the spirit of Obi-Wan, who tells him to journey to the uncharted planet of Dagobah and learn its secrets from Yoda, the Jedi Master who had been his own teacher. Luke crash lands in a swamp on the mysterious planet and encounters a small, green-skinned creature dressed in rags. Having imagined his Jedi mentor of more stalwart appearance, Luke is shocked when the wizened figure reveals himself to be Yoda, a Jedi trainer for eight hundred years.

Although the Dagobah swampland was originally planned as a location shoot, it was ultimately decided to recreate Yoda's world on soundstages at Elstree Studios. In the conceptual phase, Ralph McQuarrie designed an eerie environment, emphasizing the giant banyan trees, with their exposed root systems reaching down to the eroded soil, which are common in swamplands worldwide.

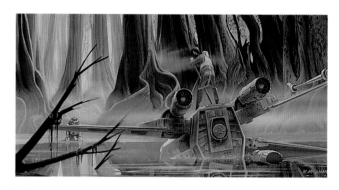

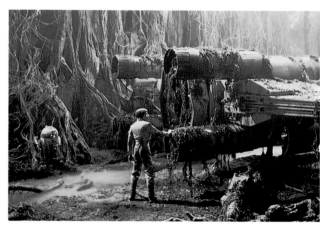

Luke and Artoo on planet Dagobah, production painting (above), and still from film (below)

Luke trains the Yoda way, storyboard sequence

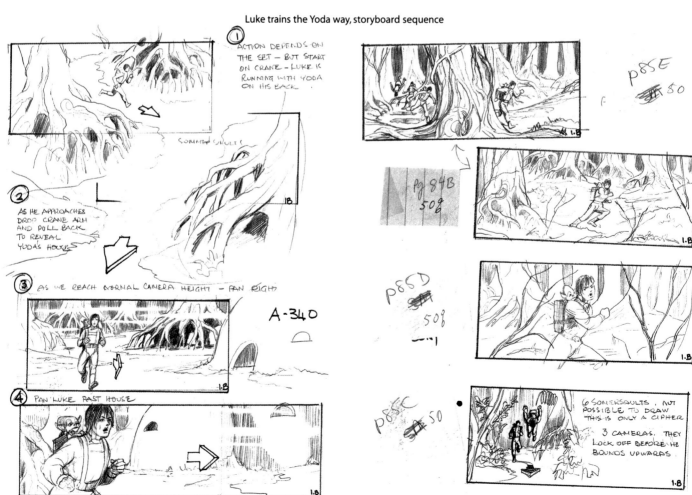

The final set, which required the work of several hundred skilled technicians, was built on platforms raised more than three feet off the stage floor. As with many set-ups, the structure was built in sections that could be arranged as needed for filming. Trees forty feet high and ten feet in circumference were formed out of tubular steel, shaped with wire mesh, and finished with plaster and paint. A three-foot-deep lagoon was built into the set in which a full-scale replica of Luke's crashed X-wing, complete with a forty-foot wingspan, was placed. Final touches included truckloads of vines gleaned from the local countryside to dress the set.

Yoda himself came to life only after a long series of design-stage evolutions. The first concept sketches

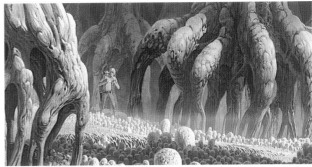

Luke and Yoda in the Dagobah Swamp, production painting (above), and still from film (below)

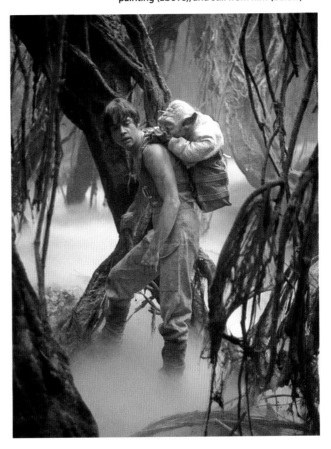

Rendezvous with destiny, production painting (Luke departs to rescue his friends as Yoda and the ghost of Obi-Wan look on)

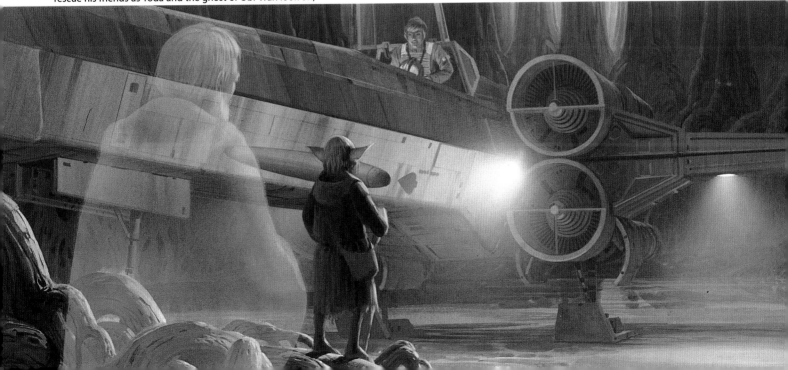

ranged from snow-bearded Santa Claus-ish figures to perky elves. The look of the final puppet, as sculpted by Stuart Freeborn, captured both the sage bearing and quirky sense of humor of the character. It was, however, puppet master Frank Oz (who had animated many of the late Jim Henson's Muppet creations) who brought Yoda to life, usually working the character from underneath the stage through hidden openings in the set. Complicated mechanisms within the skull of the Yoda puppet allowed Oz to do everything from curl the Jedi Master's lip to furrow his eyebrow.

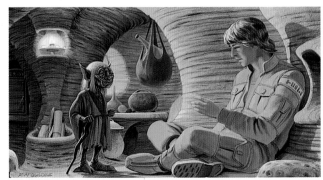

Luke and Yoda, production painting

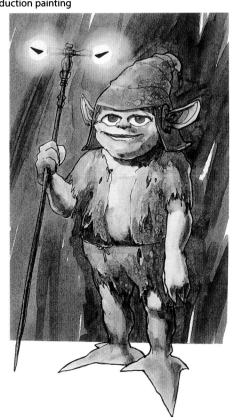

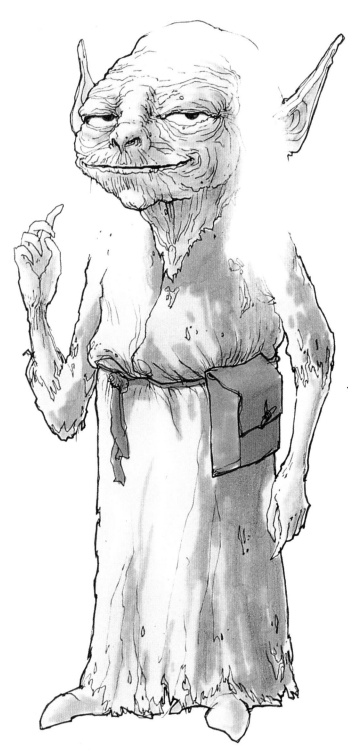

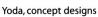

Yoda, concept designs

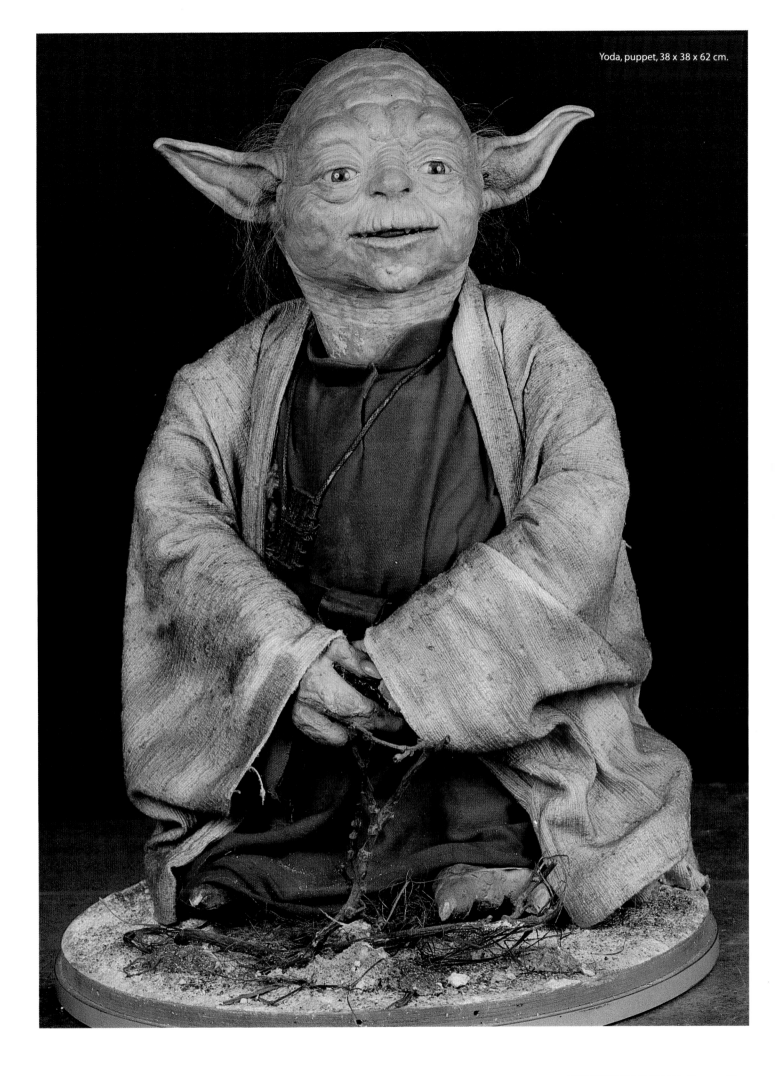

Yoda, puppet, 38 x 38 x 62 cm.

CLOUD CITY

When the *Falcon* flies down into one huge asteroid cave, a giant space slug nearly swallows the ship in a gulp.

The slug itself was a glorified hand puppet that fit over the arm of creature maker and stop-motion animator Phil Tippett. Working within an asteroid set, Tippett could move the head around while gripping an internal trigger that could cause the mouth to snap open and close.

The Cloud City of Bespin, a trading port and a neutral colony floating above the clouds was conjured up

with matte painting magic. "George thought of Cloud City as a kind of Flash Gordon city floating in the sky on a platter," says artist Ralph McQuarrie, who created a series of landing platform matte paintings for the film. "I had free rein and I gave it an aircraft carrier look, streamlined with decks. When I work I mentally walk through an environment, building the thing up in my mind and with doodles, sketches, and paintings."

The Cloud City matte paintings composited such live-action ele-

Millennium Falcon escapes Space Slug, production painting (top) and production illustration (directly below)

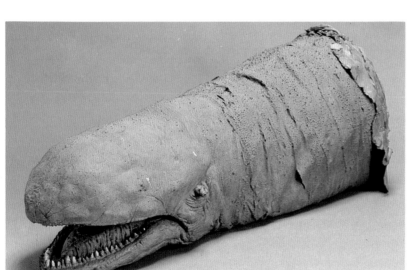

Space Slug, puppet, 28 x 79 x 28 cm.

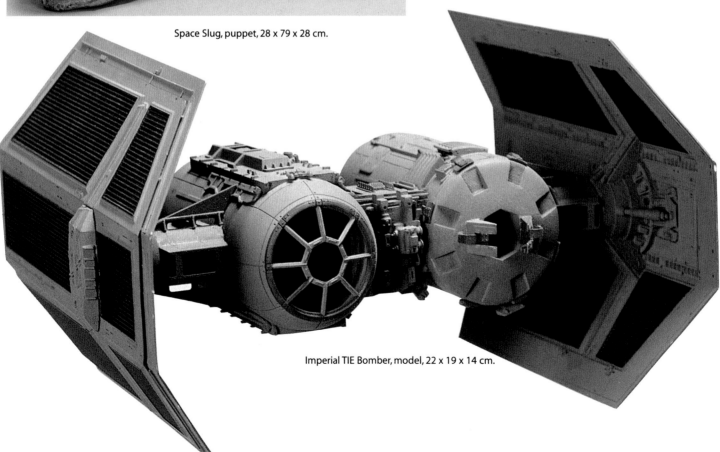

Imperial TIE Bomber, model, 22 x 19 x 14 cm.

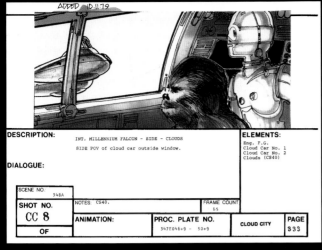

ADDED 10.11.79

DESCRIPTION:
INT. MILLENNIUM FALCON - SIDE - CLOUDS
SIDE POV of cloud car outside window.

DIALOGUE:

ELEMENTS:
Eng. F.G.
Cloud Car No. 1
Cloud Car No. 2
Clouds (CS40)

SCENE NO. 348A				
SHOT NO. CC 8	NOTES: CS40.		FRAME COUNT 65	
OF	ANIMATION:	PROC. PLATE NO. 347E046+9 - 50+9	CLOUD CITY	PAGE 333

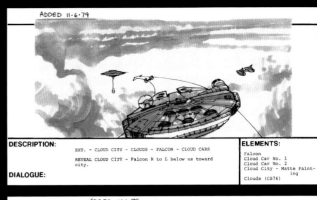

ADDED 11.6.79

DESCRIPTION:
EXT. - CLOUD CITY - CLOUDS - FALCON - CLOUD CARS
REVEAL CLOUD CITY - Falcon R to L below us toward city.

DIALOGUE:

ELEMENTS:
Falcon
Cloud Car No. 1
Cloud Car No. 2
Cloud City - Matte Painting
Clouds (CS76)

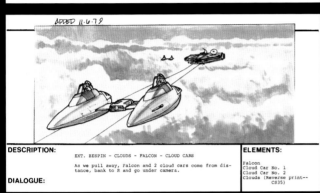

ADDED 11.6.79

DESCRIPTION:
EXT. BESPIN - CLOUDS - FALCON - CLOUD CARS
As we pull away, Falcon and 2 cloud cars come from distance, bank to R and go under camera.

DIALOGUE:

ELEMENTS:
Falcon
Cloud Car No. 1
Cloud Car No. 2
Clouds (Reverse print-- CS35)

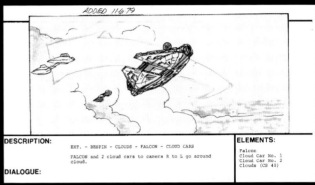

ADDED 11.6.79

DESCRIPTION:
EXT. - BESPIN - CLOUDS - FALCON - CLOUD CARS
FALCON and 2 cloud cars to camera R to L go around cloud.

DIALOGUE:

ELEMENTS:
Falcon
Cloud Car No. 1
Cloud Car No. 2
Clouds (CS 40)

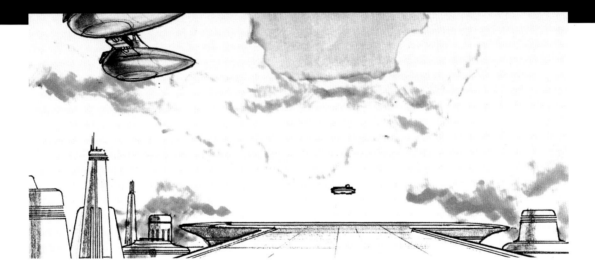

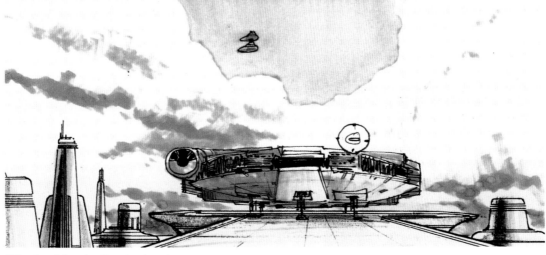

Millennium Falcon landing, storyboards

ments as Lando and his men greeting Solo on the landing platform, Princess Leia gazing out the window of a building, and Luke Skywalker and Artoo moving down an interior hallway in search of their friends. All live-action elements were combined with paintings as in-camera composites with a front-projection matte painting and compositing system built by Richard Edlund. (The upper left-hand note, "105 mm," in the painting of the landing platform at twilight, refers to the millimeter lens used by the compositing system to project the live action. Also, the middle painting features a painted *Falcon* roof, which artist McQuarrie felt reflected the dusky lighting conditions better than the stage element of Solo's ship.)

But our heroes have been tracked by the bounty hunter Boba Fett, who alerts Darth Vader to the whereabouts of his enemies and a deadly trap is sprung.

Cloud City cars, production painting

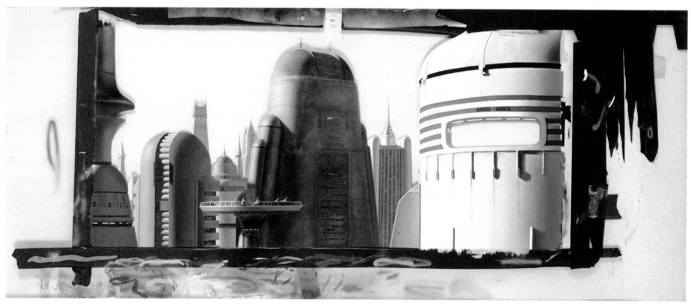

Cloud City skyline, matte painting (detail for compositing of Cloud Car flyby), 191 x 84 cm.

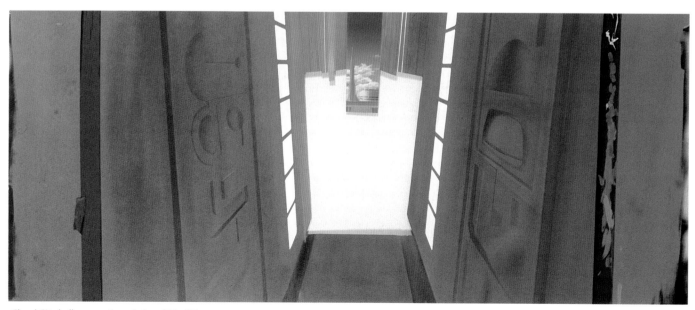

Cloud City hallway, matte painting, 191 x 84 cm.

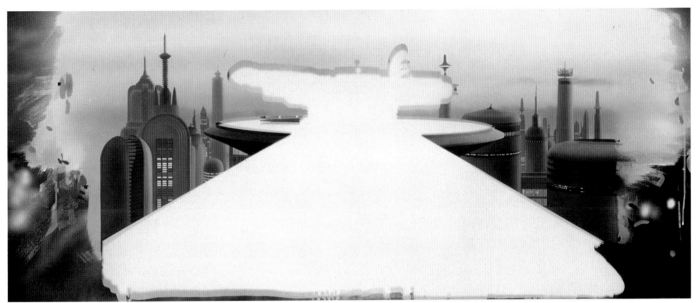

Cloud City landing platform, matte paintings, 191 x 84 cm.

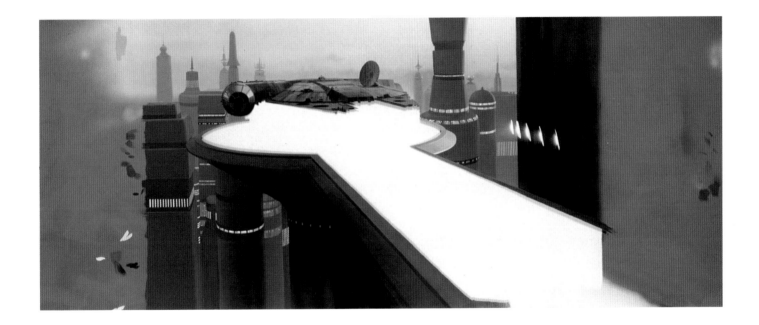

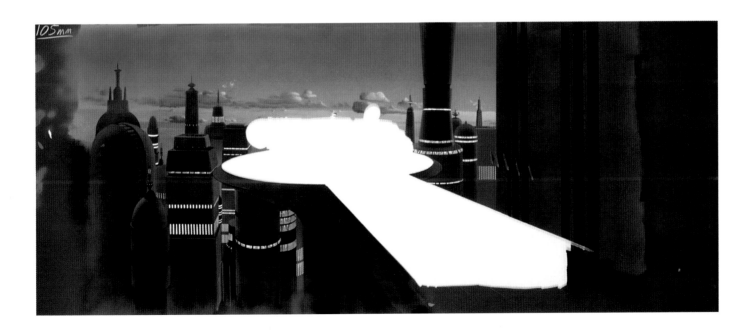

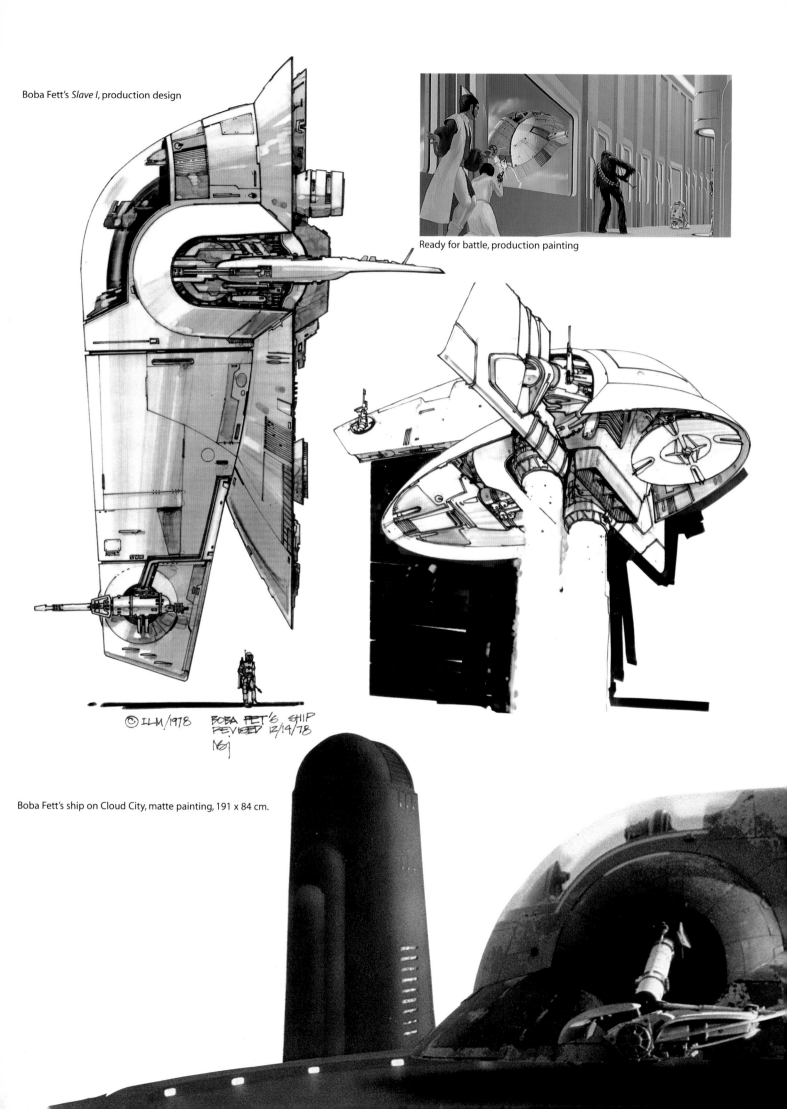

Boba Fett's *Slave I*, production design

Ready for battle, production painting

© ILM/1978 BOBA FET'S SHIP
REVISED 12/14/78

Boba Fett's ship on Cloud City, matte painting, 191 x 84 cm.

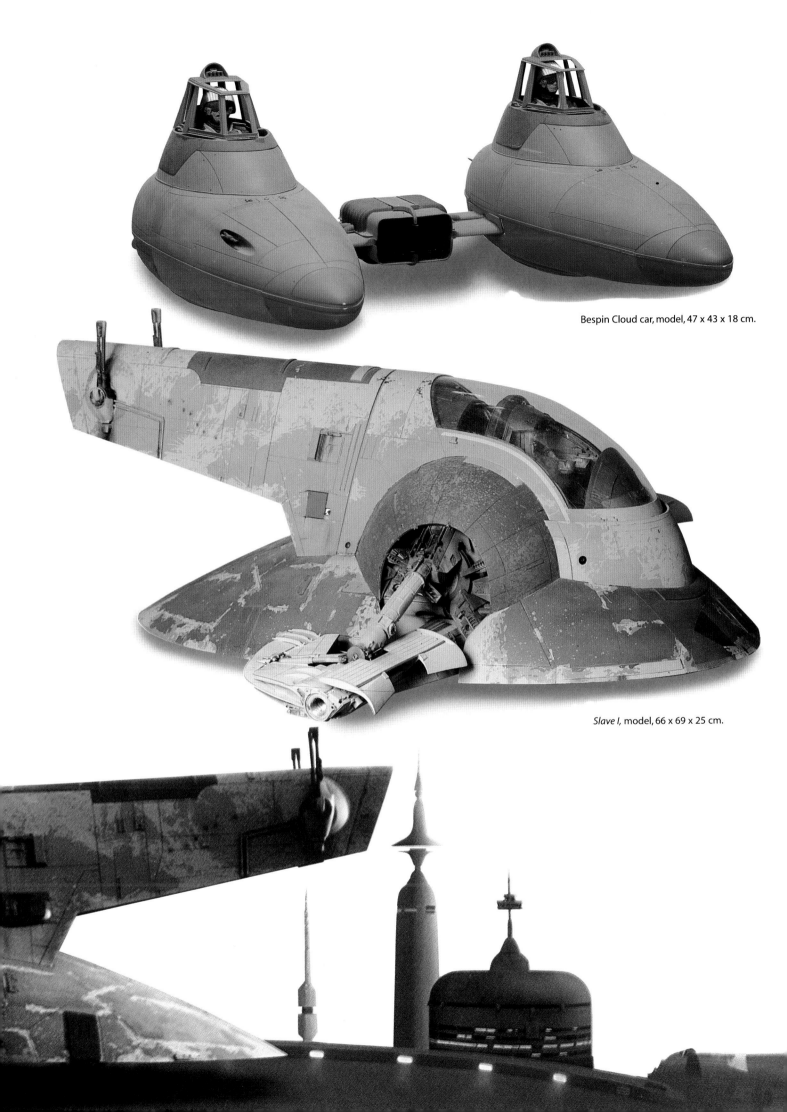

Bespin Cloud car, model, 47 x 43 x 18 cm.

Slave I, model, 66 x 69 x 25 cm.

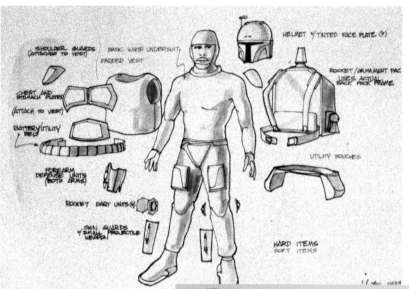

Boba Fett, costume design

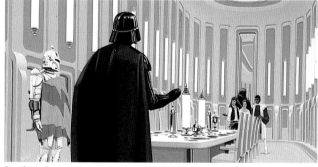

Darth Vader awaits, production painting

ADDED 10.28

DESCRIPTION:

DUSK - EXT

Boba Fett
ship. Cit

DIALOGUE:

SCENE NO.: S387	
SHOT NO. CC 28	NOTES: Mat
	ANIMAT
OF	

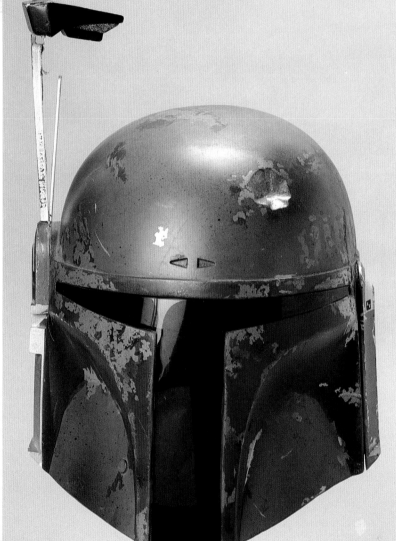

Boba Fett's helmet, costume headgear, 38 x 38 x 53 cm

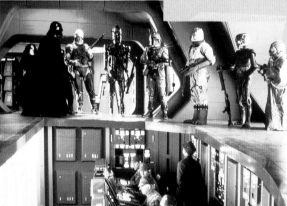

Vader enlists bounty hunters, still from film

Boba Fett, character sketch

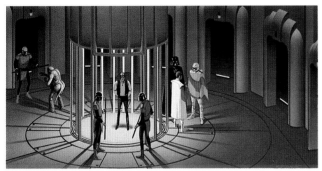

Prisoner Han Solo, production painting

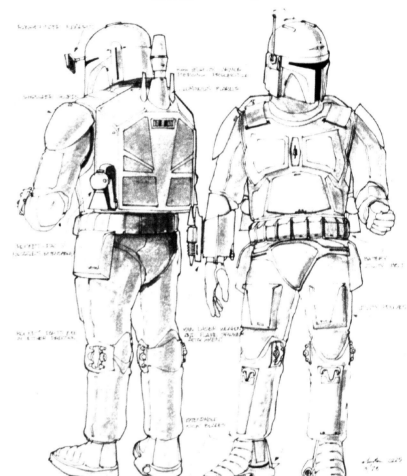

IG PLATFORM - CLOUD CITY

Han Solo's coffin going up ramp to
louds in b.g.

ELEMENTS:

English Plate
Clouds & City - Matte
Painting

Boba Fett at landing platform, storyboard

shot.

PROC. PLATE

X387A013+5 - 0

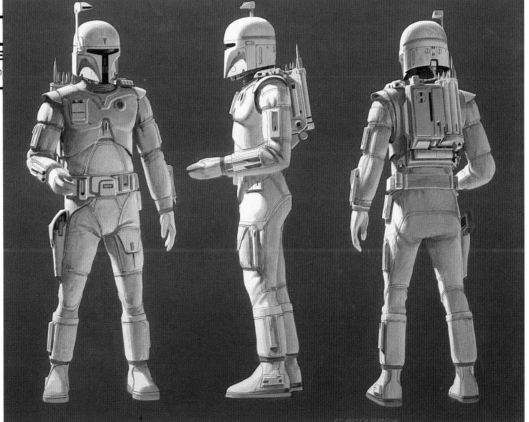

Boba Fett, production illustration

VADER'S VICTORY

Matte paintings played an important role in the creation of the pivotal scene of the movie, the dramatic battle between Vader and Skywalker on a gantry bridging the reactor shaft of Cloud City. The core, with its vertiginous drop, was realized as a matte painting, while the actors were composited with ILM's front-projection system. The glowing and striking lightsabers were created as separately filmed animation elements and composited with separate front-projection passes.

When the vanquished Luke Skywalker learns that Darth Vader is his father, he relinquishes his hold on the platform rather than accept Vader's entreaties to join the cause of the Empire. Luke is in freefall, sucked into a shaft leading to an exhaust port on the underside of the floating city. He hangs wearily onto a fragile, antenna-like device until his miraculous rescue by the escaping *Falcon* piloted by Leia, Lando, and Chewbacca.

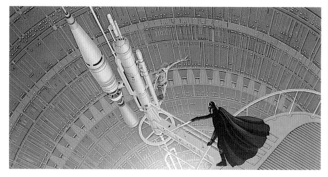

Luke and Darth Vader battle in Cloud City core, production painting

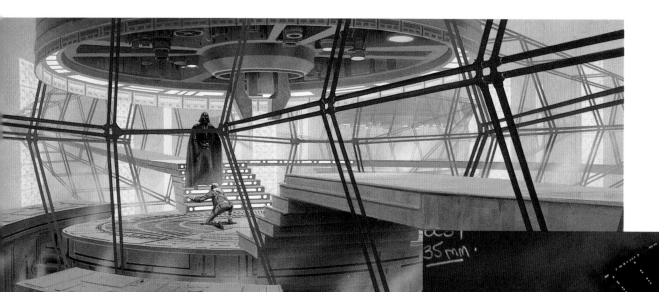

Luke faces Darth Vader, production painting, and still from film

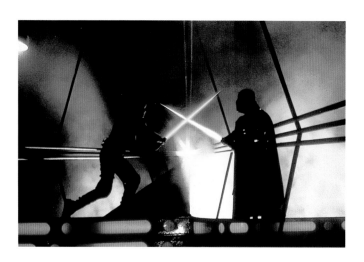

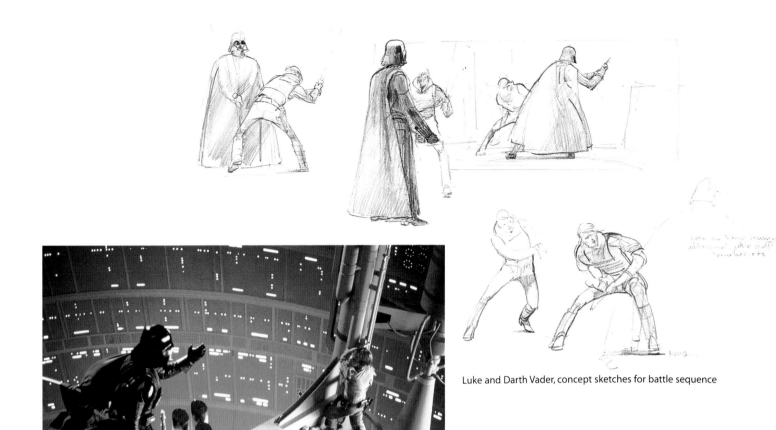

Luke and Darth Vader, concept sketches for battle sequence

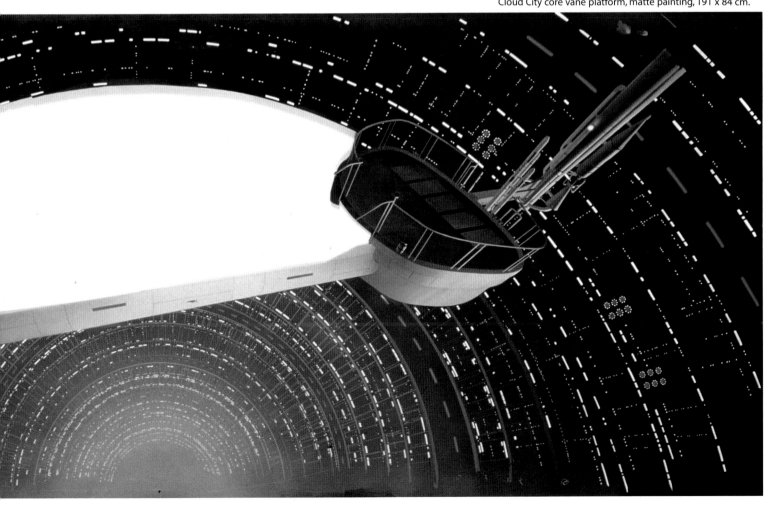

Darth Vader entreats Luke to join the Imperial cause, still from film

Cloud City core vane platform, matte painting, 191 x 84 cm.

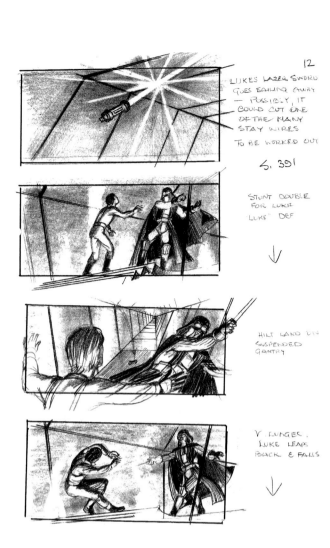

12

LUKES LAZER SWORD GOES SPINNING AWAY — POSSIBLY, IT COULD CUT ONE OF THE MANY STAY WIRES

TO BE WORKED OUT

S. 391

STUNT DOUBLE FOR LUKE "LUKE'S DEF"

HILT LAND ON SUSPENDED GANTRY

V LUNGES. LUKE LEAPS BACK & FALLS

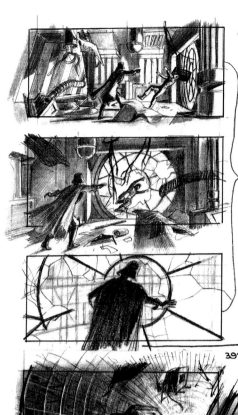

V. 391

MORE EQUIPMENT FLIES AT LUKE GLANCING OFF HIM UNTIL A LARGE PIECE HITS HIM AND CRASHES THROUGH THE WINDOW - CAUSING A WHIRLWIND SUCTION THAT DRAGS LUKE OUT WINDOW IS ANGLED TO REDUCE THE COLOUR OF THE TOFFEE GLASS. CUT AS GLASS GOES

NEW ANGLE WITH TOFFEE GLASS REPLACED BY PRE-CUT CLEAR PLASTIC. STUNT MAN DOUBLE RUNS AT WINDOW & DIVES SIDEWAYS OUT TO BOXES.

CLOSE ON VADER HURRYING TO WINDOW & LOOKING DOWN.

WIND BLOWING UP LUKE DOWN HORIZONAL

398. BOXES & DEBRIS BLOWING UP PAST CAMERA

VADERS P.O.V. OF LUKE HANGING FROM THE GANTRY OVER THE NEUCLEAR REACTOR FURNACE A MILE BELOW.

WIND DIES - BOXES ETC FALL BACK DOWN SHAFT.

GO BACK TO PREVIOUS CUT. VADER EXITS L-R.

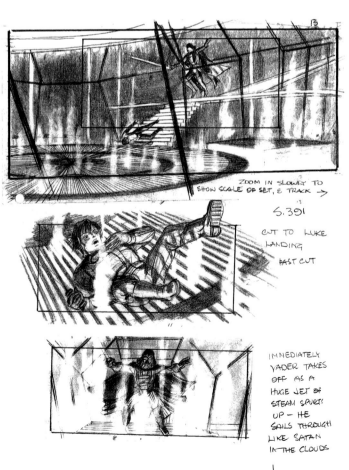

13

ZOOM IN SLOWLY TO SHOW SCALE OF SET, & TRACK →

S. 391

CUT TO LUKE LANDING

FAST CUT

IMMEDIATELY VADER TAKES OFF AS A HUGE JET OF STEAM SPURTS UP — HE SAILS THROUGH LIKE SATAN IN THE CLOUDS

33/34

WIND CHANGED BOXES ETC DROP THROUGH FRAME

T.M SHOT OWING TO PLATE LUKE DOESN'T RISE BUT ROLLS TO SAFETY GETS HIS BREATH — SEES THE SWORD HANDLE (OUT OF SHOT) & CRAWLS TO GET IT L-R CUT

CRAWLS

LIGHTING SOURCE IS IN REACTOR BELOW THE GANTRY

LUKE REACHES FOR HOLSTER KNEELS TO RISE STILL EXHAUSTED

EITHER PULL BACK & TILT UP OR IF IN CUTS — PICK HIM UP RISING INTO FRAME

SET

MATTE SHOT. STUDIO BUILD - SEE DOTTED LINE AT DOOR OPTICAL REDUCTION & DRAW IN MATTE TO WHATEVER ANGLE IS ON NEG. ACTION. LUKE MOVES UNSTEADILY TO FIND AN ENTRANCE

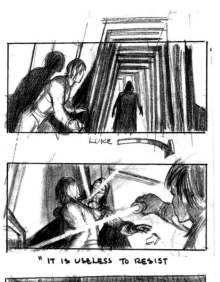

DIRECT STUDIO

398

LUKE

"IT IS USELESS TO RESIST"

LUKE BACKS AWAY
L-R.

398

END DIALOGUE

398

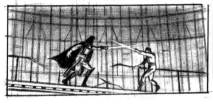

SPECTACULAR MATTE
SHOT TO SHOW
THE END OF LUKE
ABILITY TO RETREAT

T.M SHOT - SEE
MY PROJECTION
CAMERA @ 4'6"
30 MM LENS.
18° TILT. - AS
FOR STAGE I.

END SC 398

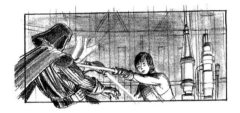

CUT IN CLOSE
STUDIO PAINTED
BACKING. BUILT
F/G GANTRY WITH
BREAK AWAY RAIL
AS VADER DESTROY
LUKES HAND
HOLDS.

DIRECT STUDIO

VADERS LAZER
SWORD CLEAVES
SHEER THROUGH
A HUGE PIECE
OF EQUIPMENT.
IT FALLS DOWN
THE SHAFT

MODEL SHOT

LONG SHOT OF REACTOR SHAFT
LUKE & VADER ARE NOW AT THE EXTREME TIP OF THE VAST
POD. WE CAN JUST CATCH THE TURNING GLINT OF
THE SHINING METAL AS IT FALLS —
POSSIBLE EASE IN OF CAMERA.

ANIMATE TWIRLING METAL PIECE

The battle of Luke and Darth Vader, storyboard sequence

DIALOGUE X-2

36

LUKE MANAGES
TO GET OVER
VADERS GUARD
SMOKE RISES.

DIRECT STUDIO.

400

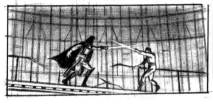

C.U. OF
HEAT BLISTER
ON VADER
ARMOUR
TILT UP TO
FULL HEAD FOR
LINE "DONT
LET YOURSELF BE
DESTROYED AS
OBI WAN DID"

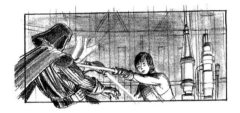

VADER
"DONT LET YOURSELF
BE DESTROYED AS
OBI WAN DID."

HE ATTACKS AGAIN
FORCING LUKE BACK
ACROSS THE LAST
PLATFORM.

"CALM, STAY
CALM

AFTER 400

39-40

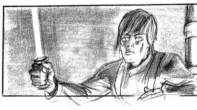

LUKE MOVES
FORWARD TO
RENEW THE
FIGHT

400

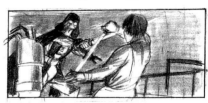

LUKE ATTACKS
AGAIN BUT IS
CUT. HE REELS
BACK IN SHOCK
AND PAIN

LUKE IN
TREMDOUS PAIN

"NO. —
NO. —
NO. —
NO.
NO."

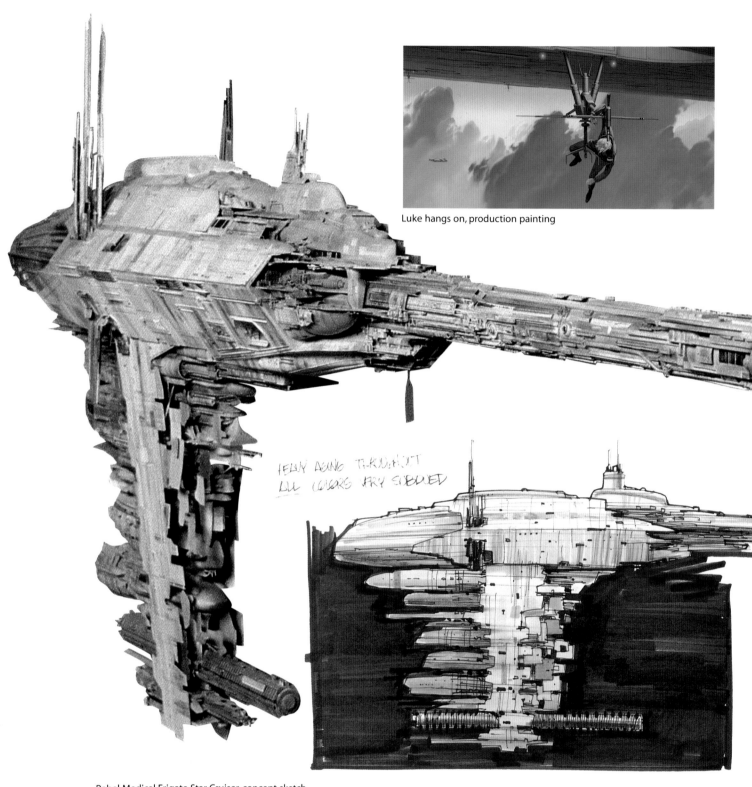

Luke hangs on, production painting

Rebel Medical Frigate Star Cruiser, concept sketch

Rebel Medical Frigate Star Cruiser, model, 50 x 247 x 99 cm.

Healing, production painting
(Luke attended by Leia,
medical droid, R2-D2, and C-3PO)

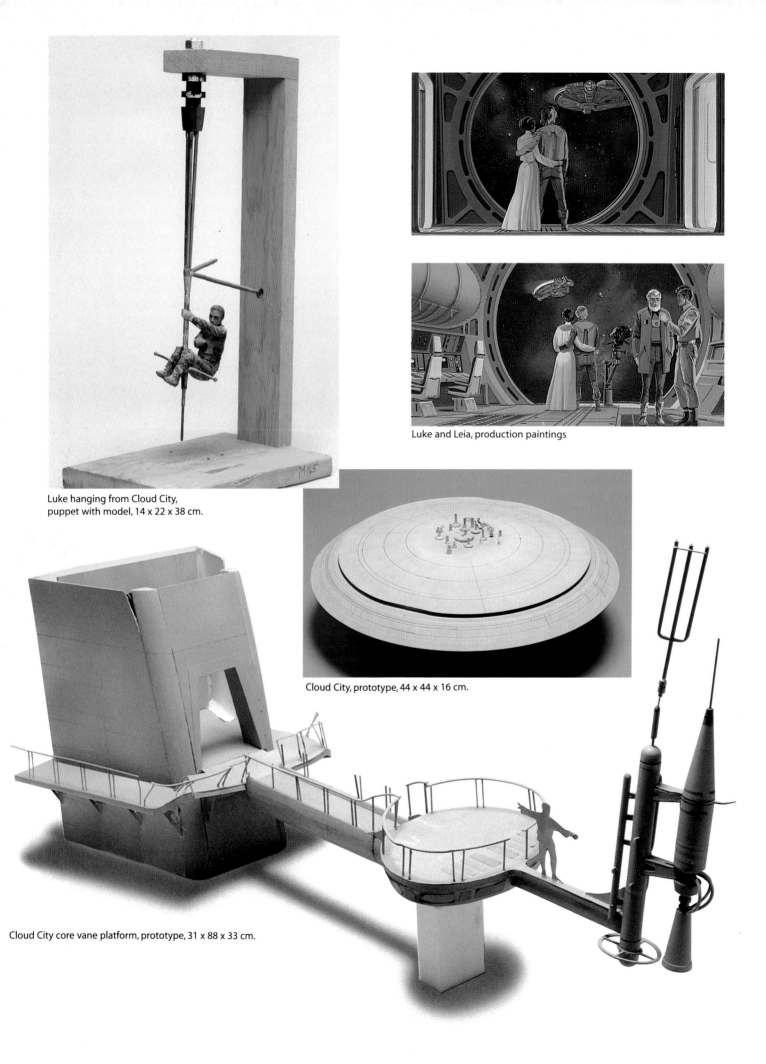

Luke hanging from Cloud City,
puppet with model, 14 x 22 x 38 cm.

Luke and Leia, production paintings

Cloud City, prototype, 44 x 44 x 16 cm.

Cloud City core vane platform, prototype, 31 x 88 x 33 cm.

BLUE HARVEST

The third chapter in the *Star Wars* saga was originally titled *Revenge of the Jedi*. Upon reflection Lucas decided that vengeance was not a particularly noble aspiration for a true Jedi Knight and the movie was retitled *Return of the Jedi*. (Another poster for the film, in which two hands hold high a Jedi lightsaber, was drawn from photographs of George Lucas himself holding a lightsaber.)

For *Jedi* the production goal, as dictated by Lucas, was to combine the experiences of the first two installments into one supreme production. The model making alone had increased by increments throughout the trilogy, from 50 models for *Star Wars* and 100 models for *Empire* to 150 models for *Jedi*. "I think George Lucas really feared that one of the sequels would not be compared favorably with the original," observes Lorne Peterson, "so he realized he had to up the ante each time."

With an underground fan market for pirated *Star Wars* video, scripts, and memorabilia—much less the inquiring minds of the media—secrecy on the production was vital. For location work in Yuma, Arizona, the production (with new director Richard Marquand on board) practiced a little of what is known in magician's circles as misdirection, using as cover the title of a fictious production, *Blue Harvest* ("Horror Beyond Imagination").

The security concerns were even extended to ILM, where the plot of the movie was not disclosed, so effects scenes were created without the artists knowing how their work fit into the entire film. As it was, the effects house, with two Academy Awards for visual effects and one Special Achievement award under its belt, had no time for intrigues. They were not only going about the business of topping themselves but had to deliver some five hundred separate effects shots.

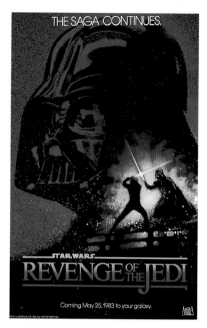

Revenge of the Jedi, pre-release poster, 69 x 104 cm.

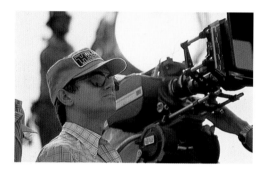

Director Richard Marquand with *Blue Harvest* cap

Blue Harvest logo

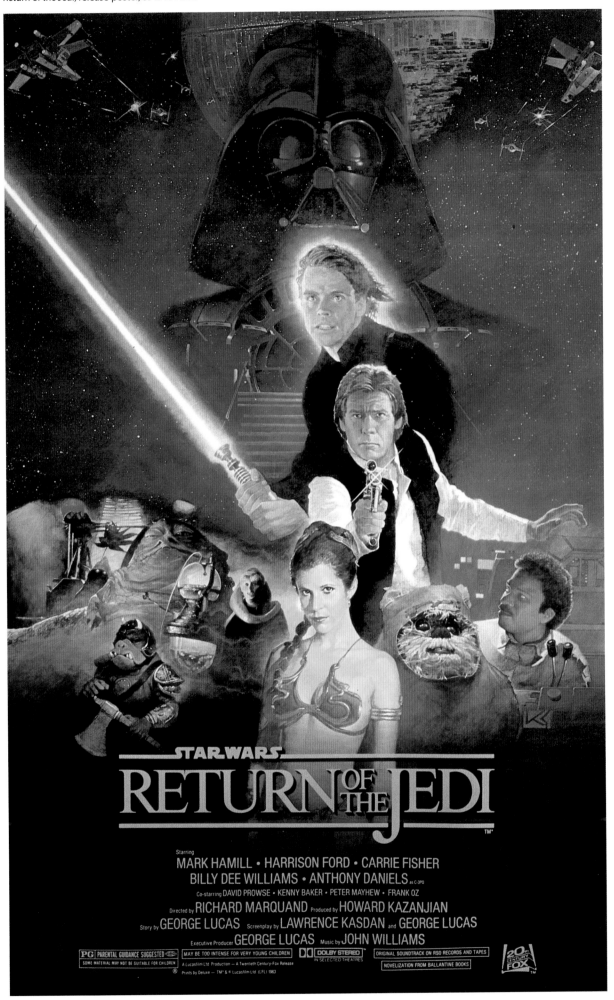

DOCK OF THE BAY

As with the previous two install-ments, much of *Jedi* was filmed at Elstree Studios in England, but as with the Imperial base, matte paint-ing magic would extend the environ-ment. For an interior painting of the Imperial docking bay painter Frank Ordaz had to match the shiny source reflections of the soundstage's black linoleum floor with a separate glare painting that was double-exposed into the final shot. (Some visual gags are included in the paintings, such as the TransAmerica Pyramid building visible to the extreme left of the mid-dle section of the "Death Star Trench Docking Bays" painting.)

The *Star Wars* Death Star had been a matte painting, which limited the camera moves. For *Jedi* the new under-construction citadel of the Empire would be created as a model.

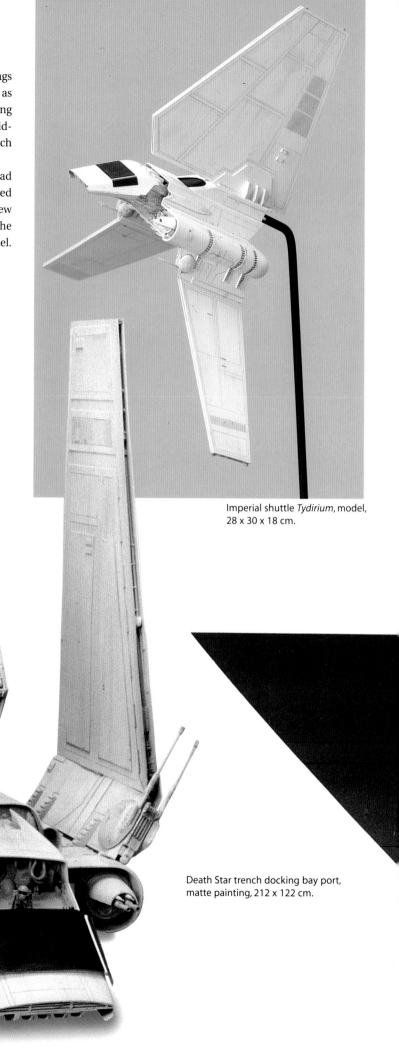

Imperial shuttle *Tydirium*, model, 28 x 30 x 18 cm.

Death Star trench docking bay port, matte painting, 212 x 122 cm.

Imperial shuttle *Tydirium*, model, 33 x 53 x 56 cm.

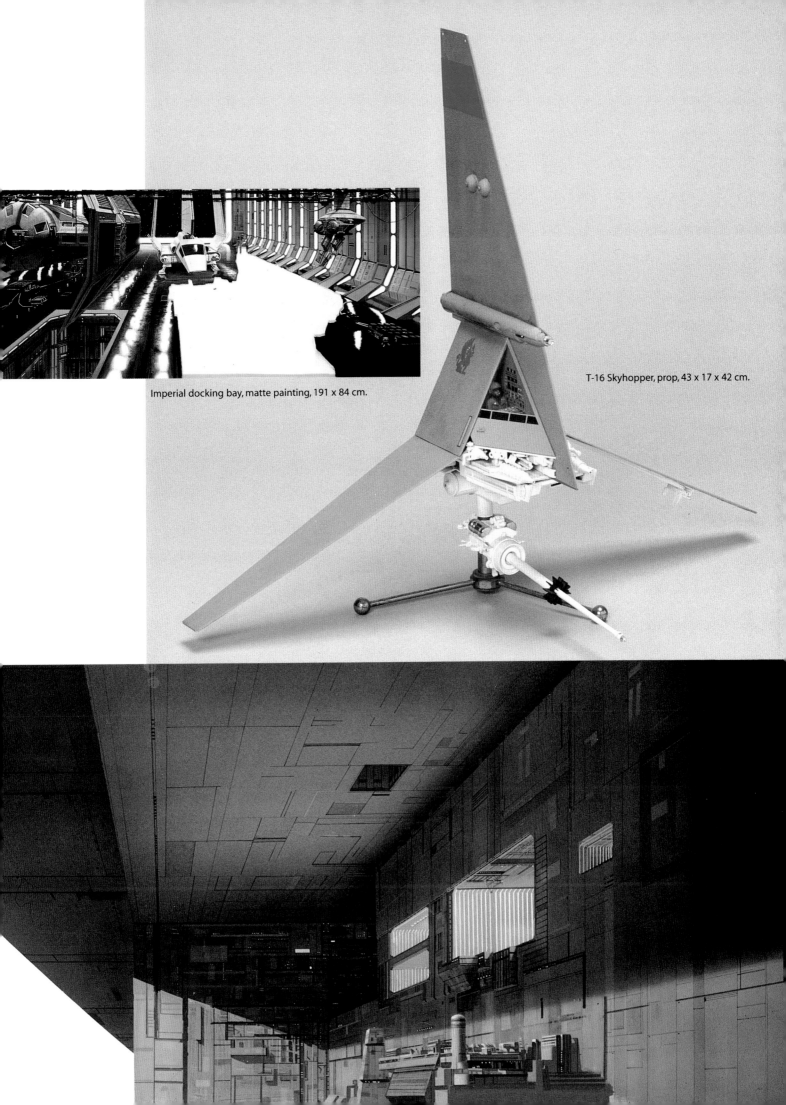

Imperial docking bay, matte painting, 191 x 84 cm.

T-16 Skyhopper, prop, 43 x 17 x 42 cm.

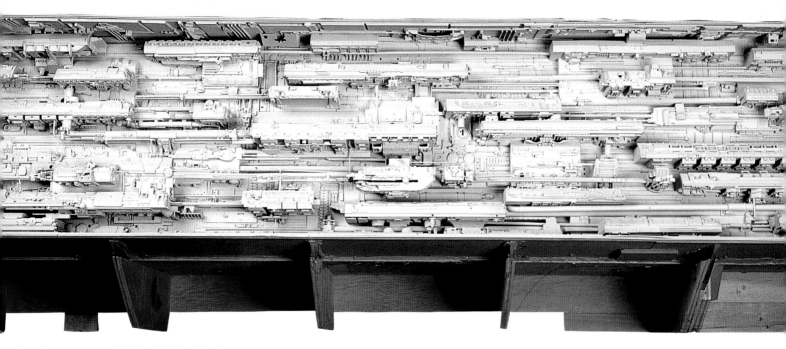

Star Destroyer, model (side detail), 325 x 76 x 61 cm.

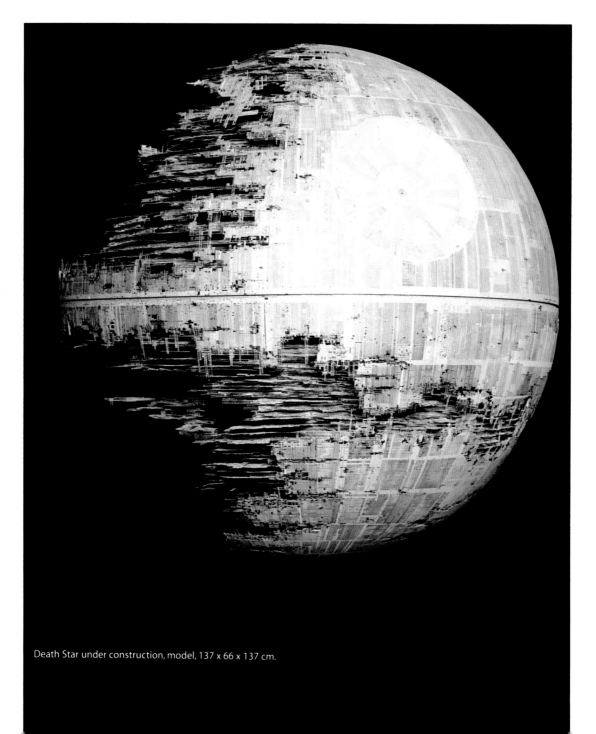

Death Star under construction, model, 137 x 66 x 137 cm.

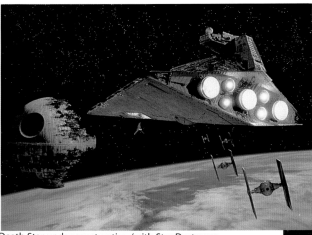

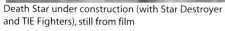
Death Star under construction (with Star Destroyer
and TIE Fighters), still from film

Death Star, concept sketch

Death Star under construction, production illustration

Death Star trench docking bays, matte painting, 244 x 122 cm.

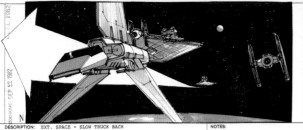

DESCRIPTION: EXT. SPACE - SLOW TRUCK BACK

REVERSE of OP 1. Shuttle coming toward camera with escort of two TIEs. Shuttle gains through shot & exits frame L, ROARING by camera. Stardestroyers & planet Endor in background.

NOTES: Shot should look like VM except closer if possible.

ELEMENTS:	STAGE	ANIM	PLATE	MATTE	NON-ILM	ELEMENTS:	STAGE	ANIM	PLATE	MATTE	NON-ILM	SHOT # / SEQUENCE
Shuttle	x											
TIE #1	x											
TIE #2	x											
Stardestroyer #1	x											OP 2
Stardestroyer #2	x											
Planet Endor	x											
Endor (moon)			x									FRM COUNT: 86
Stars	x											PAGE #

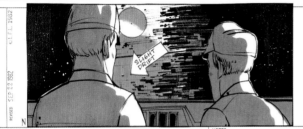

DESCRIPTION:

The Shuttle is moving in slowly on the Death Star; Death Star should drift in slightly from R with slight rotation. By end, it should have travelled down 2 fields & across 4 fields.

SLIGHT DRIFT

NOTES: Blow up plate: bring frame line in one field all the way around.

ELEMENTS:	STAGE	ANIM	PLATE	MATTE	NON-ILM	ELEMENTS:	STAGE	ANIM	PLATE	MATTE	NON-ILM	SHOT # / SEQUENCE
Shuttle Pilots			x									
Death Star	x											OP 3
Stars	x											
												FRM COUNT PAGE #

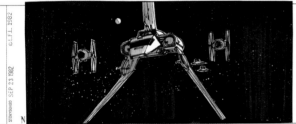

DESCRIPTION: EXT. SPACE - TRUCK BACK SLOWLY

The Shuttle and its escort of 2 TIEs move toward camera, gaining through shot & exiting frame over camera BIG. Stardestroyers & the planet Endor are in the background.

NOTES: This shot can be just like the VM.

ELEMENTS:	STAGE	ANIM	PLATE	MATTE	NON-ILM	ELEMENTS:	STAGE	ANIM	PLATE	MATTE	NON-ILM	SHOT # / SEQUENCE
Shuttle	x											
TIE #1	x											
TIE #2	x											
Stardestroyer #1	x											OP 8
Stardestroyer #2	x											
Planet Endor	x											
Stars	x											FRM COUNT: 81 PAGE #

DESCRIPTION: INT. DEATH STAR - CU VIEWSCREEN Death Star visible in full with grid around it (no scan line). Death Star is moving across R to L. Speck in upper R corner is moving across R to L. Speck meets line of grid; ZOOM IN to speck & grid line. Grid line breaks & speck (now Shuttle) goes thru force field. 1 small dot on tip of Shuttle wing lites up; at same time, paragraph of foreign language appears in upper R of screen. Another small dot on Shuttle; another on screen until 3 total. Hand pushes button; one of the paragraphs fills screen.

NOTES: Can be up to twice as long as given here. No matter what length, dots start appearing 25% into shot. Do NOT have to be fully zoomed in for dots to appear. Sync with hand.

ELEMENTS:	STAGE	ANIM	PLATE	MATTE	NON-ILM	ELEMENTS:	STAGE	ANIM	PLATE	MATTE	NON-ILM	SHOT # / SEQUENCE
Shuttle Dashboard			x									
CAX - Death Star				x								OP 9
Writing - anim				x								
												FRM COUNT PAGE #

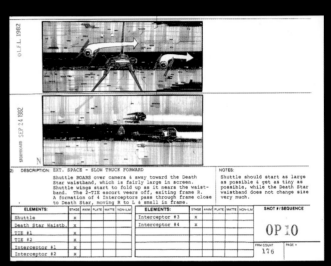

2) DESCRIPTION: EXT. SPACE - SLOW TRUCK FORWARD

Shuttle ROARS over camera & away toward the Death Star waistband, which is fairly large in screen. Shuttle wings start to fold up as it nears the waistband. The 2-TIE escort veers off, exiting frame R. A formation of 4 Interceptors pass through frame close to Death Star, moving R to L & small in frame.

NOTES: Shuttle should start as large as possible & get as tiny as possible, while the Death Star waistband does not change size very much.

ELEMENTS:	STAGE	ANIM	PLATE	MATTE	NON-ILM	ELEMENTS:	STAGE	ANIM	PLATE	MATTE	NON-ILM	SHOT # / SEQUENCE
Shuttle	x					Interceptor #3	x					
Death Star Waistb.	x					Interceptor #4	x					OP 10
TIE #1	x											
TIE #2	x											
Interceptor #1	x											FRM COUNT: 176
Interceptor #2	x											PAGE #

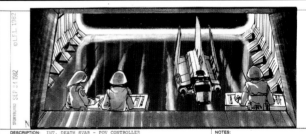

DESCRIPTION: EXT. SPACE - DEATH STAR WAISTBAND

Vader's Shuttle moves across the screen L to R toward the smaller, upper docking bay of the Death Star. In the foreground are some welders. The Shuttle is tiny in relation to the vast Death Star waistband.

NOTES:

ELEMENTS:	STAGE	ANIM	PLATE	MATTE	NON-ILM	ELEMENTS:	STAGE	ANIM	PLATE	MATTE	NON-ILM	SHOT # / SEQUENCE
Waistband/Stars				x								
Shuttle			x									OP 11
Welders	x											
												FRM COUNT: 139 PAGE #

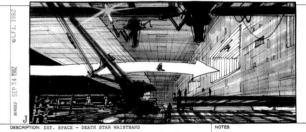

DESCRIPTION: INT. DEATH STAR - POV CONTROLLER

In the foreground are some Imperial Troopers working at a control board. Beyond is the Docking Bay. The Shuttle flies into the Docking Bay & lands.

NOTES: As in VM. People should be smaller than they are in VM.

In extreme FG is the Controller's window frame.

ELEMENTS:	STAGE	ANIM	PLATE	MATTE	NON-ILM	ELEMENTS:	STAGE	ANIM	PLATE	MATTE	NON-ILM	SHOT # / SEQUENCE
FG Troopers			x									
Docking Bay-pntg.	x											
Shuttle	x											OP 12
Stars	x											
Ex. FG Window	x											FRM COUNT: 80 PAGE #

JEDI CREATURES

While the creatures of the cantina scene in *Star Wars* were memorable, Lucas felt they lacked a truly unearthly quality. *Jedi*, for sheer number and variety of alien creatures, would be remembered as the monster movie of the series.

Creature Design Supervisor Phil Tippett and his team set up an entire creature bay and were developing creatures six months before the script was locked down. For eight months they developed designs for the strange denizens who formed the entourage of the gangster Jabba the Hutt (whose palace was created as a matte painting, with the droids composited as an in-camera, latent image effect). The crew gave nicknames to their works in progress (including "Woof," "Quee Quay," "Droopy McCool," "Apple Slug," "Hole in the Head," and "Ree-Yees." The names "Klaatu" and

"Barada" paid homage to the alien characters of the classic *The Day The Earth Stood Still*.) They evolved from design sketches to three-dimensional prototypes to final effects (which varied from costumes for actors to flip-on masks and articulated puppets).

Jabba, who held Princess Leia prisoner, would emerge as a major character in the film. Since Jabba required physical interaction with real actors, the debauched creature (inspired in part by Sydney Greenstreet's sinister role as Casper Gutman in *The Maltese Falcon*), was built as a full-scale, articulated, foam latex creature by a team headed by Stuart Freeborn. Hidden cables in the giant Jabba allowed as many as ten off-camera puppeteers to work the various articulate functions that brought the creature to life.

Palace gate of Jabba the Hutt, production painting

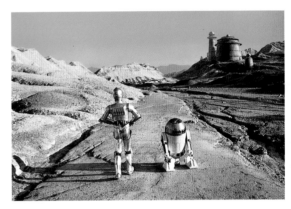

C-3PO and R2-D2 approach Jabba's palace, still from film

Palace gate of Jabba the Hutt, set design illustrations

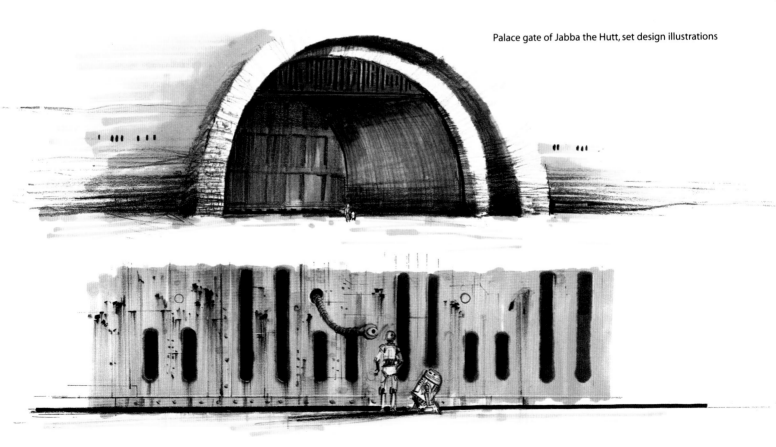

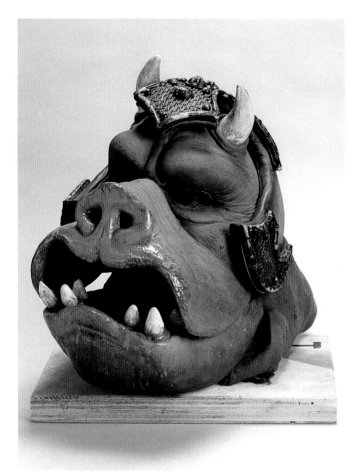

Gamorrean Guard (nicknamed "Pig Guard"),
full head mask, 35 x 38 x 52 cm.

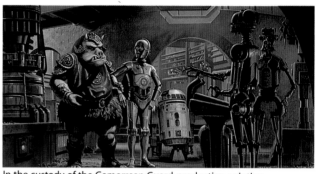

In the custody of the Gamorrean Guard, production painting

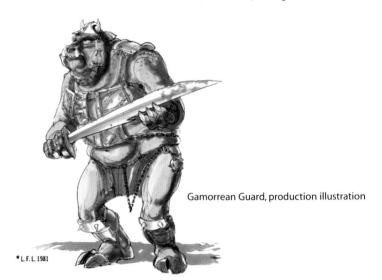

Gamorrean Guard, production illustration

° L.F.L 1981

Gamorrean Guard prototypes,

15 x 22 x 14 cm.

19 x 22 x 25 cm.

15 x 22 x 24 cm.

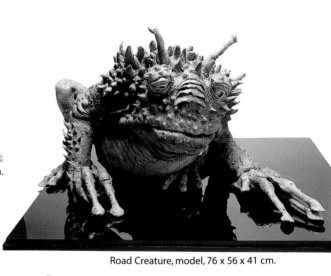

Road Creature, model, 76 x 56 x 41 cm.

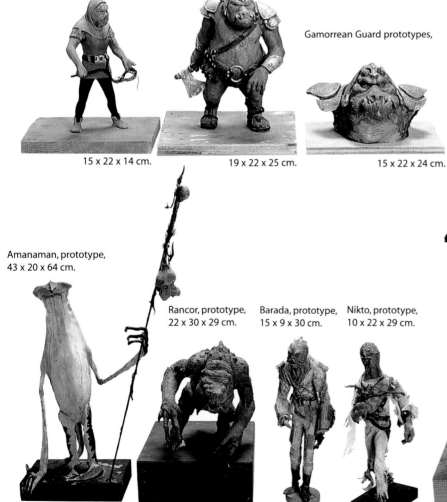

Amanaman, prototype,
43 x 20 x 64 cm.

Rancor, prototype,
22 x 30 x 29 cm.

Barada, prototype,
15 x 9 x 30 cm.

Nikto, prototype,
10 x 22 x 29 cm.

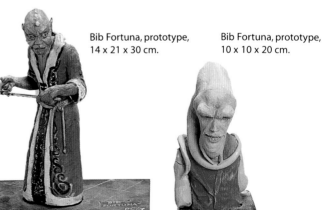

Bib Fortuna, prototype,
14 x 21 x 30 cm.

Bib Fortuna, prototype,
10 x 10 x 20 cm.

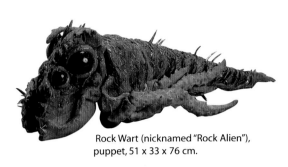

Rock Wart (nicknamed "Rock Alien"),
puppet, 51 x 33 x 76 cm.

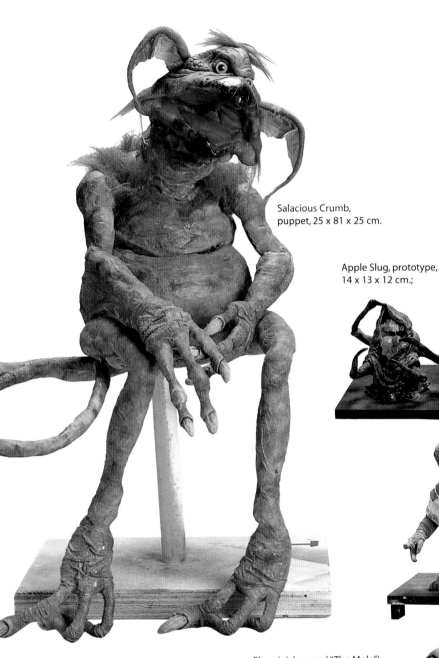

Salacious Crumb,
puppet, 25 x 81 x 25 cm.

Apple Slug, prototype,
14 x 13 x 12 cm.;

Ephant Mon (nicknamed
"Elephant Man"), prototype,
20 x 25 x 33 cm.

Quee Quay (nicknamed "Weequay"),
prototype, 9 x 20 x 20 cm.

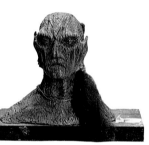

Pote Snitkin (nicknamed "Snit
Plotkin") prototype, 35 x 29 x 6 cm.

Ishi Tib (nicknamed "Starfish"),
prototype, 10 x 10 x 11 cm.

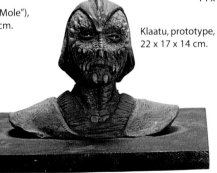

Hermi Odle, prototype,
14 x 16 x 32 cm.

Hole in the Head, prototype,
11 x 10 x 15 cm.

Elom (nicknamed "The Mole"),
prototype, 10 x 8 x 15 cm.

Klaatu, prototype,
22 x 17 x 14 cm.

Road Creature, prototype,
20 x 36 x 24 cm.

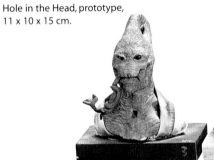

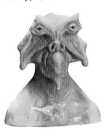

Tooth Face, prototype,
10 x 8 x 2 cm.

Ree- Yees (nicknamed "Three-
Eyes"), prototype,
9 x 14 x 20 cm.

Droopy McCool, prototype,
10 x 9 x 13 cm.

Yak Face, prototype,
10 x 14 x 18 cm.

Max Rebo, prototype
10 x 11 x 15 cm.

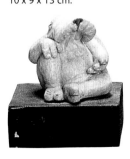

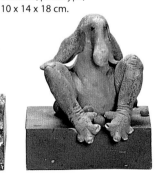

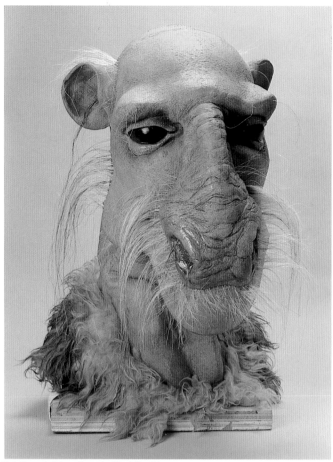

Yak Face, full-head mask, 41 x 74 x 51 cm.

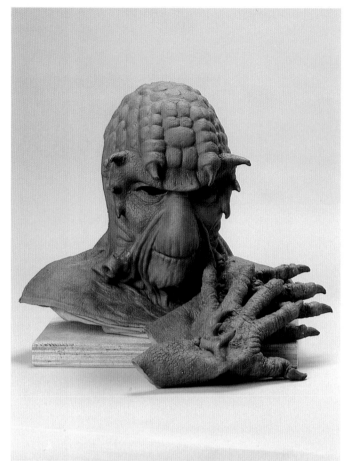

Nikto, full-head mask, 46 x 53 x 41 cm.

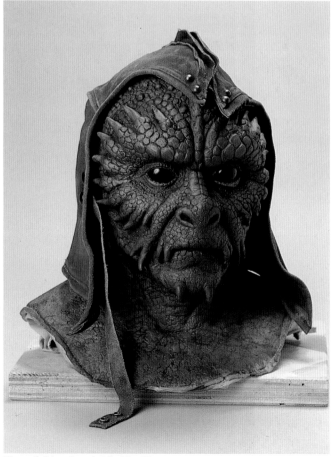

Klaatu, full-head mask, 36 x 53 x 33 cm.

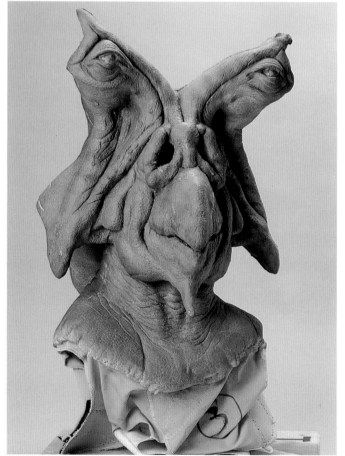

Ishi Tib (nicknamed "Starfish"), full-head mask, 36 x 51 x 41 cm.

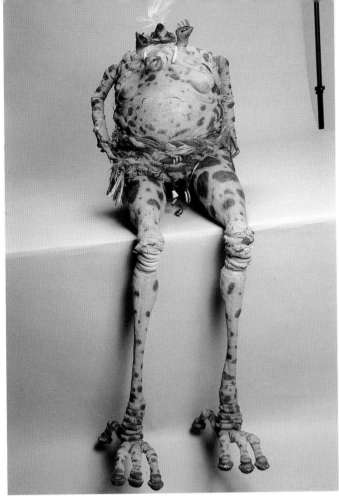

Sy Snootles, rod puppet, 41 x 53 x 147 cm.

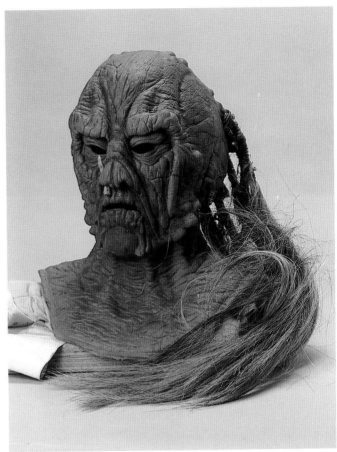

Quee Quay (nicknamed "Weequay"), full-head mask, 41 x 42 x 30 cm.

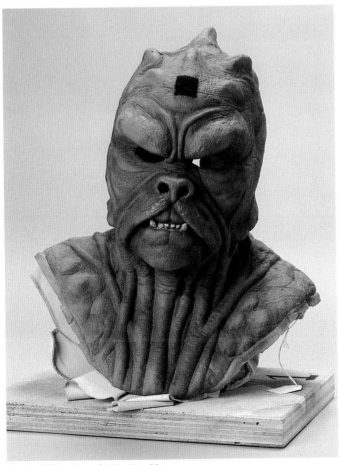

Barada, full-head mask, 38 x 51 x 30 cm.

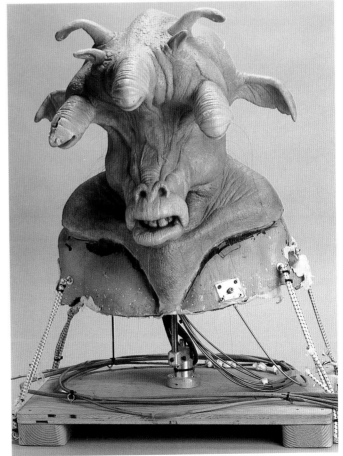

Ree-Yees (nicknamed "Three-eyes"), full-head mask, 58 x 76 x 41 cm.

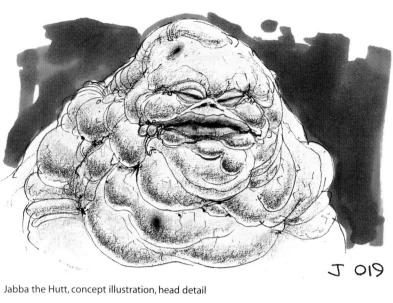

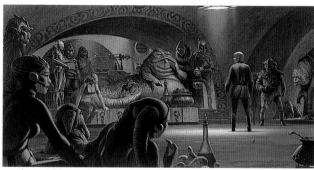

Luke in Jabba's Lair, production painting

Jabba the Hutt, concept illustration, head detail

J 019

15 x 20 x 17 cm.

14 x 10 x 8 cm.

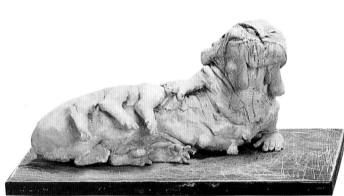

24 x 14 x 18 cm.

Jabba the Hutt, prototypes,

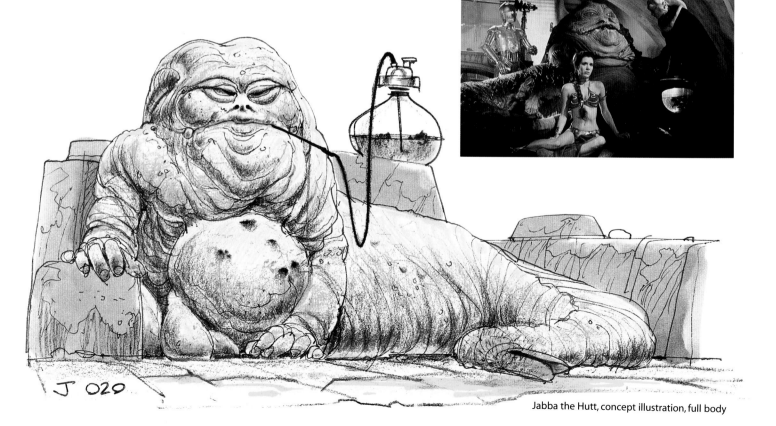

J 020

Jabba the Hutt, concept illustration, full body

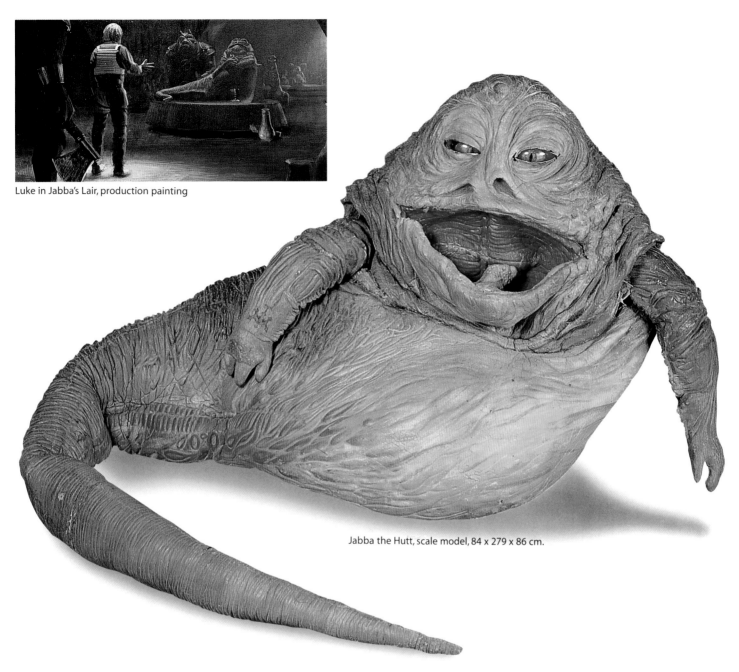

Luke in Jabba's Lair, production painting

Jabba the Hutt, scale model, 84 x 279 x 86 cm.

Luke confronts Jabba, production illustration

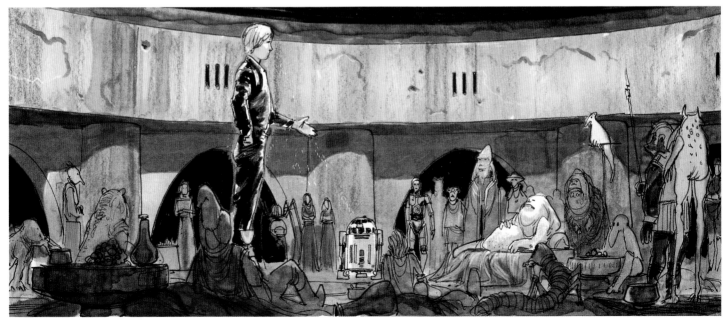

SOLO RELIEF

The Empire Strikes Back ends with Han Solo, captured by the Imperial forces, encased in carbonite. The life-size prop utilized life molds of actor Harrison Ford's head.

Ford actually felt his character should have been killed off, entombed forever in the carbonite slab, a martyr to the cause of the Rebellion. But George Lucas disagreed, so Solo was rescued from the clutches of death and dropped back into the action.

Solo's salvation comes in the form of Princess Leia, who is armed with a thermal detonator and disguised as the bounty hunter Boushh. Lando and Luke, who also infiltrate the palace in disguise, are not far behind.

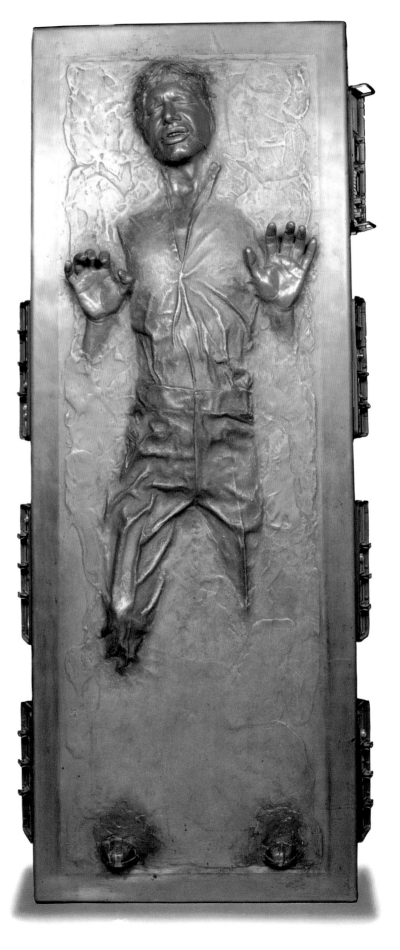

Han Solo in carbonite, prop, 81 x 203 x 25 cm.

RANCOR MONSTER

One of the most terrifying creatures in the film is the rancor beast, a flesh-eating creature locked in a cave pit below Jabba's palace. Phil Tippett recalls that Lucas originally wanted the rancor to be "the best Godzilla that had ever been done." Like Godzilla, the rancor was planned as a body outfit to be worn by an actor. Although intense preparations went into the idea, with the prop crew in England even shipping over a full-scale rancor cave set, the effect did not look realistic.

The rancor was instead produced as a two-foot-tall, foam-rubber rod puppet. A miniature pit set was built that concealed the three puppeteers needed to work the creature. In order

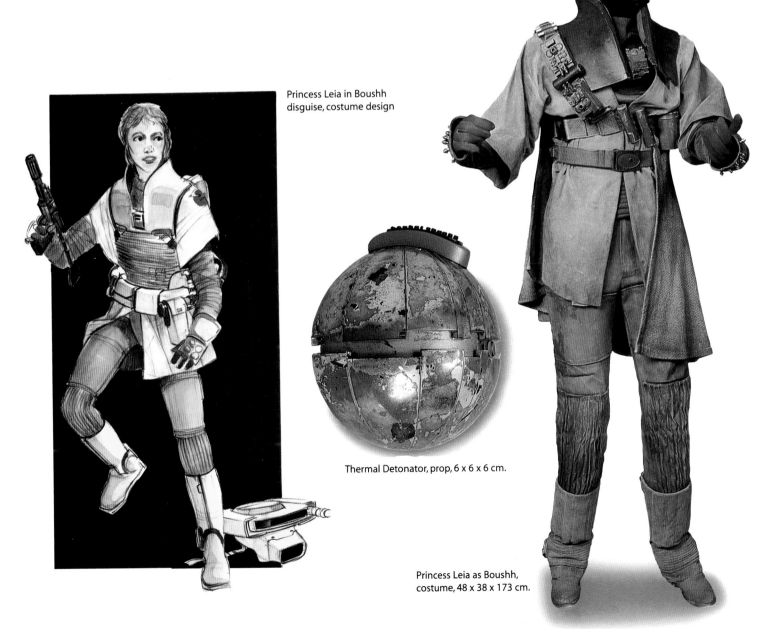

Princess Leia in Boushh disguise, costume design

Thermal Detonator, prop, 6 x 6 x 6 cm.

Princess Leia as Boushh, costume, 48 x 38 x 173 cm.

to create a feeling of weight and scale, the rancor puppet was shot at seventy-two frames a second instead of the normal twenty-four frames. "In stop-motion animation you try to imply weight and frame by frame you sculpt your movement," says Tippett. "But shooting high speed everything slows down, and it's tricky getting into a rhythm that will impart the sense of weight and scale. It's a very strange temporal space."

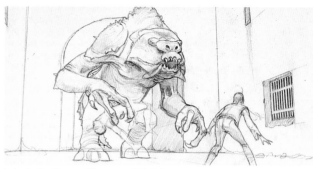

Luke in the Rancor Pit, concept sketch

Rancor Beast, model,
58 x 53 x 38 cm.

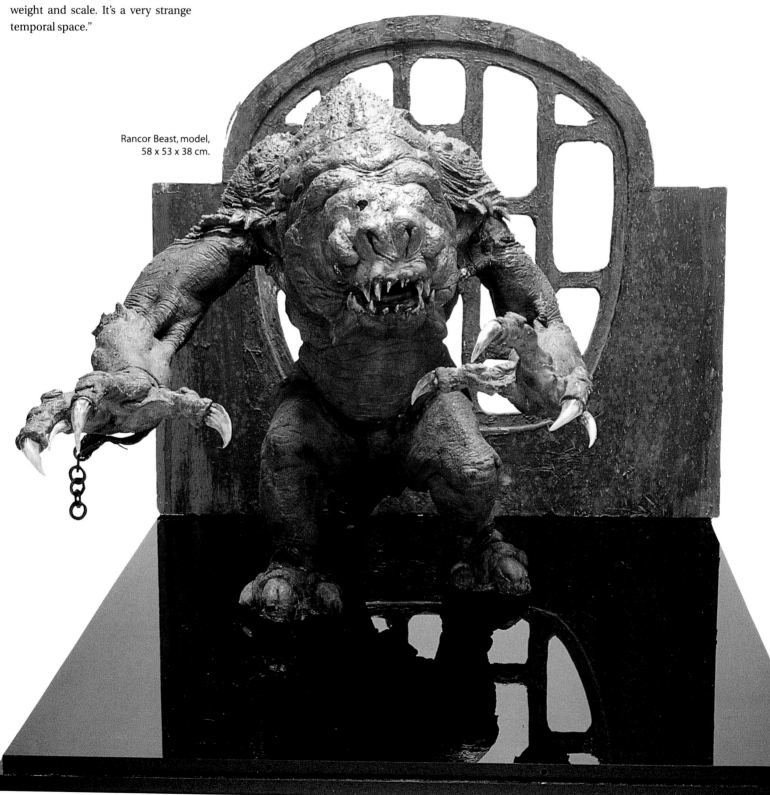

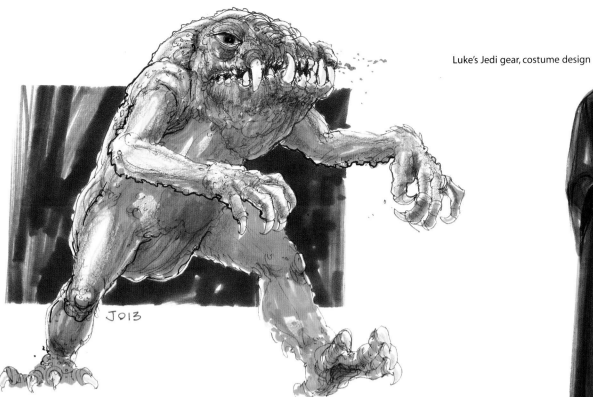

Rancor Beast, production illustration

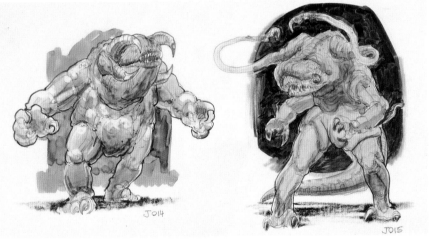

Rancor Beast, concept illustrations

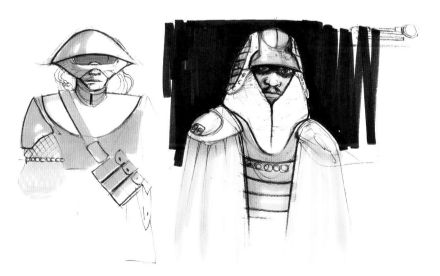

Lando in disguise, costume design

Luke's Jedi gear, costume design

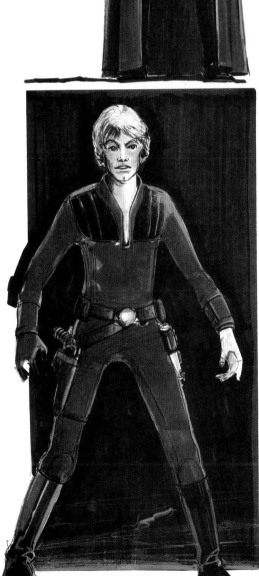

Luke in Jedi gear, costume design

JABBA'S SAIL BARGE

One of the major scenes in *Jedi* is a desert sequence of Jabba's regal sail barge, which was staged at the location site in Yuma, Arizona. Both the barge and a sand skiff in which Skywalker and company make their escape required an extensive design phase.

The Yuma shoot was a million-dollar piece of the production pie, with a four-acre shooting area surrounded by a chain link fence, the ground cleared of vegetation, and thirty-thousand square-foot area topped by a sixty-foot set. Local police and production security patrolled the perimeter. When a helicopter chartered by the media tried to fly overhead and take photographs, a production helicopter (bearing the *Blue Harvest* logo) drove away the interlopers.

The barge set construction required thousands of workhours to build, thousands of thirty-foot-long sheets of lumber, and more than fourteen thousand pounds of nails. Director Richard Marquand would remember the set as a frightening place on which to work, even with harnesses and other safety precautions for cast and crew.

Winged Transport, production painting

Winged Transport, production illustration

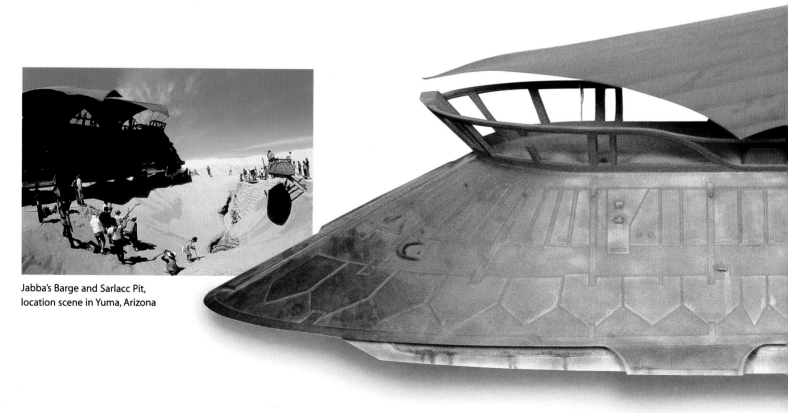

Jabba's Barge and Sarlacc Pit,
location scene in Yuma, Arizona

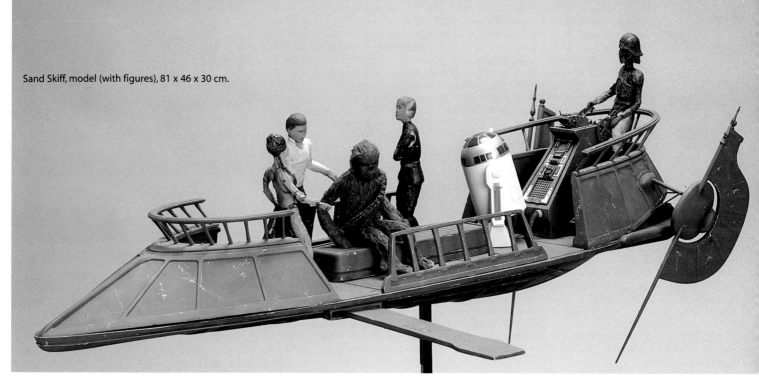

Sand Skiff, model (with figures), 81 x 46 x 30 cm.

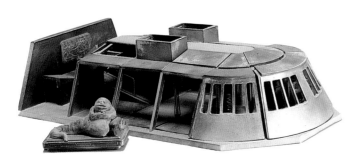

Jabba's Sail Barge, prototype, 36 x 64 x 15 cm.

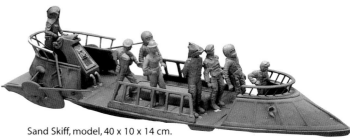

Sand Skiff, model, 40 x 10 x 14 cm.

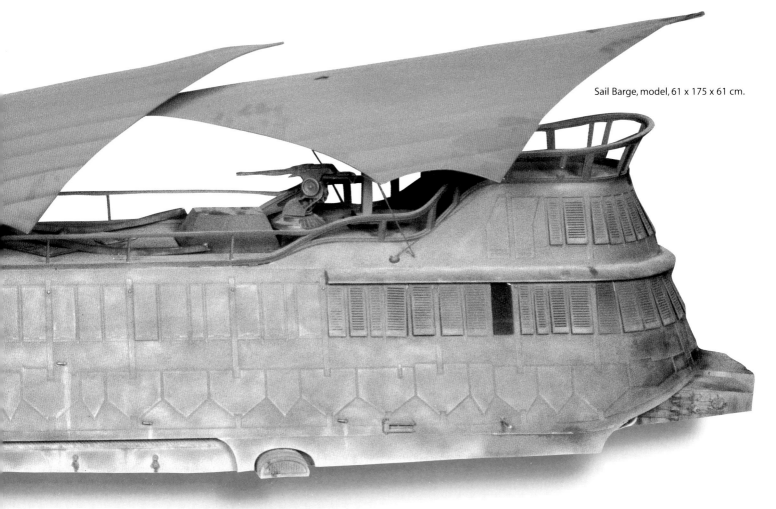

Sail Barge, model, 61 x 175 x 61 cm.

Battle on the Skiff, production painting

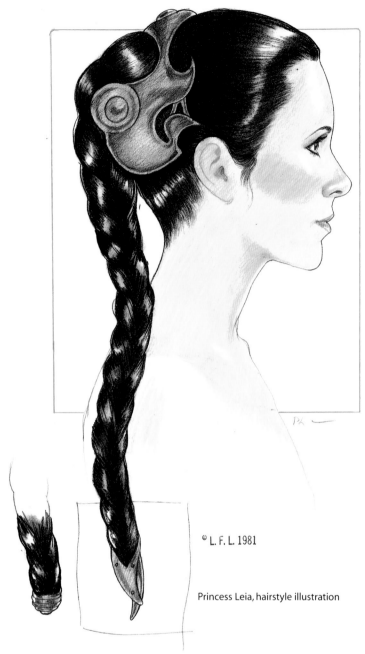

© L. F. L. 1981

Princess Leia, hairstyle illustration

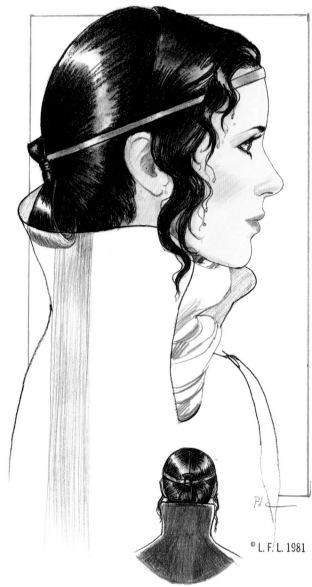

© L. F. L. 1981

Princess Leia, hairstyle illustration

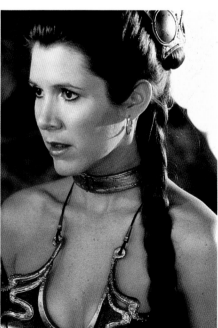

Above the Sarlacc Pit, production painting

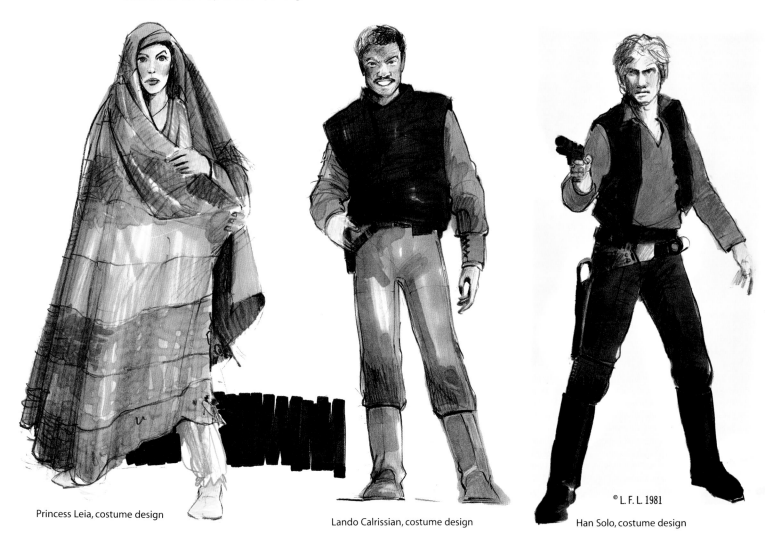

Princess Leia, costume design

Lando Calrissian, costume design

© L. F. L. 1981

Han Solo, costume design

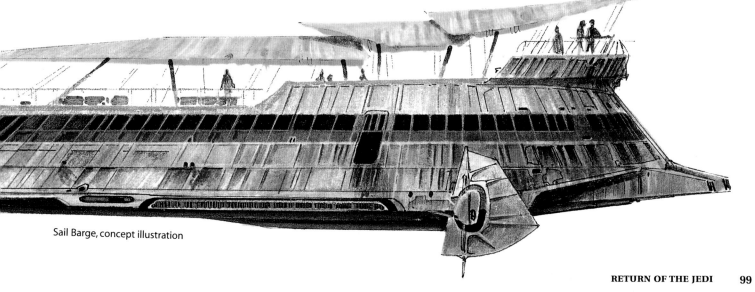

Sail Barge, concept illustration

IMPERIAL TROOPS ASSEMBLE

An impressive scene in *Jedi* is when seemingly thousands of Imperial troopers assemble in the Death Star bay, standing at attention to receive the Emperor and his entourage.

Matte painting extended the action. Only two hundred costumed extras were needed for the soundstage element, with hundreds more foot soldiers provided as oil-painted creations by artist Chris Evans. Even some of the shining glints of light reflecting off the black helmets were painted effects.

The Emperor (played by Ian McDiarmid) was conceived as an older person. But, unlike Yoda's gentle sagacity, the Emperor is consumed by the dark side of the Force. To add to his evil personality, costume design concepts dressed the Emperor in a hooded cloak to partially conceal his face.

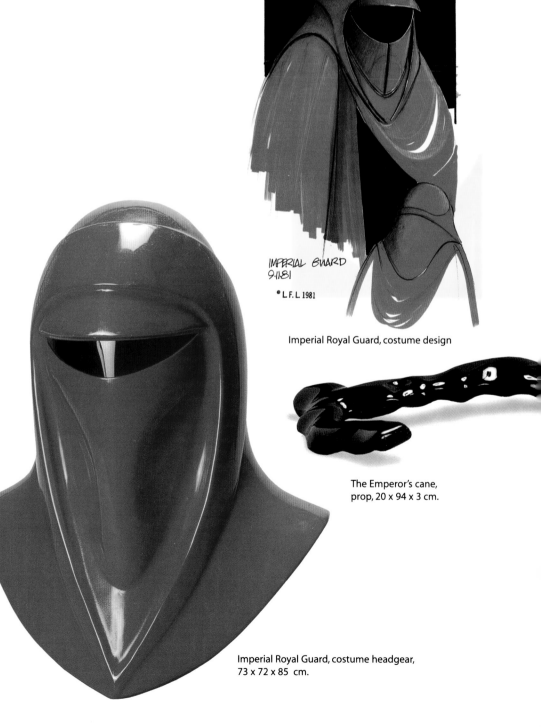

Imperial Royal Guard, costume design

The Emperor's cane,
prop, 20 x 94 x 3 cm.

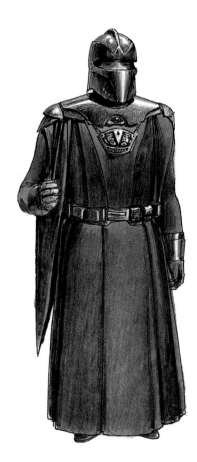

Imperial Royal Guard, costume design

Imperial Royal Guard, costume headgear,
73 x 72 x 85 cm.

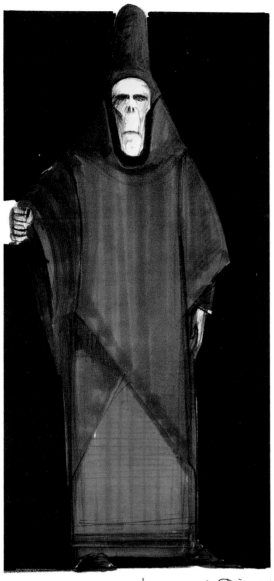

Imperial Dignitary, costume design *Imperial Dignitary®*

The Emperor, costume design EMPEROR

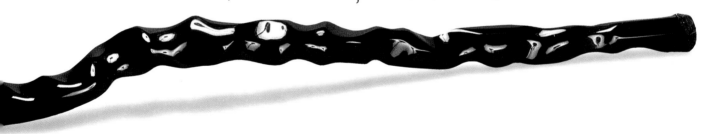

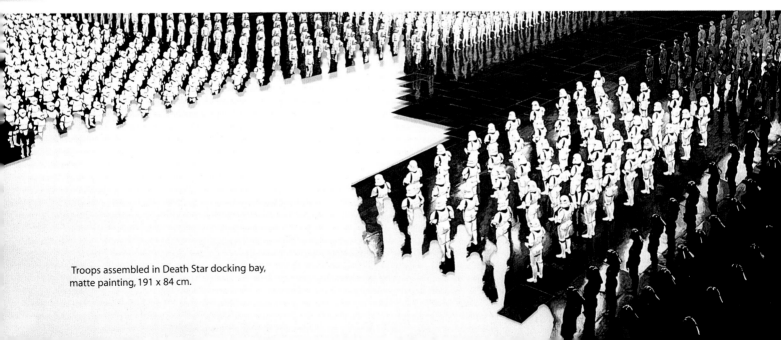

Troops assembled in Death Star docking bay,
matte painting, 191 x 84 cm.

REBEL FORCE

New ships were created for *Jedi*, in particular the Rebel Star Cruiser commanded by Admiral Ackbar, one of the race of aliens known as Mon Calamari. In the film, Ackbar's ship is the site of an important conference by the Rebel Alliance in which strategies for destroying the Death Star are plotted. The scene provided a dual challenge for both the creature shop artists who had to create the fishlike appearance of the Mon Calamarians and the model makers who created the Calamarian ships.

Ackbar, designed by Phil Tippett, was originally one of many anonymous creations filling the creature shop. "One day George [Lucas] walked in and said, 'that's Admiral Ackbar,'" Tippett recalls. "George

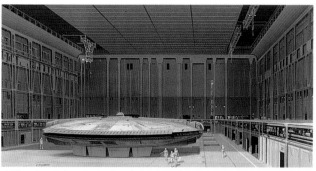

Millennium Falcon in the Death Star, production painting

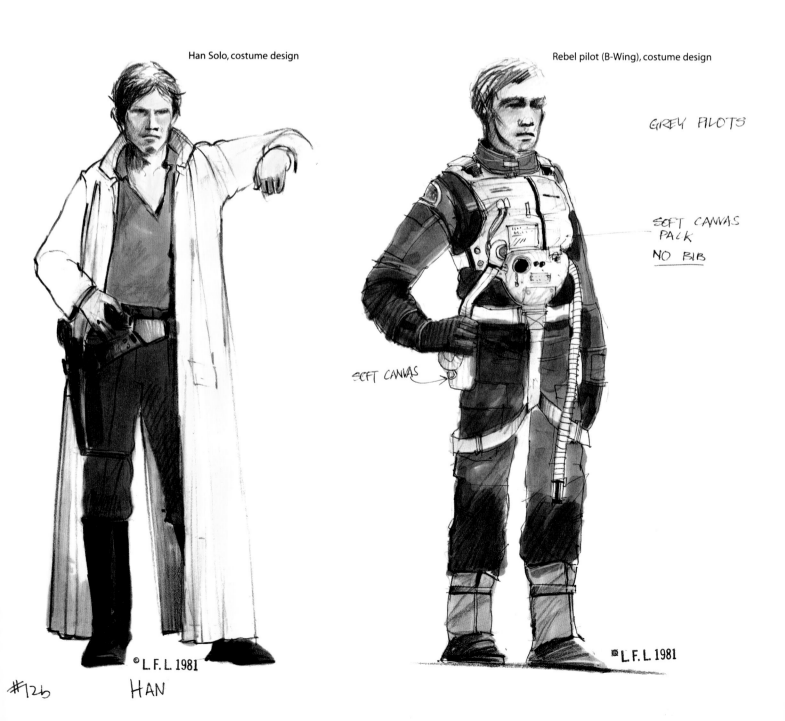

Han Solo, costume design

Rebel pilot (B-Wing), costume design

GREY PILOTS

SOFT CANVAS PACK
NO BIB

SOFT CANVAS

© L.F.L. 1981

#126 HAN

© L.F.L. 1981

knighted him. We made two versions of Ackbar. One was a slip-on head harness that had ancillary cables hidden off-camera to operate the eyes and mouth. For close-ups we constructed a foam latex hand puppet."

Nien Nunb was another unsung creation who was snatched out of anonymity for a supporting role as Han Solo's copilot. Like Ackbar, Nien was realized as a slip-on head harness.

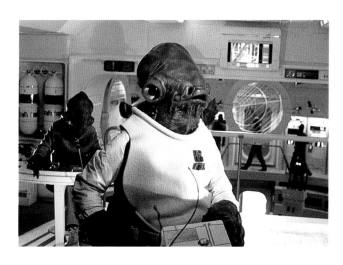

Admiral Ackbar, costume design

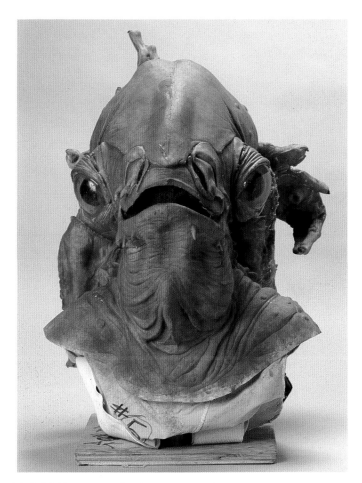

Admiral Ackbar, costume headgear, 38 x 71 x 41 cm.

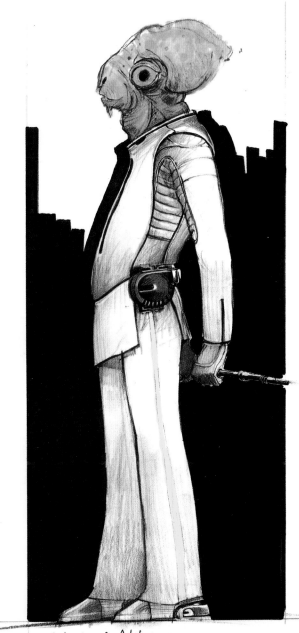

Admiral Akbar

©L.F.L. 1981

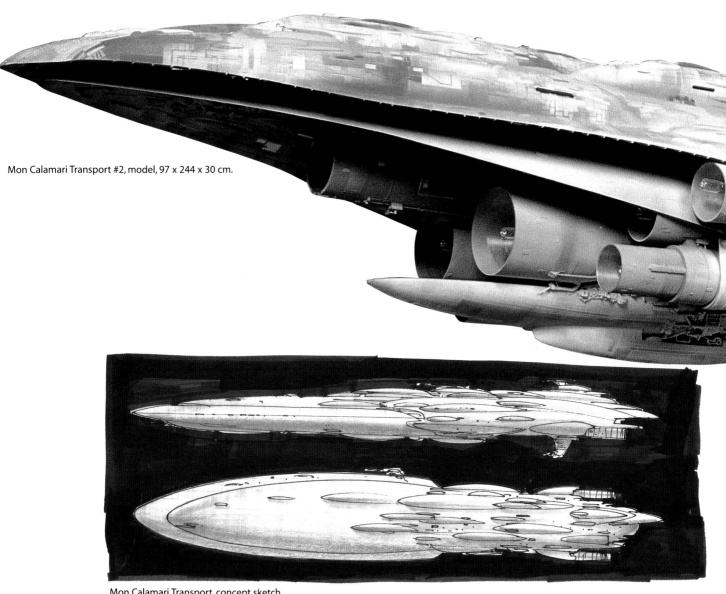

Mon Calamari Transport #2, model, 97 x 244 x 30 cm.

Mon Calamari Transport, concept sketch

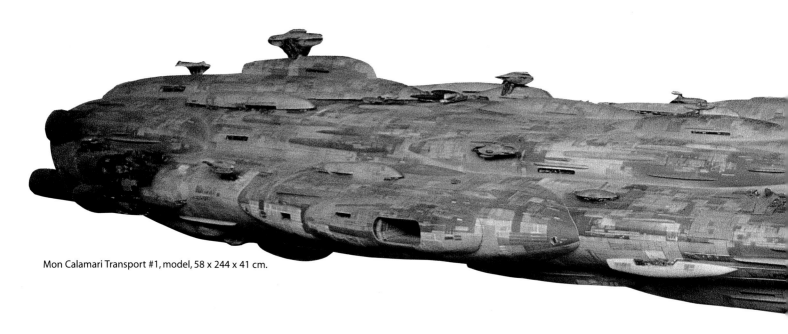

Mon Calamari Transport #1, model, 58 x 244 x 41 cm.

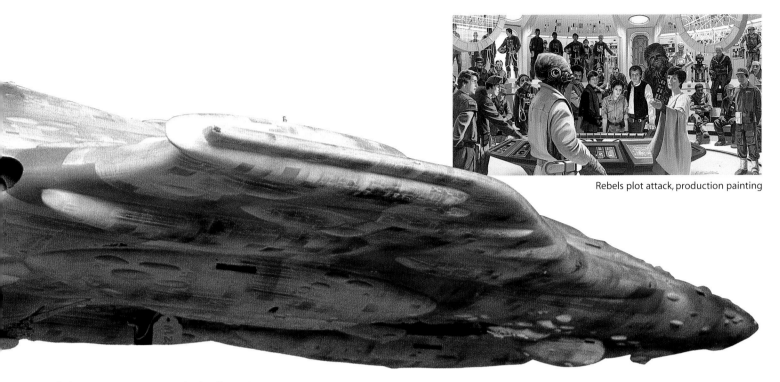

Rebels plot attack, production painting

Rebel Transport War Room, production illustration

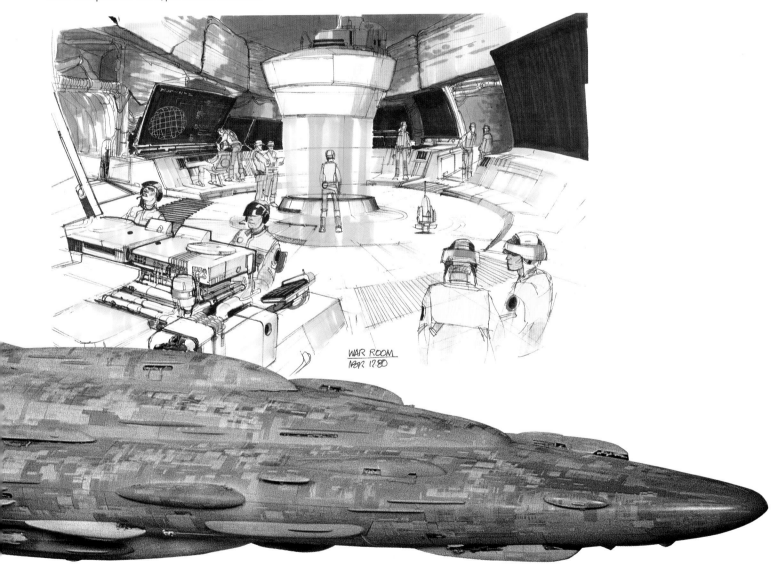

WAR ROOM
MAR 12·80

LAND OF THE EWOKS

The final battle between Rebellion and Empire takes place on the forest planet of Endor where Rebels seek to deactivate a generator that maintains a protective force field around the Death Star. But to sabotage the generator the Rebels have to get past Imperial bike scouts and two-legged scout walkers (or AT-STs: All Terrain Scout Transport).

The walkers were created as both eighteen-inch and three-foot models filmed on a miniature forest set under natural sunlight at ILM's Marin County facility, and as stop-motion puppets. The speeder sequence has become a textbook example of optical compositing, with actors on full-scale bikes filmed in front of a bluescreen and composited with background footage (called the "background plate") that was shot by visual effects supervisor Dennis Muren and his crew in the woods of Northern California.

The speeder scenes also utilized bike and puppet models mounted to motorized pylons and stop-motion animated. The stop-motion effect was rendered even more realistic with ILM "go-motion," a breakthrough technique in which external motion-controlled rods attached to the models allowed for realistic motion blur while the shutter was still open, avoiding the staccato effect often evident in stop-motion work.

The battle sequences also featured some matte painting effects,

such as "Endor Forest with Dead Stormtroopers." "George used the matte department as a way to enhance his vision," says Craig Barron, a matte photographer on *Jedi*. "If he couldn't get a shot on location he'd say, 'Oh, don't worry, I'll have [the matte department] paint it in later.' Which we were very happy to do, by the way."

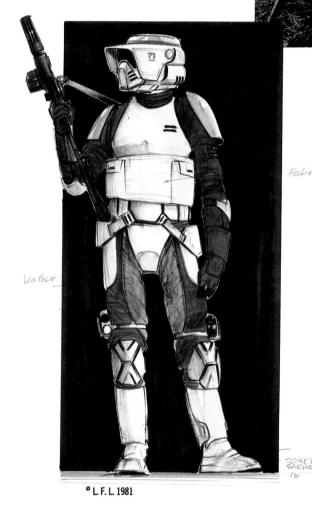

® L.F.L 1981

Imperial Scout Trooper, costume design *IMPERIAL BIKE RIDER*

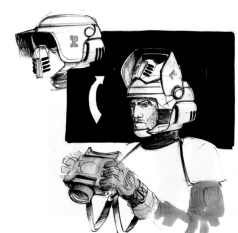

IMPERIAL RIDERS
● L.F.L 1981

Imperial Scout Trooper, costume design

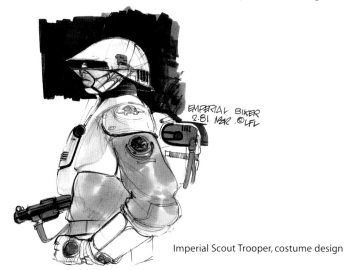

EMPERIAL BIKER
2·81 NBR. ©LFL

Imperial Scout Trooper, costume design

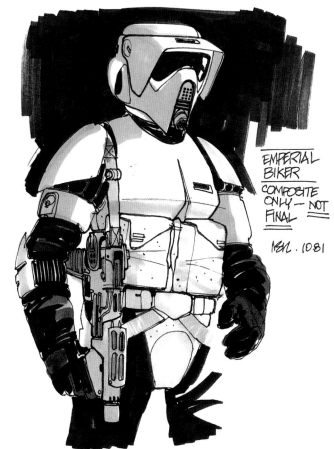

EMPERIAL BIKER
COMPOSITE
ONLY — NOT
FINAL

NBR. 10·81

Imperial Scout Trooper, costume design

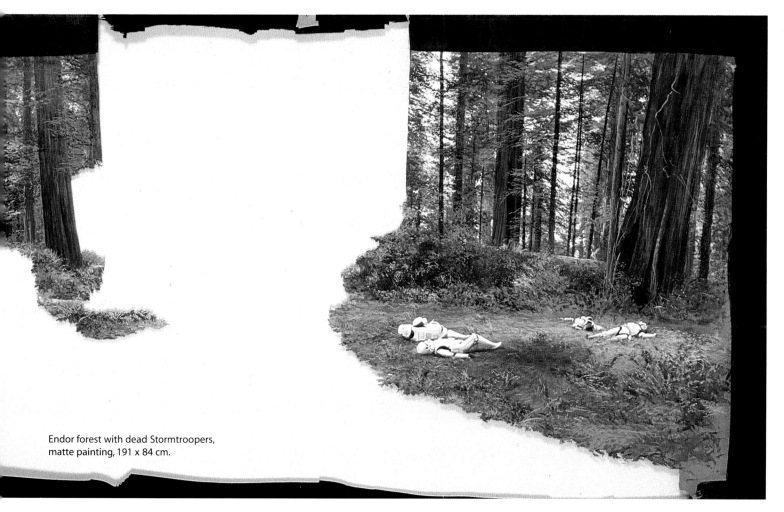

Endor forest with dead Stormtroopers,
matte painting, 191 x 84 cm.

Storyboard BC 9

DESCRIPTION: EXT. FOREST - BIKERS - LUKE & LEIA
First the two BIKERS, then Luke & Leia, bank between two trees that are close to camera & exit frame R. All the bikes are closer now (Luke & Leia have gained on the Bikers).

NOTES: Camera should be close to ground; the closer the bikes get to camera the better.

ELEMENTS:	STAGE	ANIM	PLATE	MATTE	NON-ILM	ELEMENTS:	STAGE	ANIM	PLATE	MATTE	NON-ILM	SHOT # / SEQUENCE
Forest			x									
Biker #1	x											BC 9
Biker #2	x											
Luke/Leia	x											FRM COUNT 51 · PAGE #

Storyboard BC 17

DESCRIPTION: EXT. FOREST - TRUCKING - LOW TO GROUND
Very low, looking up & passing forest. The vanes hit once.

NOTES:

ELEMENTS:	STAGE	ANIM	PLATE	MATTE	NON-ILM	ELEMENTS:	STAGE	ANIM	PLATE	MATTE	NON-ILM	SHOT # / SEQUENCE
Forest			x									
Vanes	x											BC 17
Sparks		x										FRM COUNT 37 · PAGE #

Storyboard BC 24

DESCRIPTION: EXT. FOREST - PAN - LUKE & LEIA
Bikes should be fairly close to camera, but PAN should not be so fast it is a total blur.

NOTES: Have bikes go behind tree if possible?

ELEMENTS:	STAGE	ANIM	PLATE	MATTE	NON-ILM	ELEMENTS:	STAGE	ANIM	PLATE	MATTE	NON-ILM	SHOT # / SEQUENCE
Forest			x									
Luke	x											BC 24
Leia	x											FRM COUNT 49 · PAGE #

Storyboard BC 32

DESCRIPTION: EXT. FOREST - LUKE & LEIA - SIDE VIEW
MS. Luke brakes, leaving frame L. Leia speeds ahead, starting to move out of frame R.

NOTES:

ELEMENTS:	STAGE	ANIM	PLATE	MATTE	NON-ILM	ELEMENTS:	STAGE	ANIM	PLATE	MATTE	NON-ILM	SHOT # / SEQUENCE
Forest			x									
Luke			x									BC 32
Leia			x									FRM COUNT 82 · PAGE #

Imperial Speeder Bike, concept illustration

Imperial Speeder Bike, concept illustration

Imperial Speeder Bike, concept illustration

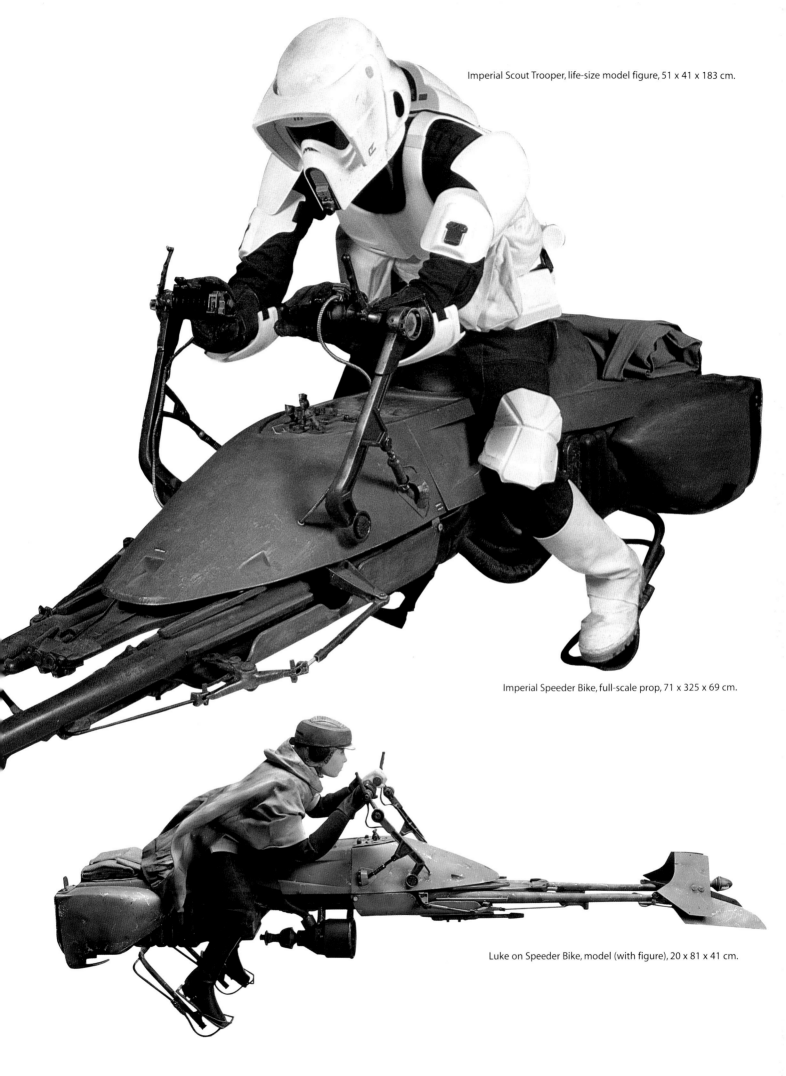

Imperial Scout Trooper, life-size model figure, 51 x 41 x 183 cm.

Imperial Speeder Bike, full-scale prop, 71 x 325 x 69 cm.

Luke on Speeder Bike, model (with figure), 20 x 81 x 41 cm.

The tide turns for the Rebels with the aid of the Ewoks, the furry denizens inhabiting the Endorian woods. Although Phil Tippett wanted to sculpt Neanderthal-like cannibal creatures, Lucas saw them as cute from the start. Joe Johnston (who also designed the speeder bikes) designed the creatures with furry bodies and puppy-dog faces. After the design stage, the Ewoks were made as costumes to be worn by a cast of dwarf actors. Ewok body casts had to be made for each actor, with separate casts for the heads. Attention to detail was such that every single fingernail had to be made separately.

Darth Vader on Endor, production painting

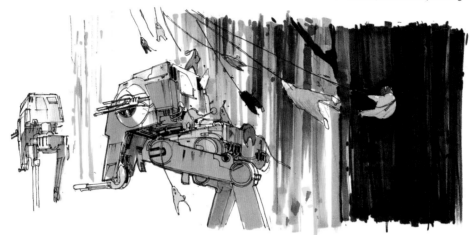

Ewok's attack, production illustration

Imperial Scout Walker (nicknamed "Chicken Walker," AT-ST), scale reference sketch

Imperial Scout Walker, scale reference sketch

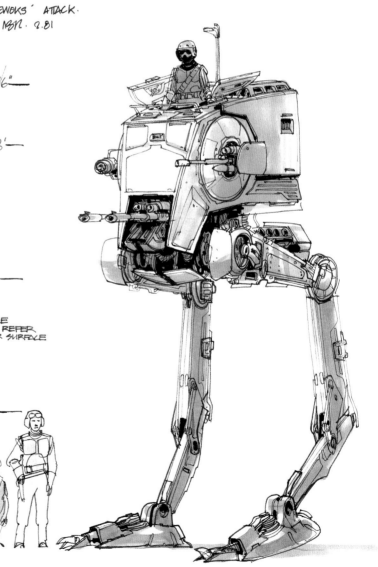

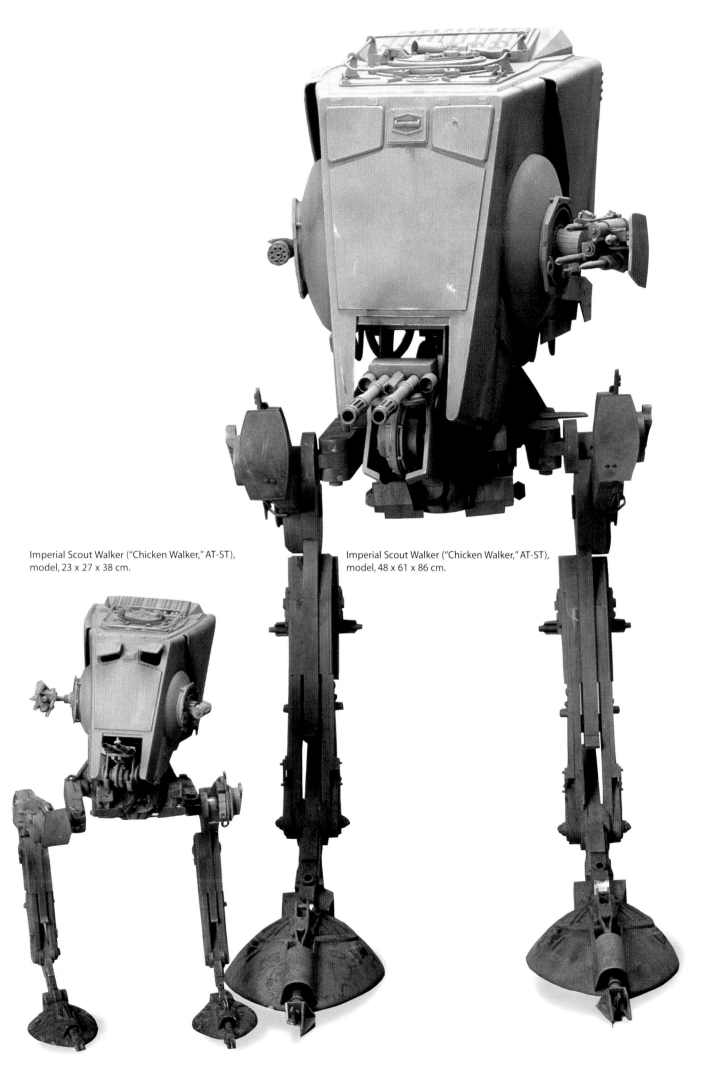

Imperial Scout Walker ("Chicken Walker," AT-ST), model, 23 x 27 x 38 cm.

Imperial Scout Walker ("Chicken Walker," AT-ST), model, 48 x 61 x 86 cm.

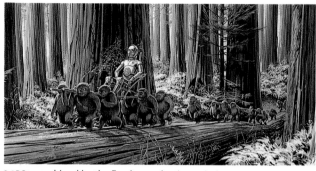

C-3PO: worshiped by the Ewoks, production painting

Ewok, costume suit, 56 x 31 x 91 cm.

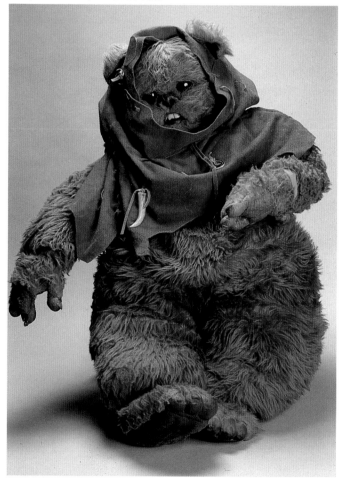

Princess Leia, hairstyle illustration

©L.F.L. 1981

© L. F. L. 1981

Ewok with hang glider, prototype, 45 x 10 x 21 cm.

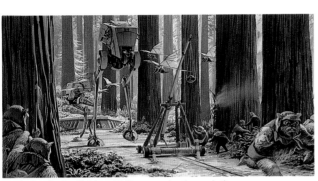

Ewoks battle the Chicken Walkers, production painting

Ewok, production illustration

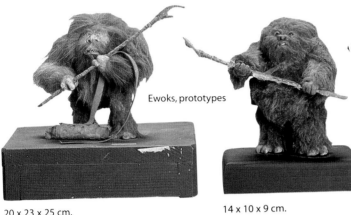

Ewoks, prototypes

20 x 23 x 25 cm.

14 x 10 x 9 cm.

MAY 21 1981

J 140

Ewoks crush an Imperial Scout Walker, production illustration

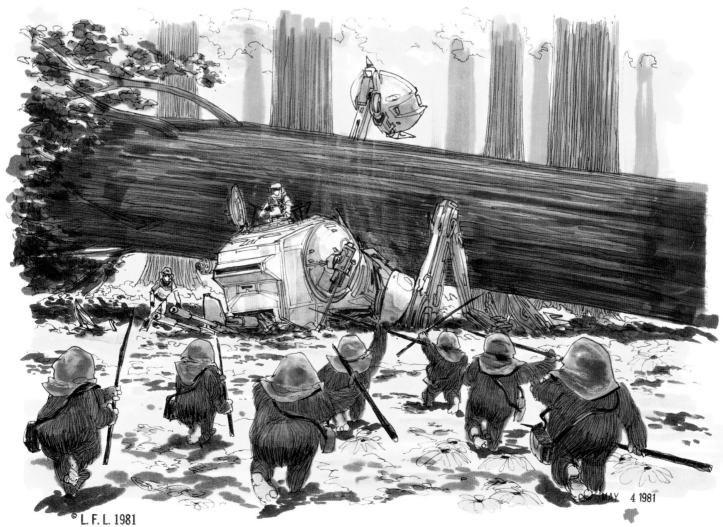

© L. F. L. 1981

MAY 4 1981

J 126

JEDI TRIUMPHANT

By the end of the film the reactor core of the Death Star has been bombed by Rebel forces, setting off the chain reaction that ends in the explosion of the Empire's stronghold. In a climactic showdown, Luke wins Vader back from the dark side of the Force. Freed from his spell, Vader tosses the evil Emperor to his death in the Death Star reactor shaft.

The film was a triumph for ILM, who produced some of the most complex effects shots in movie history. Whereas a *Star Wars* optical shot typically had thirty to forty separate

elements, the most complex *Jedi* shots required between twenty and eighty elements. One space battle shot, among the most complex optical effects ever, used more than three hundred separate elements.

The *Star Wars* trilogy stands as one of the great stories in film history. But the films only represent chapters four through six in a final, nine-part saga. More than a decade later, Lucasfilm has begun gearing up for a return to the *Star Wars* universe and the legendary time of the Jedi Knights.

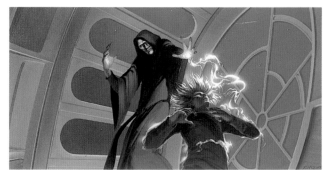

Luke attacked by the Emperor, production painting

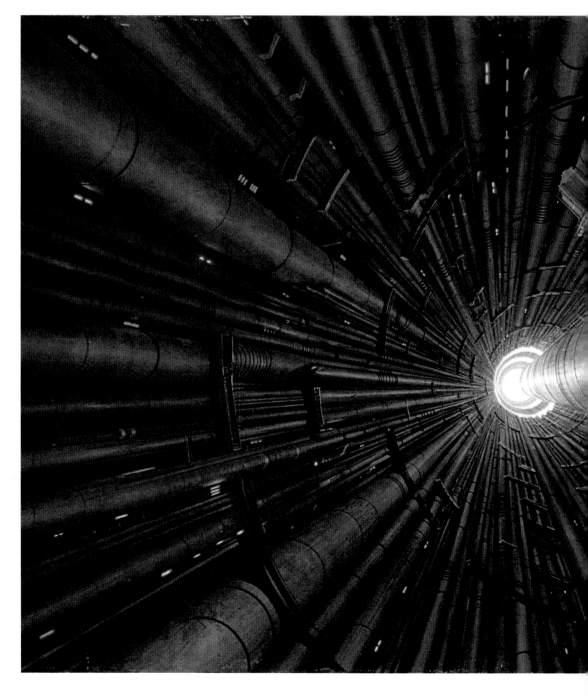

Death Star reactor shaft, matte painting, 191 x 84 cm.

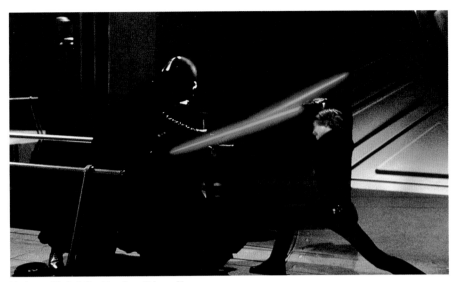
Vader and Luke's final battle, still from film

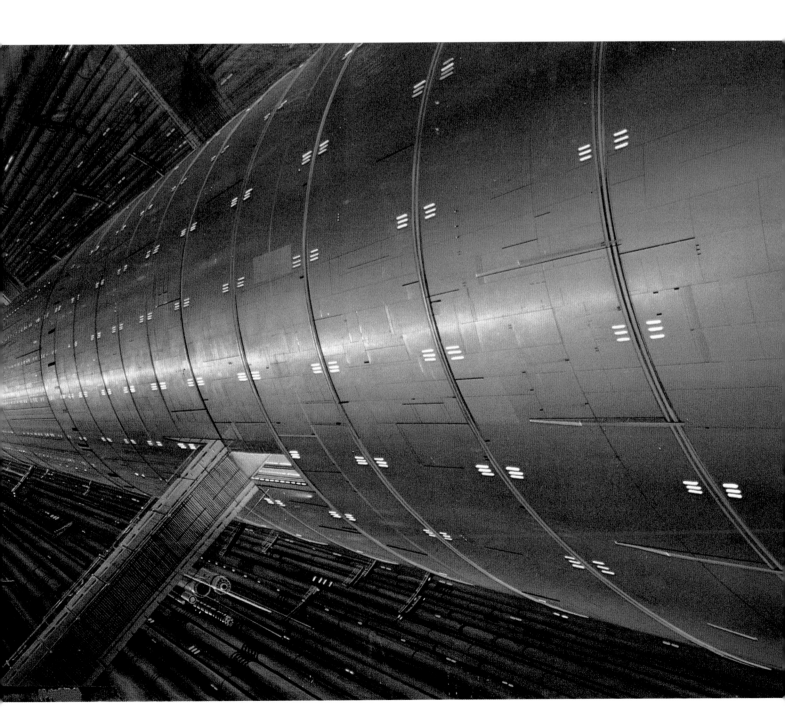

DESCRIPTION: EXT. SPACE - DEATH STAR SURFACE

TRUCKING, skimming Death Star surface. X-Wing and A-Wing enter frame under camera, gain through shot & turn into the tunnel. Camera continues to skim surface without ships & CUTS when it tilts down into tunnel.

NOTES: Use BG surface plate up to last available frame.

ELEMENTS:	STAGE	ANIM	PLATE	MATTE	NON-ILM	ELEMENTS:	STAGE	ANIM	PLATE	MATTE	NON-ILM	SHOT #/SEQUENCE
Death Star Surface	x											126-12
X-Wing	x											
A-Wing	x											
Lasers		x										**RA 15**
Flak		x										
Stars	x											FRM COUNT 99

PAGE #

DESCRIPTION: EXT. SPACE/INT. DEATH STAR - TUNNEL #1 - TRUCKING

TRUCKING along Death Star surface & into Tunnel #1. Falcon enters under camera & turns into Tunnel #1. It gains through shot, moving away from the camera; then the A-Wing, Y-Wing & X-Wing speed around camera & away after Falcon.

NOTES:

REVISED JUL 26 1982 ©L.F.L. 1982

N J

ELEMENTS:	STAGE	ANIM	PLATE	MATTE	NON-ILM	ELEMENTS:	STAGE	ANIM	PLATE	MATTE	NON-ILM	SHOT #/SEQUENCE
Surface/Tunnel #1	x					Stars		x				126-15
Falcon	x					Lasers			x			
A-Wing	x					Flak			x			**RA 17**
X-Wing	x											

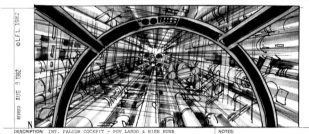

DESCRIPTION: INT. FALCON COCKPIT - POV LANDO & NIEN NUNB

Tunnel #1. X-Wing & A-Wing are not as far ahead any longer. They do some crisscrossing moves as they maneuver their ways through the tunnel.

NOTES:

REVISED AUG 9 1982 ©L.F.L. 1982 N

ELEMENTS:	STAGE	ANIM	PLATE	MATTE	NON-ILM	ELEMENTS:	STAGE	ANIM	PLATE	MATTE	NON-ILM	SHOT #/SEQUENCE
Falcon Cockpit			x									
Tunnel #1	x											
X-Wing	x											**RA 19**
A-Wing	x											

DESCRIPTION: EXT. SPACE - DEATH STAR - TIES - TRUCKING

TRUCKING BACK. Three TIEs and three Interceptors are skimming the Death Star surface toward camera. They dive into the same tunnel the Rebel fighters have just entered. TIEs are gaining through shot.

NOTES:

REVISED APR 13 1982 ©L.F.L. 1982 J

2

ELEMENTS:	STAGE	ANIM	PLATE	MATTE	NON-ILM	ELEMENTS:	STAGE	ANIM	PLATE	MATTE	NON-ILM	SHOT #/SEQUENCE
Surface/Tunnel #1	x					Interceptor #2		x				126-17
TIE #1	x					Interceptor #3		x				

RA 30

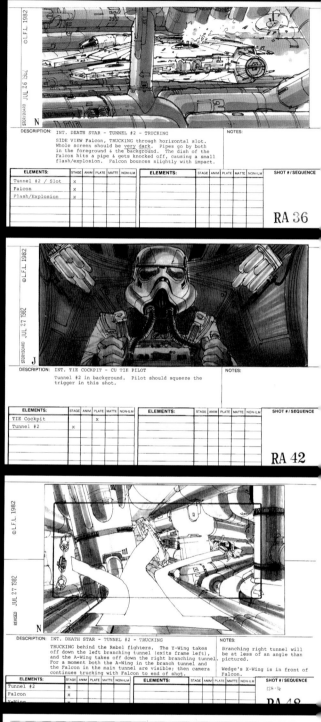

DESCRIPTION: INT. DEATH STAR - TUNNEL #2 - TRUCKING

SIDE VIEW Falcon, TRUCKING through horizontal slot. Whole screen should be very dark. Pipes go by both in the foreground & the background. The dish of the Falcon hits a pipe & gets knocked off, causing a small flash/explosion. Falcon bounces slightly with impact.

STORYBOARD JUL 26 1982 ©L.F.L. 1982 N

NOTES:

ELEMENTS:	STAGE	ANIM	PLATE	MATTE	NON-ILM	ELEMENTS:	STAGE	ANIM	PLATE	MATTE	NON-ILM	SHOT #/SEQUENCE
Tunnel #2 / Slot	x											
Falcon	x											
Flash/Explosion	x											**RA 36**

DESCRIPTION: INT. TIE COCKPIT - CU TIE PILOT

Tunnel #2 in background. Pilot should squeeze the trigger in this shot.

STORYBOARD JUL 27 1982 ©L.F.L. 1982 J

NOTES:

ELEMENTS:	STAGE	ANIM	PLATE	MATTE	NON-ILM	ELEMENTS:	STAGE	ANIM	PLATE	MATTE	NON-ILM	SHOT #/SEQUENCE
TIE Cockpit			x									
Tunnel #2	x											**RA 42**

DESCRIPTION: INT. DEATH STAR - TUNNEL #2 - TRUCKING

TRUCKING behind the Rebel fighters. The Y-Wing takes off down the left branching tunnel (exits frame left), and the A-Wing takes off down the right branching tunnel. For a moment both the A-Wing in the branch tunnel and the Falcon in the main tunnel are visible; then camera continues trucking with Falcon to end of shot.

REVISED JUL 27 1982 ©L.F.L. 1982 N

NOTES: Branching right tunnel will be at less of an angle than pictured.

Wedge's X-Wing is in front of Falcon.

ELEMENTS:	STAGE	ANIM	PLATE	MATTE	NON-ILM	ELEMENTS:	STAGE	ANIM	PLATE	MATTE	NON-ILM	SHOT #/SEQUENCE
Tunnel #2	x											128-76
Falcon	x											
Y-Wing												**RA 48**

DESCRIPTION: INT. DEATH STAR - TUNNEL #2 - TRUCKING SLOWLY

REVERSE of RA 48. 2 TIEs and 2 Interceptors are coming toward camera, gaining through shot. The 2 front TIEs turn off after the two Rebel fighters; the 2 Interceptors continue after the Falcon & the X-Wing, roaring over camera.

REVISED JUL 27 1982 ©L.F.L. 1982 N

NOTES:

ELEMENTS:	STAGE	ANIM	PLATE	MATTE	NON-ILM	ELEMENTS:	STAGE	ANIM	PLATE	MATTE	NON-ILM	SHOT #/SEQUENCE
Tunnel #2	x											128-17
TIE #1	x											
TIE #2	x											**RA 49**

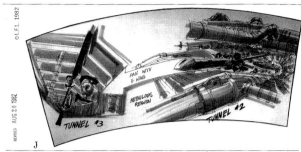

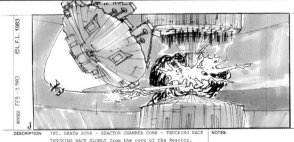

REVISED AUG 20 1982

PAN WITH X-WING

NEBULOUS REGION

TUNNEL #3

TUNNEL #2

J

DESCRIPTION: PAN - INT. DEATH STAR - TUNNEL #2 to #3

PAN, side view, as X-Wing & Falcon dive a 90° turn down into Tunnel #3. PAN with X-Wing, then HOLD as Falcon & 2 Interceptors ROAR over camera & down Tunnel #3.

NOTES: NO DISH ON FALCON!

ELEMENTS:	STAGE	ANIM	PLATE	MATTE	NON-ILM	ELEMENTS:	STAGE	ANIM	PLATE	MATTE	NON-ILM	SHOT # / SEQUENCE
Tunnel #2/#3		x										128-18
Falcon		x										**RA 50**
X-Wing		x										

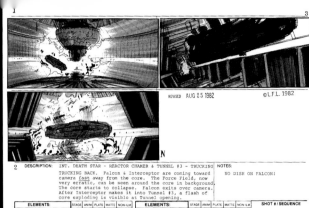

1 3

REVISED AUG 25 1982

N

2 **DESCRIPTION:** INT. DEATH STAR - REACTOR CHAMER & TUNNEL #3 - TRUCKING

TRUCKING BACK. Falcon & Interceptor are coming toward camera fast away from the core. The Force Field, now very erratic, can be seen around the core in background. The core starts to collapse. Falcon exits over camera. After Interceptor makes it into Tunnel #3, a flash of core exploding is visible at Tunnel opening.

NOTES: NO DISH ON FALCON!

ELEMENTS:	STAGE	ANIM	PLATE	MATTE	NON-ILM	ELEMENTS:	STAGE	ANIM	PLATE	MATTE	NON-ILM	SHOT # / SEQUENCE
Reactor Chamber					x	Explosion - TBD						129-19
Tunnel #3		x										**RA 90**
Falcon		x										

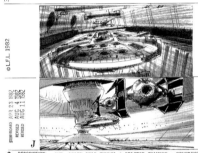

(1)

STORYBOARD APR 23 1982
REVISED AUG 4 1982
REVISED AUG 11 1982

J

2 **DESCRIPTION:** INT. DEATH STAR TUNNEL & REACTOR CHAMBER - TRUCKING

TRUCKING through third Death Star tunnel. Start with Falcon close to camera; ships gain thru shot. Ships and camera pass through small opening into extremely large Reactor Chamber. Ends as 2 Interceptors enter over camera, following Falcon & X-Wing (still trucking).

NOTES: Scale of Reactor Chamber is important. Although ships are gaining thru shot, they are not noticeably closer to core. A force field surrounds core.

ELEMENTS:	STAGE	ANIM	PLATE	MATTE	NON-ILM	ELEMENTS:	STAGE	ANIM	PLATE	MATTE	NON-ILM	SHOT # / SEQUENCE
Tunnel #3		x				Lasers				x		123-9
X-Wing		x				Flak				x		**RA 81**
Falcon		x				Reactor Chamber					x	

REVISED AUG 4 1982

N

DESCRIPTION: INT. FALCON COCKPIT - POV LANDO & NIEN NUNB

Entrance of Tunnel #1 is VERY SMALL, far away... Speeding out as fast as possible. Small explosions are coming in somewhat from sides of tunnel at very end of shot.

NOTES:

ELEMENTS:	STAGE	ANIM	PLATE	MATTE	NON-ILM	ELEMENTS:	STAGE	ANIM	PLATE	MATTE	NON-ILM	SHOT # / SEQUENCE
Tunnel #1		x										
Falcon Cockpit			x									130-5
Stars		x										
Explosion - TBD												**RA 99**

STORYBOARD AUG 4 1982
REVISED AUG 11 1982

N

DESCRIPTION: INT. DEATH STAR - REACTOR CHAMBER - TRUCKING

TRUCKING BACK with Falcon coming to camera in the enormous Reactor Chamber. The Interceptors are still chasing the Falcon & firing. At end of shot, the Falcon shoots laser out frame left.

NOTES:

ELEMENTS:	STAGE	ANIM	PLATE	MATTE	NON-ILM	ELEMENTS:	STAGE	ANIM	PLATE	MATTE	NON-ILM	SHOT # / SEQUENCE
Reactor Chamber					x							
Falcon	x											
Interceptor #1	x											
Interceptor #2	x											
Lasers		x										
Flak		x										**RA 87**

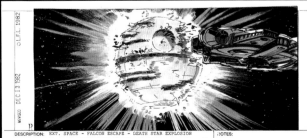

STORYBOARD AUG 4 1982

N

DESCRIPTION: EXT. SPACE - FALCON

The Falcon speeds away over camera toward Endor. No other Fleet ships are visible.

NOTES:

ELEMENTS:	STAGE	ANIM	PLATE	MATTE	NON-ILM	ELEMENTS:	STAGE	ANIM	PLATE	MATTE	NON-ILM	SHOT # / SEQUENCE
Falcon	x											
Endor - pntg.	x											
Stars	x											**RA 101**

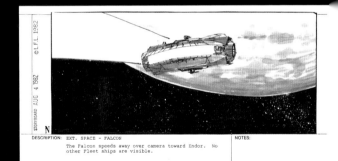

REVISED FEB 8 1983

J

DESCRIPTION: INT. DEATH STAR - REACTOR CHAMBER CORE - TRUCKING BACK

TRUCKING BACK SLOWLY from the core of the Reactor. The Falcon comes around the core & toward camera, still following over camera. The two Interceptors are still following, but the second Interceptor is caught by a tongue of the now-erratic Force Field, and it blows up. The core erupts in an explosion.

NOTES:

ELEMENTS:	STAGE	ANIM	PLATE	MATTE	NON-ILM	ELEMENTS:	STAGE	ANIM	PLATE	MATTE	NON-ILM	SHOT # / SEQUENCE
Reactor Chamber	x											
Falcon	x											
Interceptor #1	x											
Interceptor #2	x											128-18
Force Field: arc	x											
Force Field: cone	x											**RA 89**

REVISED DEC 13 1982

D

DESCRIPTION: EXT. SPACE - FALCON ESCAPE - DEATH STAR EXPLOSION

Camera is MOVING BACK SLOWLY. The Falcon comes toward camera. The Death Star hangs in space for a beat as explosions ripple across its surface. The Falcon exits over camera as the explosions overtake the Death Star & it erupts in one giant explosion.

NOTES:

ELEMENTS:	STAGE	ANIM	PLATE	MATTE	NON-ILM	ELEMENTS:	STAGE	ANIM	PLATE	MATTE	NON-ILM	SHOT # / SEQUENCE
Death Star	x											
Explosion - Stock												
Falcon	x											
Stars	x											**RA 102**

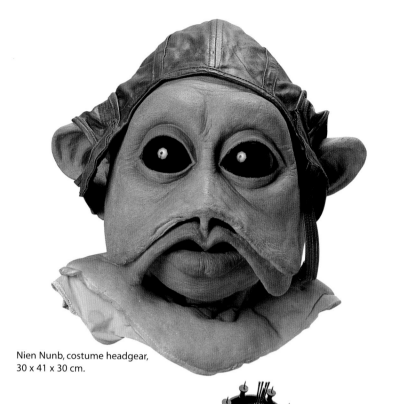

Nien Nunb, costume headgear,
30 x 41 x 30 cm.

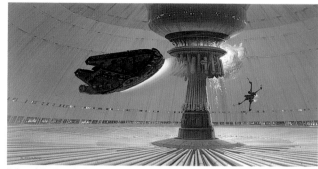

Falcon hits Death Star reactor core, production painting

Endor radar dish, prototype,
25 x 37 x 43 cm.

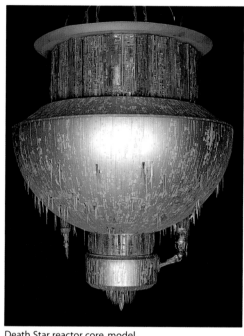

Death Star reactor core, model,
89 x 89 x 109 cm.

Damaged sphere, Imperial Star Destroyer,
model, 20 x 20 x 15 cm.

Death Star surface exhaust port,
model (detail), 122 x 122 x 28 cm.

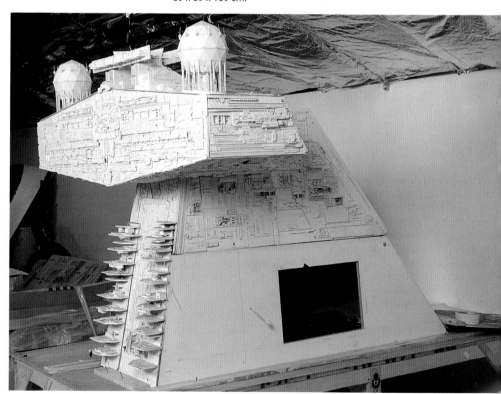

Imperial Star Destroyer bridge, model (detail), 152 x 173 x 135 cm.

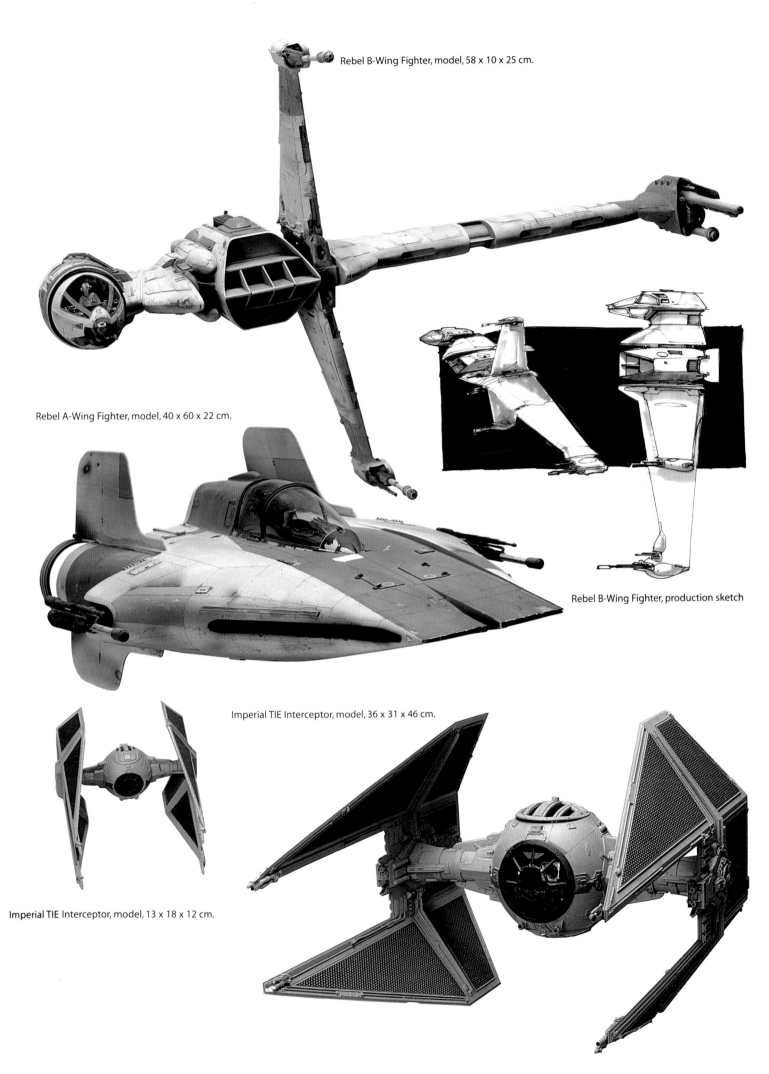

Rebel B-Wing Fighter, model, 58 x 10 x 25 cm.

Rebel A-Wing Fighter, model, 40 x 60 x 22 cm.

Rebel B-Wing Fighter, production sketch

Imperial TIE Interceptor, model, 36 x 31 x 46 cm.

Imperial TIE Interceptor, model, 13 x 18 x 12 cm.

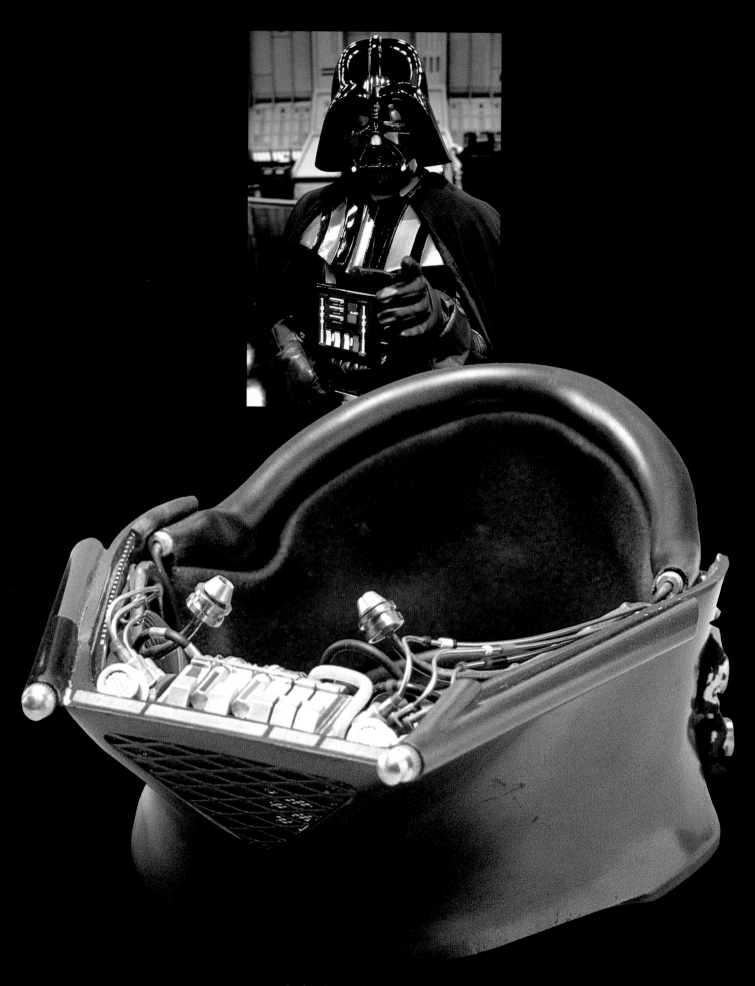

Darth Vader mask for Anakin Skywalker's reveal,
costume headgear, 23 x 33 x 12 cm.

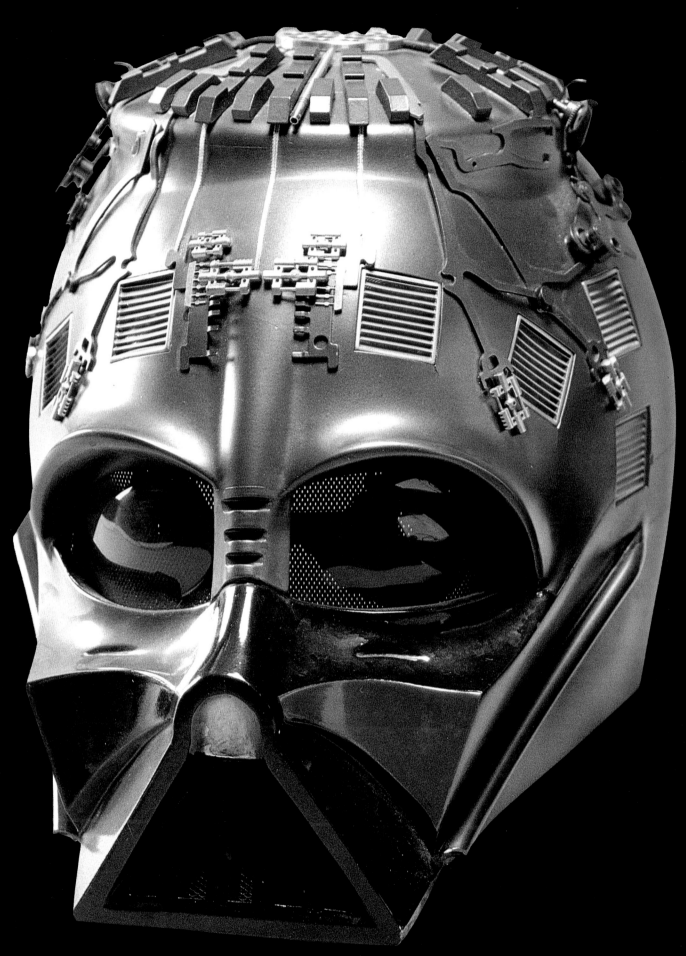

Darth Vader mask for Anakin Skywalker's reveal,
costume headgear, 23 x 33 x 18 cm.

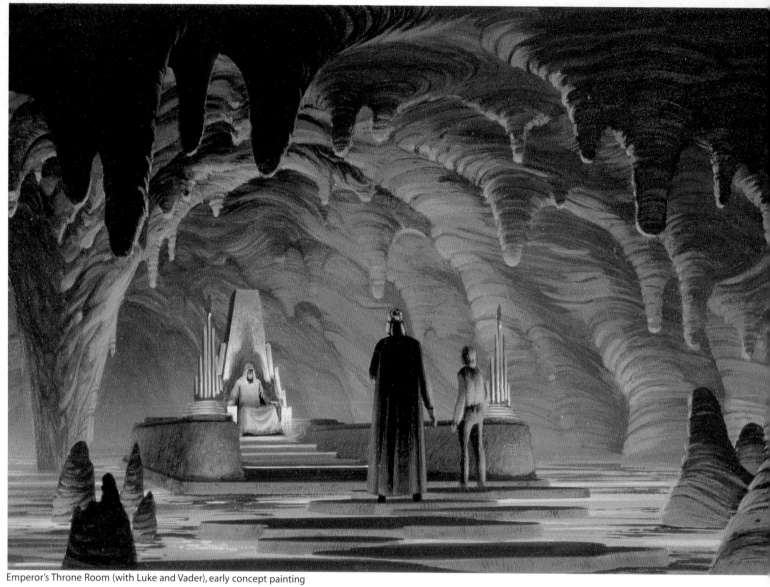

Emperor's Throne Room (with Luke and Vader), early concept painting

George Lucas in the final Emperor's Throne Room set

II

FORTUNE AND GLORY

RAIDERS OF THE LOST ARK
(Lucasfilm/Paramount) 1981

THE GOLDEN IDOL

The creation of Indiana Jones is now the stuff of movie legend: Lucas and Spielberg relaxing on a Hawaiian beach (even as *Star Wars* box office receipts are going through the roof on the mainland), Spielberg revealing his desire to direct a James Bond picture and Lucas going him one better, telling him about a character he has created, an adventuring archaeologist whose thirst for fortune and glory would lead him on a search for the legendary Ark of the Covenant (the symbol of God's contract with the Israelites into which Moses placed the tablets of the Ten Commandments). Spielberg, intrigued by the concept, expresses his interest in directing the movie and the two friends make a handshake deal.

Indiana Jones (whose name was inspired by Lucas's dog Indiana) was fleshed out in every detail by Lucas, Spielberg, and screenwriter Lawrence Kasdan. In spirit the character embodies the two-fisted, swashbuckling panache of the classic pulp magazine and matinee serial heroes. Indiana would lead two lives, from the soft-spoken professor of archaeology at a small New England college who dressed in tweed to the globe-trotting seeker of relics outfitted for action in a fedora hat, leather jacket, a cracking whip in hand, and a gun and holster on his hip. (During the character's gestation period many concepts were considered. Lucas was even interested in giving Indy the high-life of a Manhattan playboy, an aspect of his character never fully explored in the films.) Indy came to life with the casting of Harrison Ford, an actor Spielberg praised as a combination of Errol Flynn (in *The Adventures of Don Juan*) and Humphrey Bogart (a villainous turn in *The Treasure of Sierra Madre*).

Raiders of the Lost Ark would, like Lucasfilm's *Star Wars* films, require first-unit filming at far-flung locales, soundstage work at EMI Elstree Studios in England, and the visual effects wizardry of Industrial Light & Magic. With story and characters set in the mid-1930s the production also had to recreate the period look. Although the production values and character development were light years beyond

STATUE SEEMS TO BE WATCHING AS WELL...

PUSH IN...

HOLD SHOT FOR ALL OF INDY'S TRANSFER...
PAUSE — SUDDENLY THE PEDESTAL DROPS 5"!

Indy approaches the Golden Idol of Fertility, storyboard sequence

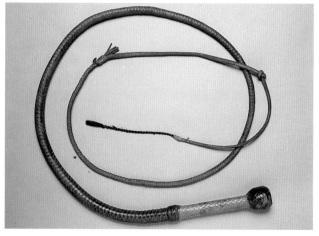

Indy's whip, prop, 244 x 3 x 3 cm.

Raiders of the Lost Ark, 10th anniversary poster, 69 x 104 cm.

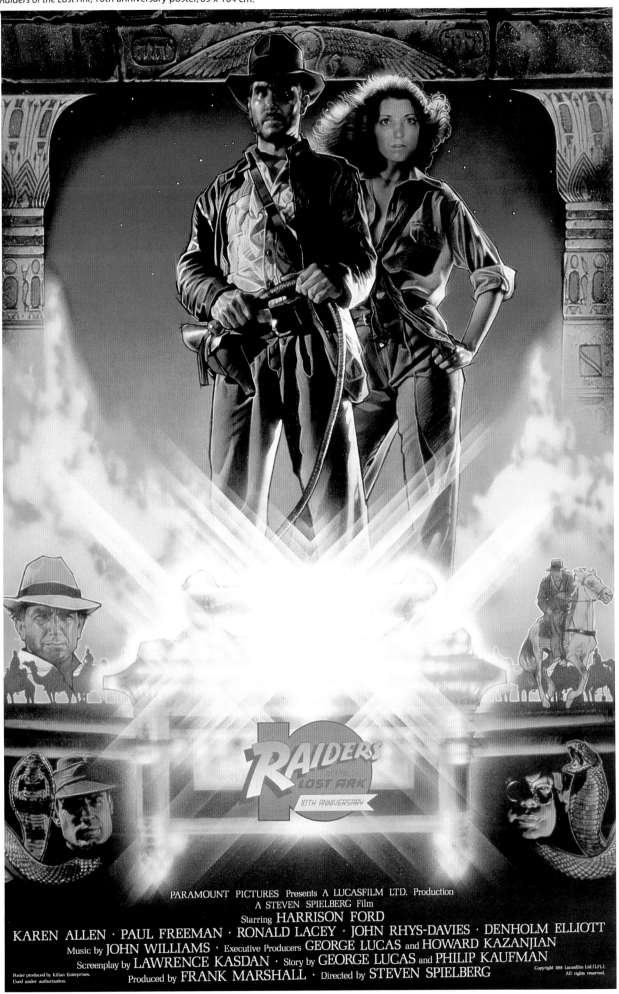

the slam-bang staging of the old serials, *Raiders* would retain their tradition of cliff-hanging thrills.

In the opening sequence alone, Indiana, making his way through a South American jungle (shot on location on the Hawaiian island of Kauai), would brave the betrayal of his guides, the poison-tipped spears of native warriors, and the deadly booby traps of an ancient temple to pluck his prize: the Golden Idol of Fertility.

The idol prop itself, built by the production art department in England, was inspired by Inca and pre-Columbian art. The female figure was designed with a horrific countenance to heighten the suspense as Indy cautiously approaches the golden relic. When Spielberg sketched an image of the idol he scribbled the note: "statue seems to be watching, cursing his every step."

Literally every step Indy would take was carefully plotted. To outwit the ancient keepers of the idol, who have left behind traps ready to be sprung should the idol be removed from its pedestal, Indiana tries to transfer a weighted sack of sand for his golden prize. Despite his precautions the traps are triggered, including a crushing boulder rolling down a chute after our hero, which ranks as one of the most famous thrills of any movie. The camera composition and cuts, all planned and storyboarded in advance—from the "big face close up" as our hero realizes his peril to the wide shot of the juggernauting boulder and Indy running for his life—bring the death-defying situation to the audience with full dramatic impact.

In the path of danger, storyboard sequence and still from film

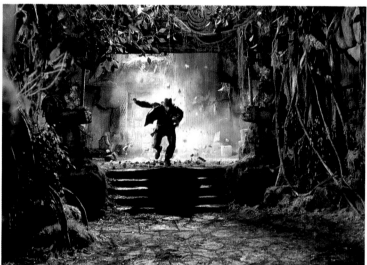

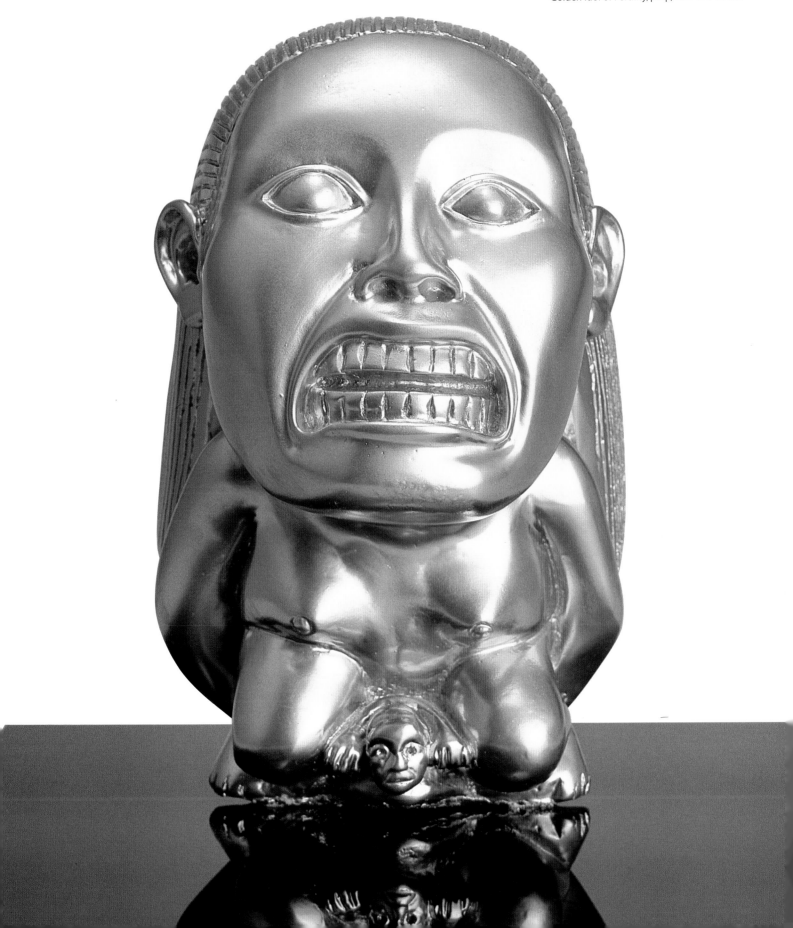

Golden Idol of Fertility, prop, 15 x 15 x 20 cm.

PAN AM CLIPPER

The logistics and economics of moviemaking often require effects artists to fabricate scenes of seemingly ordinary reality. One such fabrication of reality in *Raiders* is a loading dock and an amphibious clipper plane that Indy boards for the first leg of his journey to find the Ark.

Though the production team had tracked down an operating clipper ship of the period five thousand miles from Lucasfilm's Northern California headquarters, only a few miles away, in a Bay Area boatyard, sat the hulk of a 1930s clipper plane undergoing restoration. Since it was a quick shot (ultimately eight seconds on screen), the production team opted for creating the scene in their own backyard with the broken-down ship, even though the craft was so unseaworthy it would sink if placed in water.

The shot was achieved by combining a glass matte painting of the loading dock, complete with sky, period cabs, cargo-loading cranes, and the airline name added in period type style, with separately filmed elements of water and the actors boarding the dry-docked seaplane. The live elements of water and actors boarding were then rear projected onto the glass painting, allowing the combined elements to be photographed as one image.

The airborne craft as it wings its way toward the setting sun and the Golden Gate Bridge was realized as a model composited with a background plate. Succeeding shots of Indy's journey to Nepal were planned and storyboarded to evoke the montage-shot tradition of classic movies.

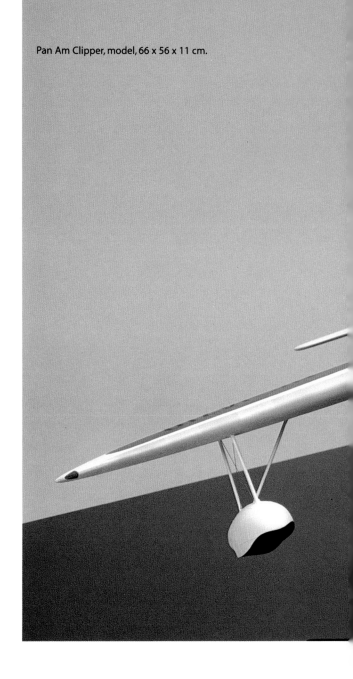

Pan Am Clipper, model, 66 x 56 x 11 cm.

Pan Am Clipper boarding dock, matte painting, 191 x 84 cm.

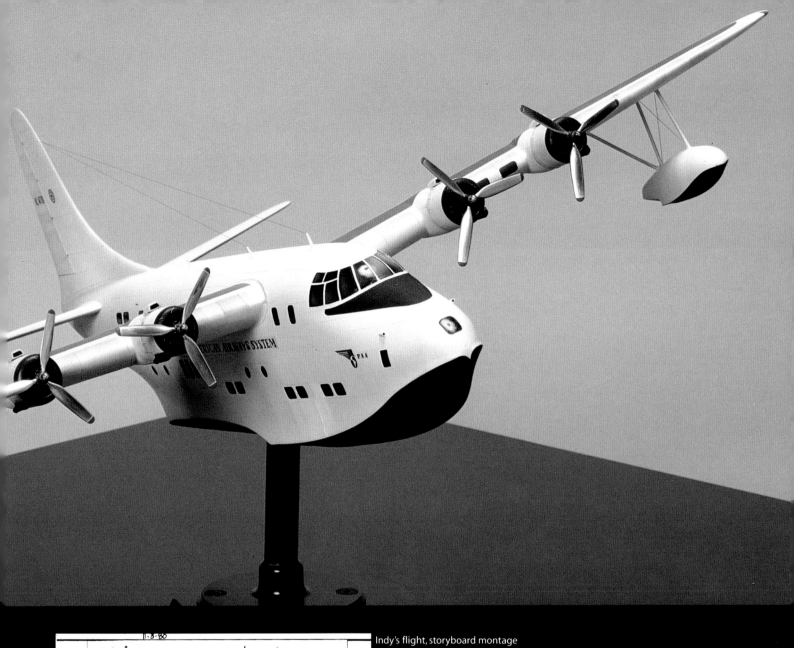

Indy's flight, storyboard montage

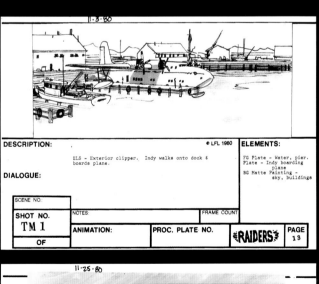

DESCRIPTION:

ELS - Exterior clipper. Indy walks onto dock & boards plane.

© LFL 1980

ELEMENTS:

FG Plate - Water, pier.
Plate - Indy boarding plane
BG Matte Painting - sky, buildings

DIALOGUE:

SCENE NO.			
SHOT NO. TM 1	NOTES:	FRAME COUNT	**RAIDERS** PAGE 13
OF	ANIMATION:	PROC. PLATE NO.	

DESCRIPTION:

Superimposed over a stock shot of a DC-3 flying over the Himalayas is a map of its route: Nepal to Cairo.

© LFL 1980

ELEMENTS:

Stock footage
Map w/moving line

DIALOGUE:

DESCRIPTION:

MLS China Clipper travelling west. Superimposed is a map of the continuing voyage.

© LFL 1980

ELEMENTS:

Plate - Helicopter
Seaplane
Map w/moving line

DIALOGUE:

DESCRIPTION:

ESTABLISHING SHOT - Cairo. Superimposed over this shot of Cairo is the map from the previous shot. This map fades during this shot.

© LFL 1980

ELEMENTS:

Cairo - Matte Painting
Map w/moving line

DIALOGUE:

RAIDER RELICS

One of the key props created by the *Raiders* art department in England was the headpiece of the staff of Ra, a relic that, as the story goes, will lead searchers to the long-lost Ark of the Covenant.

In ancient Egyptian cosmology Ra was the Sun God, a deity identified with dawn and rebirth. But other than the allusions to Ra, the art department took poetic license in their design of a purely fictional example of Egyptian antiquity.

To obtain the medallion Jones journeys to Nepal, where the relic is in the possession of Marion Ravenwood (played by actress Karen Allen), a headstrong woman, former flame of Indy (and daughter of one of

Staff of Ra, prop, 1.5 x 1.5 x 216 cm.

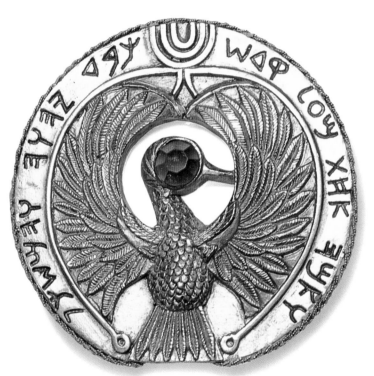

Headpiece of the Staff of Ra, prop, 9 x 1 x 11 cm.

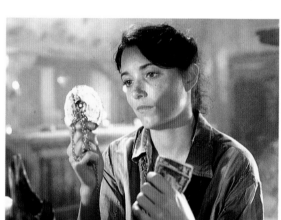

Marion Ravenwood contemplates the Ra headpiece, still from film

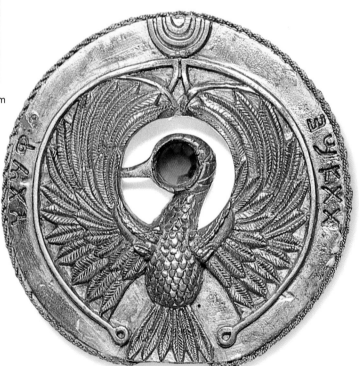

Indy's professors). But Nazi agents are also on the trail of the headpiece, following the order of Adolf Hitler, who is convinced that possession of the Ark will clinch his plan for world dominance.

With Indy and Marion teamed up, the action shifts to Cairo, Egypt, with the Nazis in hot pursuit. A stroll through the marketplace becomes a battle as Indy is attacked by the henchmen of his Nazi foes. (As with most movie weapons, the swords brandished by Indy's attackers were created as life-size props.) The fight scene boasts one of the great ad-libs to make it to the screen: instead of engaging in the long attack pitting Indy's whip against swords as scripted, actor Harrison Ford, suffering from fatigue and intestinal illness, simply pulled the gun from his holster and fired away.

In the climax of the sequence, Marion, who's hidden herself in a basket, is being carried off with Indy giving chase. The scenes, as storyboarded, provide instructions for the camera work, from close-ups to crane downs and pans.

Indy battle in the marketplace, still from film

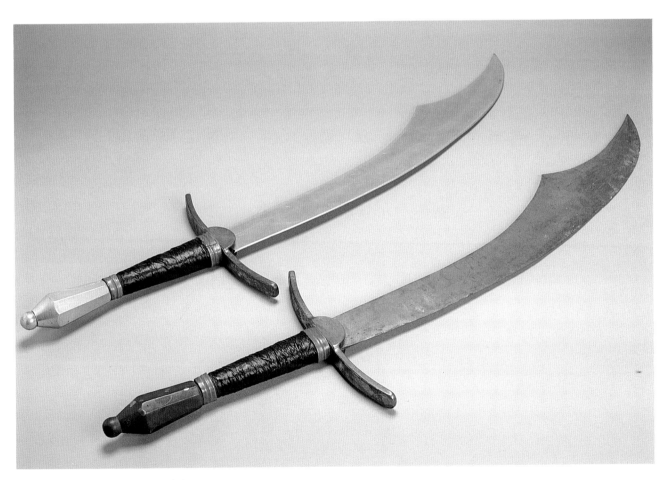

Swords, props, left: 29 x 4 x 109 cm.; right: 30 x 4 x 109 cm.

MONKEY JUMPS INTO VASE TO DEMONSTRATE

53

THEN LEAPS OUT AND LEADS THEM BACK DOWN THE
ALLEY.

54

GERMAN AGENT: SHOUTS IN ARABIC AND POINTS

BACK WHERE THEY CAME!

ALL HEAD BACK ...

55

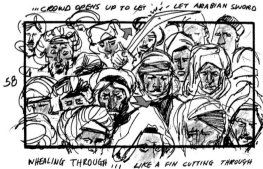

56

A CIRCLE OF HUMANITY CLOSES ON INDY — WE DON'T
KNOW WHETHER THEY ARE HOSTILE OR CURIOUS —

"... THEY CLOSE AROUND HIM ... INDY SEES AHEAD —

57

"... CROWD OPENS UP TO LET ..." LET ARABIAN SWORD

58

WHEALING THROUGH ... LIKE A FIN CUTTING THROUGH
THE WATER ARABIAN SWORD APPROACHES ABOVE A SEA
OF HEADS —

59

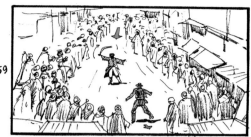

INDY QUICKLY BACKPEDALS FROM SWORD WEILDER —
CROWD STARTS TO ROOT AND CHEER LIKE ITS "ROCKY"

60

BUTCHER CASUALLY BRUSHES THE NEATLY CUT PIECES
INTO RECEPTICLE AND REPLACES THE EMPTY CUTTING
BOARD WITH NEW BONES.

INDY DUCKS R- CUT —DUCKS AGAIN- L- CUT

61

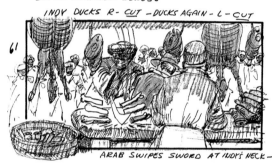

ARAB SWIPES SWORD AT INDY'S NECK—

62

CUTS HANGING MEAT!

BUTCHER REMAINS TOTALLY BLASE
AS IF THIS HAPPENS EVERYDAY —

63

INDY HITS HIM!

O.S. "HELP INDY!"

64

INDY LOOKS UP AND SEES

RLAC 00883

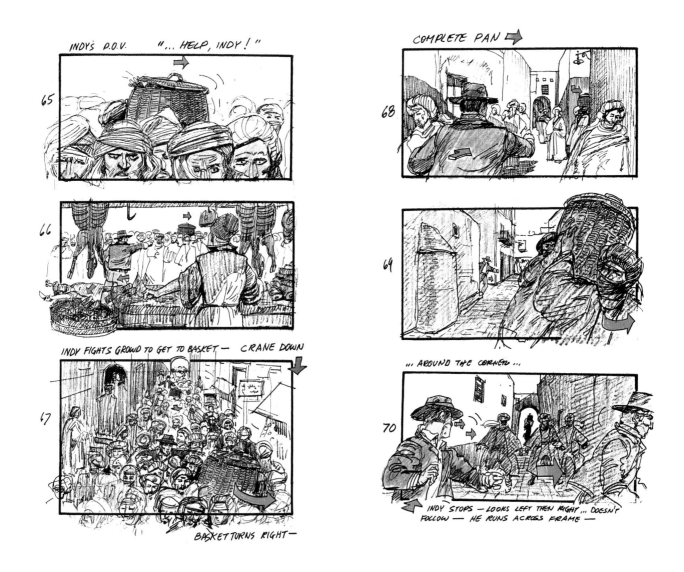

INDY'S P.O.V. "... HELP, INDY!"

65

COMPLETE PAN

68

66

69

INDY FIGHTS CROWD TO GET TO BASKET — CRANE DOWN

67

BASKET TURNS RIGHT —

... AROUND THE CORNER ...

70

INDY STOPS — LOOKS LEFT THEN RIGHT ... DOESN'T
FOLLOW — HE RUNS ACROSS FRAME —

Marketplace chase, storyboard sequence (with Marion in basket)

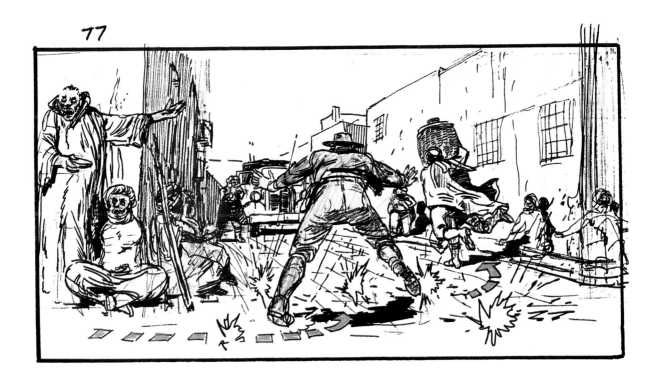

77

THE WELL OF SOULS

Dressed in Arab garb, Indy infiltrates a desert dig site outside Cairo where the Nazis are searching for the Ark. Our hero discovers the Map Room, a chamber hidden beneath the ancient sands that holds a miniature model of the city which once flourished on the site. With the headpiece of Ra raised up on a staff, a beam of sunlight passing through the medallion illuminates the spot of the Well of Souls, the long-lost resting place of the Ark.

Storyboard artist Dave Negron captures Indiana's wide-eyed look of wonder as the Well of Souls site is revealed, but Indiana is all business as he is lowered down into the Well of Souls to snatch his prize. The set for the Well of Souls, constructed by production designer Norman Reynold's crew at Elstree Studios, was considered by many the most impressive set in the film. Egyptian jackal god statues tower thirty-seven feet in the air while the sandy floor below is filled with thousands of cobras, pythons, and boa constrictors.

The set also has one of those production in-jokes which decorate many a Lucasfilm production: on a wall behind the revealed Ark, hidden among the hieroglyphics, are depictions of those lovable droids, R2-D2 and C-3PO.

Indy lowers himself into the Well of Souls, still from film

Indiana uses Staff of Ra in the Map Room, storyboard sequence

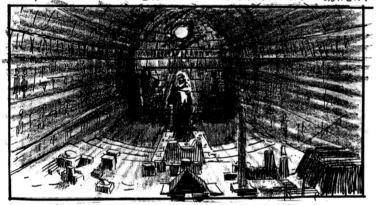

4 – CAMERA PULLS BACK TO REVEAL MORE...MORE... UNTIL...

INDY TAKES MEDALLION AND STAFF FROM HIS

BEAM OF SUNLIGHT HITS THE TOP OF THE MEDALLION IT SHINES!!

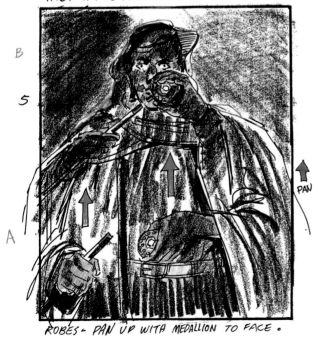

B
5
A

ROBES - PAN UP WITH MEDALLION TO FACE.

SUNLIGHT TRAVELING OVER CITY!!

PASSES OVER THE RED CIRCLED BUILDING WHERE BELLOQ IS DIGGING—

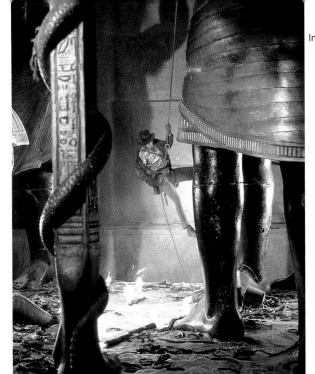

Indy lowers himself into the Well of Souls, still from film

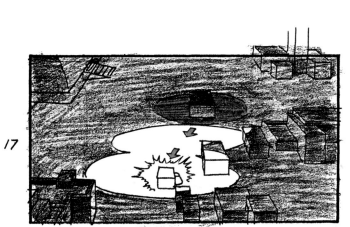

17

A BUILDING HIT BY COLORED QUARTZ SEEMS TO GLOW!

18

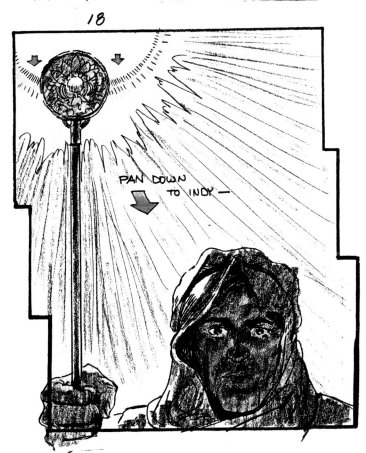

PAN DOWN
TO INDY —

19

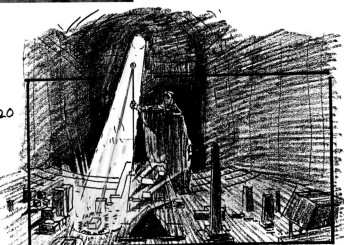

20

21

Indiana uses Staff of Ra in the Map Room, storyboard sequence

THE FLYING WING

At an airport near the dig site sits a Flying Wing, which will transport the Ark to Hitler. The dream of an all-wing airplane (which could theoretically reduce drag and make a craft more aerodynamic) is as old as aviation. For *Raiders*, artist Ron Cobb designed a prototype Flying Wing that, with its end wing flaps tilted downward, was closer to the look of a U.S. prototype developed in the 1940s.

The final, life-size Wing was built by the Vickers Aircraft Company in England and painted at EMI Elstree Studios. Once completed the craft had to be disassembled and shipped to the location site in Tunisia, where it was rebuilt on location.

In the shadow of the Flying Wing, Indy battles a burly Nazi while Marion subdues the pilot. During the carefully staged fight sequence, there was a moment when Harrison Ford tumbled to the ground and was in the path of the moving wheel of the airplane, which alert crew members stopped in time. Spielberg is said to have called an unscheduled coffee break to allow nerves to settle after the real-life escape.

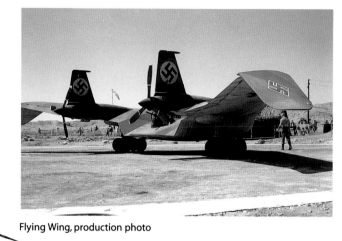

Flying Wing, production photo

German officer, character sketch

Flying Wing, production sketch

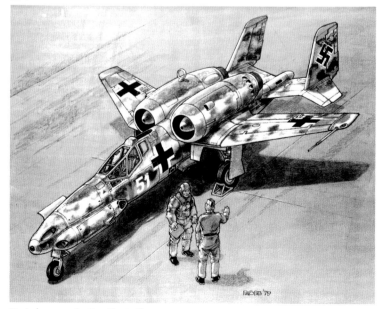

Nazi plane, production illustration

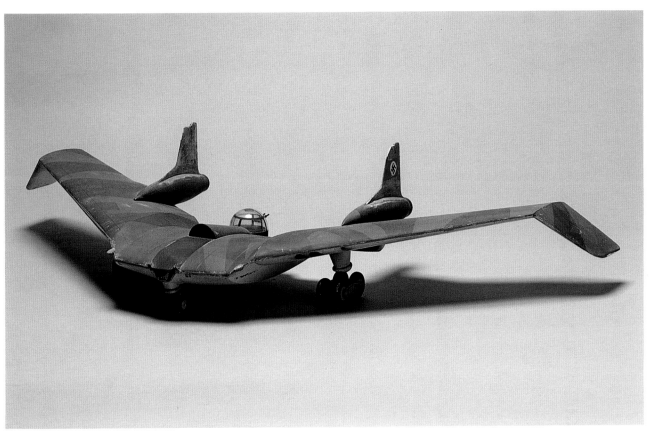

Flying Wing, model, 89 x 36 x 17 cm.

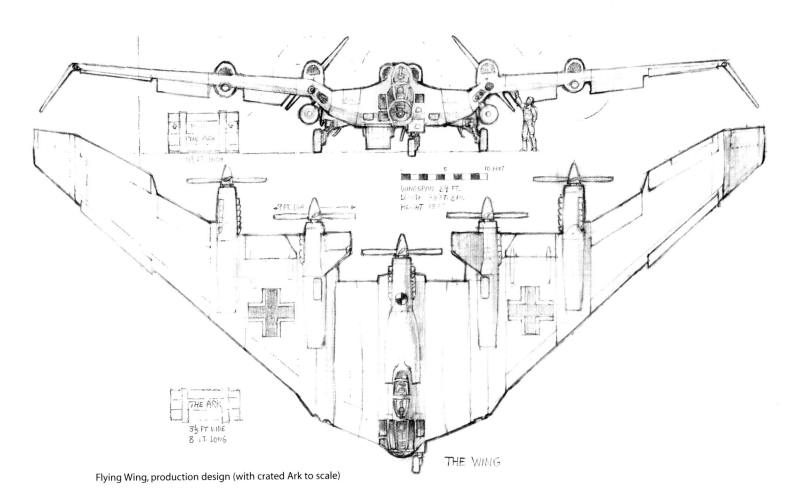

Flying Wing, production design (with crated Ark to scale)

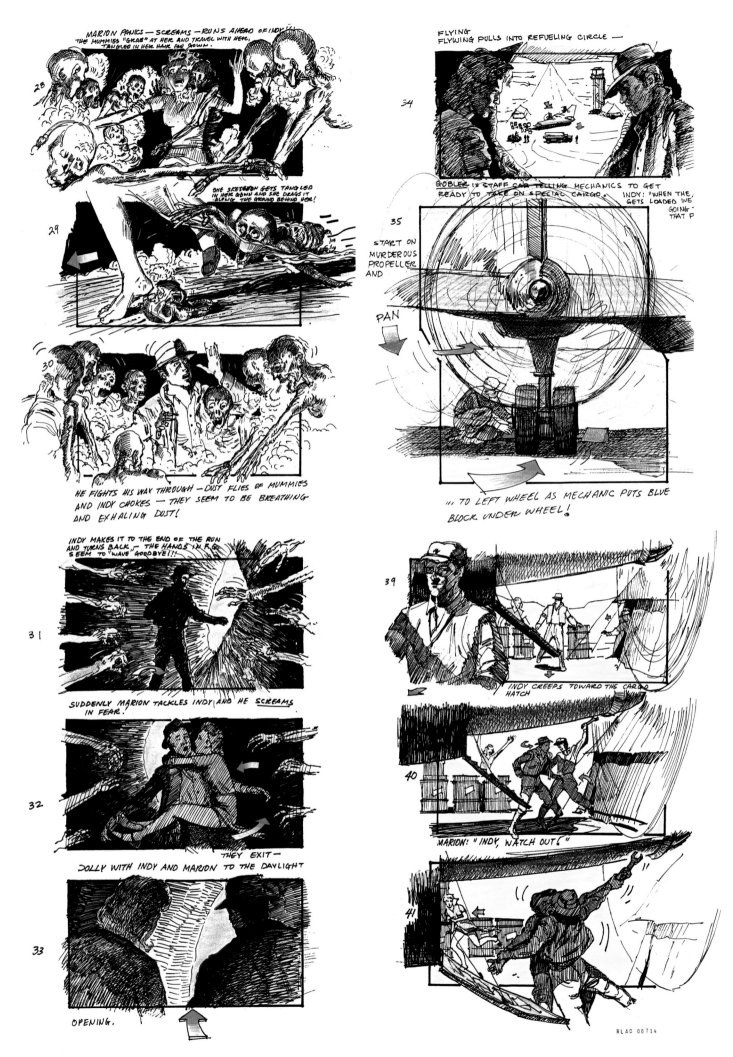

MARION PANICS — SCREAMS — RUNS AHEAD OF INDY!!
THE MUMMIES "GRAB" AT HER AND TRAVEL WITH HER,
TANGLED IN HER HAIR AND GOWN.

28

FLYING
FLYING PULLS INTO REFUELING CIRCLE —

34

ONE SKELETON GETS TANGLED
IN HER GOWN AND SHE DRAGS IT
ALONG THE GROUND BEHIND HER!

29

GOBLER IN STAFF CAR TELLING MECHANICS TO GET
READY TO TAKE ON SPECIAL CARGO. INDY: "WHEN THE
GETS LOADED WE
GOING
THAT P

35

START ON
MURDEROUS
PROPELLER
AND

PAN

30

HE FIGHTS HIS WAY THROUGH — DUST FLIES OF MUMMIES
AND INDY CHOKES — THEY SEEM TO BE BREATHING
AND EXHALING DUST!

"... TO LEFT WHEEL AS MECHANIC PUTS BLUE
BLOCK UNDER WHEEL!

INDY MAKES IT TO THE END OF THE RUN
AND TURNS BACK — THE HANDS IN F.G.
SEEM TO "WAVE" GOODBYE!!!

31

39

INDY CREEPS TOWARD THE CARGO
HATCH

SUDDENLY MARION TACKLES INDY AND HE SCREAMS
IN FEAR.

32

40

MARION: "INDY, WATCH OUT!"

THEY EXIT —
DOLLY WITH INDY AND MARION TO THE DAYLIGHT

33

41

OPENING.

RLAC 00714

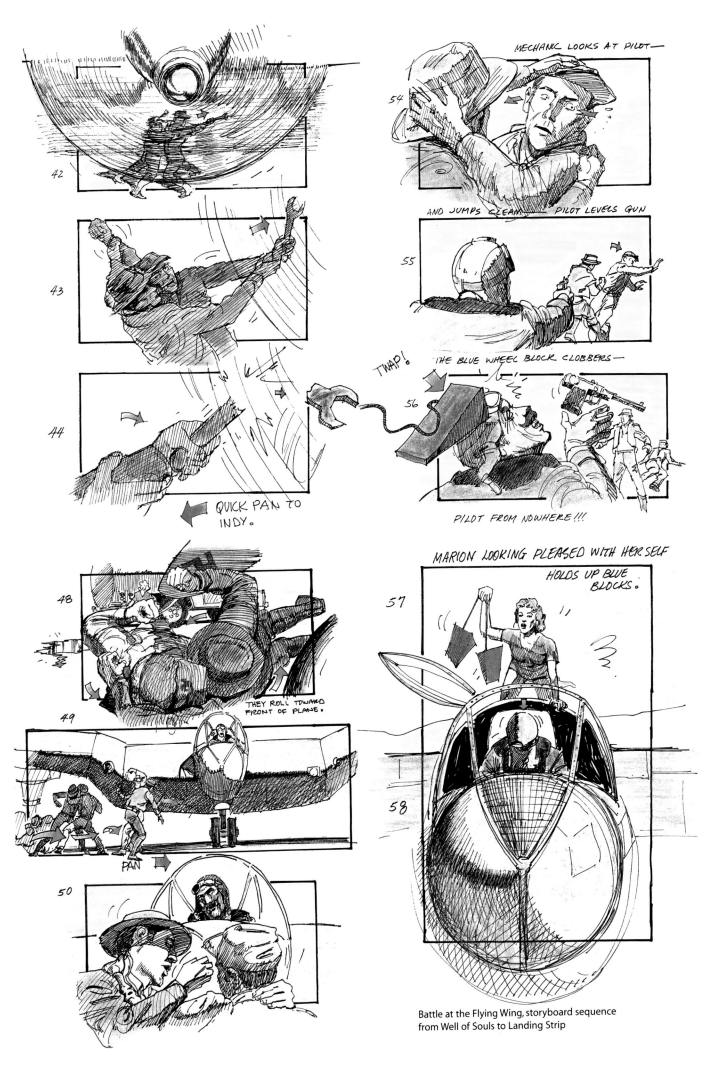

MECHANIC LOOKS AT PILOT—

54

AND JUMPS CLEAR— PILOT LEVELS GUN

55

TWAP!

THE BLUE WHEEL BLOCK CLOBBERS—

56

PILOT FROM NOWHERE!!!

42

43

44

QUICK PAN TO INDY.

MARION LOOKING PLEASED WITH HERSELF

HOLDS UP BLUE BLOCKS.

57

58

48

THEY ROLL TOWARD FRONT OF PLANE.

49

PAN

50

Battle at the Flying Wing, storyboard sequence
from Well of Souls to Landing Strip

SECRETS OF THE ARK

One of the greatest chases ever filmed is the truck chase in which Indy pursues Nazis who are making their getaway with the Ark. The sequence intercut both live-action stunt work and ILM's visual effects magic. A key ILM shot had Indy drive a Nazi jeep off a cliff, an effect executed with a matte painting of the cliff's sheer drop in which opticals composited separate elements of a miniature jeep and puppets. Long-time ILMer John Ellis points to the shot as a signature example of Lucas's understanding of his audience, explaining that when Lucas viewed the shot in dailies he told his team to print it, despite a chorus of

concerns that there was still work to be done—color timings, additional painting details, some work on the matte lines. But Lucas instinctively knew the shot couldn't be improved upon and that audiences would cheer it in the theaters.

The chase for the Ark shifts to the Nazi submarine where the Ark has been crated. The crate, complete with Nazi insignia, called for an ILM animation effect to have the Ark burn the crate's surface, foreshadowing the eventual destruction of the Nazis when they open the Ark.

The opening of the Ark was presided over by Belloq, Indy's old foe in the hunt for lost treasures of

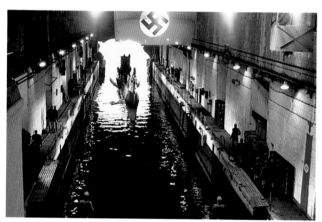

Submarine bearing the Ark docks in Nazi stronghold, still from film

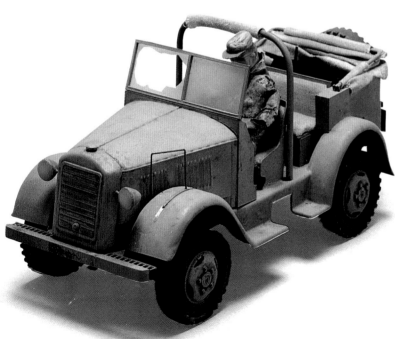

Cliff drop, matte painting, 122 x 244 cm.

Nazi jeep, model (with figure), 13 x 26 x 13 cm.

Nazi crate, prop, 136 x 93 x 10 cm.

Ark smolders in crate, storyboards

Nazi crate burned, prop, 136 x 93 x 10 cm.

(1) REVISED 12·2·80

(2) DESCRIPTION:
Continuation of NC1. CU Nazi crate with smouldering
fire. Camera continues move in the XCU as the Nazi
insignia goes black.

© LFL 1980

ELEMENTS:
Plate - Nazi crate
Smouldering
Smoke

SCENE NO:	NOTES:		FRAME COUNT		
SHOT NO. NC 2	ANIMATION: Smouldering	PROC. PLATE NO.		RAIDERS	PAGE 40

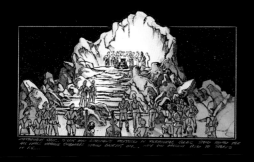

Reverse angle... spirit passing thru...

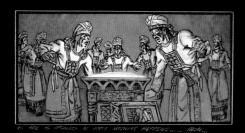

As ark is opened at first nothing happens..... then...

Spirit passing thru moves up toward soldiers head... as if to confront him... with something...

(no sun) haze pours out of ark... x-rays spectres have confront germans...

Close over shoulder... face of spirit veiled rises toward nazis face....

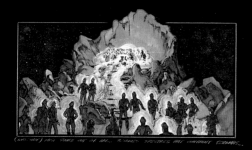

mist pours forth and skerry faces and surroundings everywhere...

Reverse angle... german staring entranced... mystified...

passes close to him...

face of spirit then reveals itself... the face of death !!!

and thru him... as if in disbelief... soldier asks himself is this is really happening...

soldiers reaction... begins a scream which is never heard... for he has begun morphing to bone...

PIECES OF UNDEAD FLESH FALL AWAY REVEALING SKELETON BENEATH...

GABLES... TOHT AND OTHERS BEGIN TO BREAK APART...

UNTIL THE WHOLE FACE CRUMBLES TO DUST...

WIDER ANGLE... CONCUSSION BECOMES MORE INTENSE...

INDY... "KEEP YOUR EYES CLOSED!!" SPIRITS HAUNT INDY AND MARION

LOWER ANGLE... BODIES DISINTEGRATING... UNTIL...

CLOSE ON INDY AND MARION RESISTING SPIRITS...

ONLY SKELETONS REMAIN... UNTIL THEY TOO ARE BLOWN

GERMAN SOLDIERS BEGIN DISINTEGRATING...

Opening of Ark and the Nazi destruction, storyboard

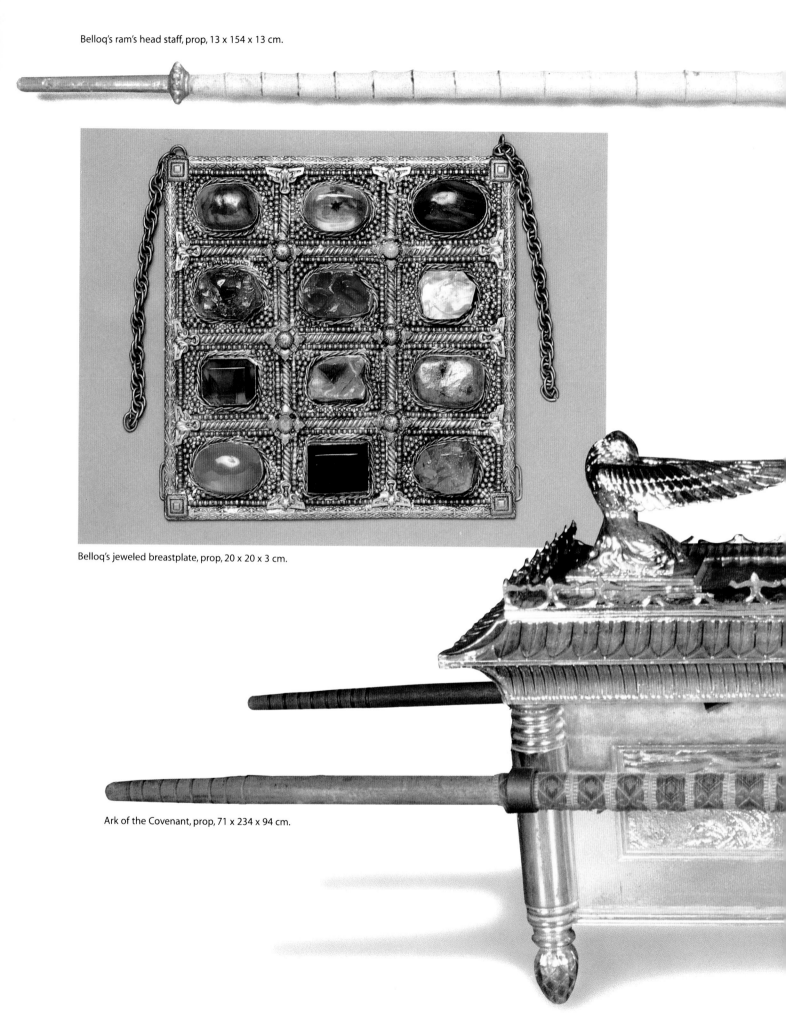

Belloq's ram's head staff, prop, 13 x 154 x 13 cm.

Belloq's jeweled breastplate, prop, 20 x 20 x 3 cm.

Ark of the Covenant, prop, 71 x 234 x 94 cm.

Ark of the Covenant, research material

Portable altar, research material

antiquity. For the fateful ceremony several props were inspired by ancient Hebrew ceremonial objects, including a bejeweled breastplate and ram's head staff.

The *Raiders* art department had divine source material in recreating the Ark. Its design, including golden, winged cherubs facing one another atop a wooden chest plated inside and out with gold, is described in exact detail in the Old Testament's book of Exodus. The design research also included old religious texts and archaeological journals in which the sacred relic had been drawn to biblical specifications.

The climactic opening of the Ark, with the destruction of the Nazis, required a mix of live action and visual effects. Bolts of energy that zap the Nazis were created as cel animation, with the actors' shirts rigged with lightbulbs to represent the entry point for the energy bolts. Although the storyboards dictated close-ups of Belloq and several Nazis having their faces shatter and crumble away, the final close-ups in the movie had waxen life masks (created by Chris Walas) melting and, in the case of poor Belloq, exploding.

After the Nazis have been destroyed with a biblical blast of power and U.S. authorities lay claim to the Ark, Indy and Marion are left wondering how the government will handle this treasure of cosmic power.

The final scene reveals the Ark, once again crated up, being wheeled into a seemingly endless warehouse filled with packing crates. The final shot, which leads into the credit crawl, leaves audiences wondering what other secrets might be packed up, stored, and forgotten in the mysterious warehouse.

ILM matte painter Michael Pangrazio rendered the huge warehouse as a matte painting. The painting, with a slice of live action of the worker wheeling in the crate, was on screen for more than thirty seconds, astounding given that a few seconds is considered the optimum length of time before an audience might suspect the illusion. The expert design of the shot conceals the cinematic trickery. The eyes of the audience are naturally drawn to the light and movement of the live action insert rather than the shadowy painting of the dimly lit warehouse. Key to the shot was that Pangrazio blended the edges of his painting with the natural edges of the matted-in live-action element.

Raiders of the Lost Ark became one of the most successful films ever, generating $242,374,454 in domestic box office and finishing first in the top ten movies for 1981. It was an auspicious beginning for both the swashbuckling Indiana Jones character and the collaboration of George Lucas and Steven Spielberg. For the next installment Lucas and Spielberg would take Indy to India for an encounter with occult forces.

Government warehouse, storyboard

Government warehouse, matte painting, 191 x 84 cm.

TREASURE OF SHIVA

INDIANA JONES
AND THE TEMPLE OF DOOM
(Lucasfilm/Paramount) 1984

HOORAY FOR HOLLYWOOD!

In *The Temple of Doom*, the Lucasfilm production goal was to surpass the original in thrills and spectacle. The ambitious number of effects shots to be undertaken by Industrial Light & Magic also necessitated as much in-camera work as possible, avoiding the potential production bottleneck of optically compositing elements.

To set the appropriate over-the-top tone, the movie opens with an "Anything Goes" production number set in "Club Obi Wan," a Shanghai nightclub. To choreograph the dance number with all the wild exuberance of the classic Hollywood musical, as well as pay homage to a lost entertainment art, the preproduction research team studied the old movie musicals themselves, particularly the MGM Busby Berkeley numbers that set the standard for glorious excess.

Willie Scott (Kate Capshaw) leads the Club Obi Wan dancers in a big production number

George Lucas surveying Club Obi Wan set

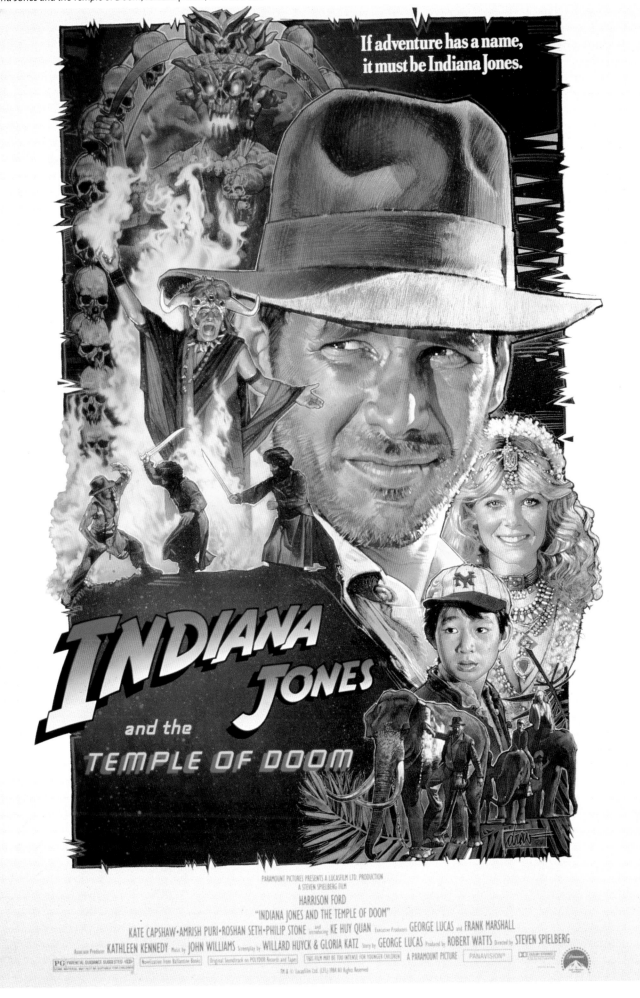

CLUB OBI WAN

The Obi Wan nightclub (its name another in-joke aimed at *Star Wars* fans) is the scene of a battle of wills between Indiana and local crime lord Lao Che (played by Roy Chiao). A straight trade-up—a funerary urn holding the ashes of Lao's ancestor, Nurhache, in Indy's possession for a diamond Lao holds and Indy covets—turns treacherous as Lao slips poison into Indy's champagne. Indy manages to grab the antidote from the crimelord and drink the saving serum, but only after a furious gun battle provides an early "last call" for the patrons of Club Obi Wan.

The funerary urn prop, built at Elstree Studios in England where the *Temple* set work was staged and filmed, was inspired by classic Chinese jade work of the Manchu period.

Vial with antidote, prop, 2 x 2 x 9 cm.

Ashes of Nurhache, storyboard sequence

LOW ANGLE TABLE — INDY PUSHES ORNATE BOX TOWARD LAOS TREMBLING HAND... CAM FOLLOWS BOX AS LAO PULLS IT ACROSS THE TABLE TOWARD HIM...

SN-47a

CLOSE ON LAO AND HIS HENCHMEN CROWDED AROUND HIM AS HE OPENS THE SACRED BOX... "AT LAST I HAVE THE ASHES OF MY ANCESTOR. (CUT)"

SN-48

Funerary urn with Nurhache's remains, prop, 9 x 7 x 16 cm.

THE EVIL OF PANKOT PALACE

Indiana begins his big adventure, with his sidekick Short Round (played by Ke Huy Quan) and nightclub performer Willie Scott (actress Kate Capshaw) along for the ride, with a fateful flight from Shanghai airport. (There are a number of cameos in the scene, which was filmed at a closed Air Force base in Marin County, including comedian and actor Dan Aykroyd as an airport staff member.) But unbeknownst to our hero, the Ford tri-motor plane he and his friends have boarded belongs to crime lord Lao. Once airborne the pilot empties the fuel tanks and parachutes to safety. Indy cheats death again by disembarking with his friends in a rubber life raft, moments before the low-flying tri-motor crashes into a snowy mountainside.

Although the actual plane crash and explosion would be accomplished with a smaller model rigged with pyrotechnics, the shots of the plane heading toward impact required a scale tri-motor model and a miniature snowscape set. The model, a precise replica with a three-foot wingspan built by ILM model makers Michael Fulmer and Ira Keeler, and a snowy mountain set were filmed in natural sunlight on the roof of ILM's main stage. A carriage above the snowscape was rigged, the model suspended from wires, and the tri-motor "flown" into the mountain.

By a strange twist of fate, Indy and company are delivered to a village where a shaman tells them of the travails ever since the disappearance of the village's sacred stones:

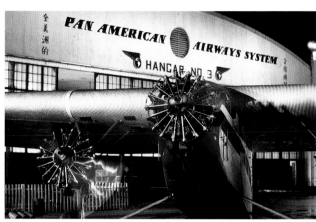

Tri-motor at Shanghai Airport, production photo

Ford tri-motor airplane, model, 122 x 99 x 43 cm.

Shanghai airport set

withered crops, dead animals, and children who have mysteriously disappeared. A scrap of a Sanskrit cloth painting arouses Indiana's archaeological interest and leads him and his friends to look for the sacred stones at Pankot Palace.

Instead of building an expensive Pankot Palace set, and because filming restrictions in India precluded finding and shooting a real location, it was decided to conjure up the exterior palace scenes with matte paintings. The matte-painted establishing shot reproduced here was substituted for another shot in the final movie. "The hardest thing to do is to make a matte painting establishing shot look real," says Craig Barron, the matte camera supervisor for the movie. "We didn't think this front-lit shot looked realistic enough, so we did a back-lit matte painting of the Palace at sunset."

The design of the exterior, with its shadowy walls and courtyard hinting at the evil within, as well as a foreboding cave beneath the palace began with Spielberg's rough sketches (or "hieroglyphics" as he calls them) and were developed as production sketches prior to the matte artist's brush and oil work. Artist Frank Ordaz's Pankot cave painting, faithful to Spielbergian hieroglyphics depicting a stalactite- and stalagmite-ridged chasm, was dubbed "Jaws IV" by the ILM matte department.

ILM films tri-motor airplane crash

Sanskrit cloth painting, prop, 20 x 15 x 0.5 cm.

Pankot Palace, matte painting, 193 x 85 cm.

Spielberg sketch for Pankot Palace cave

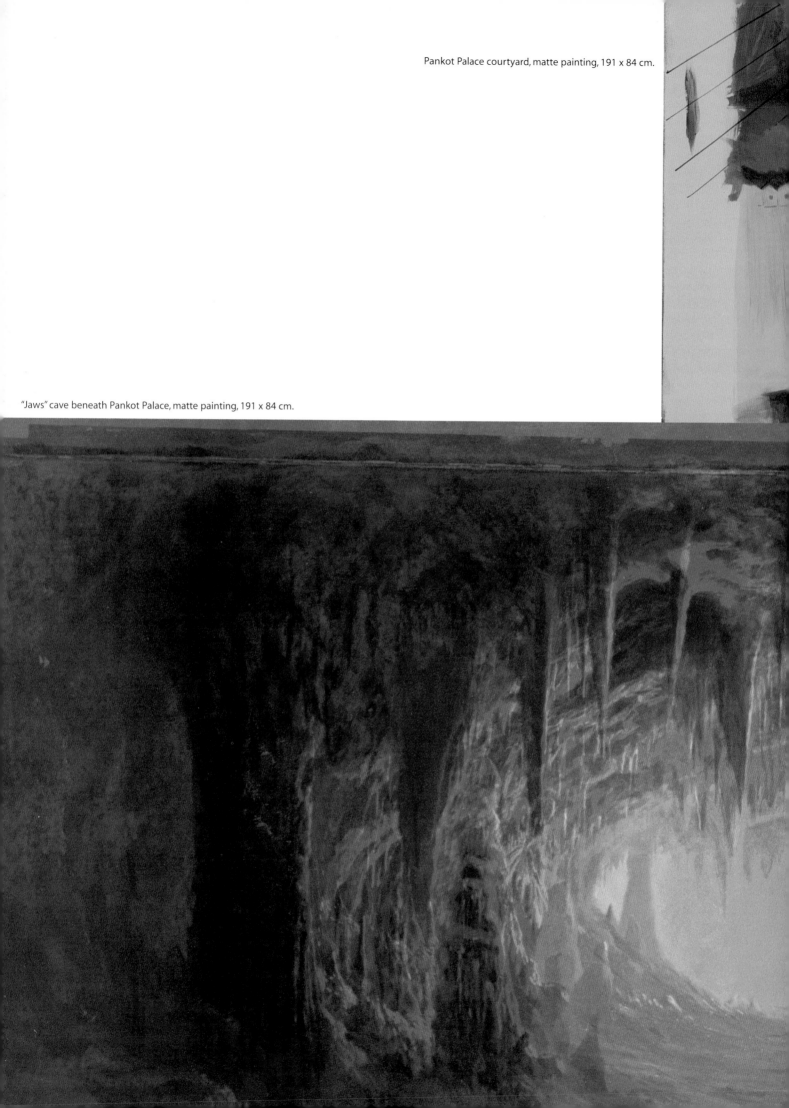

Pankot Palace courtyard, matte painting, 191 x 84 cm.

"Jaws" cave beneath Pankot Palace, matte painting, 191 x 84 cm.

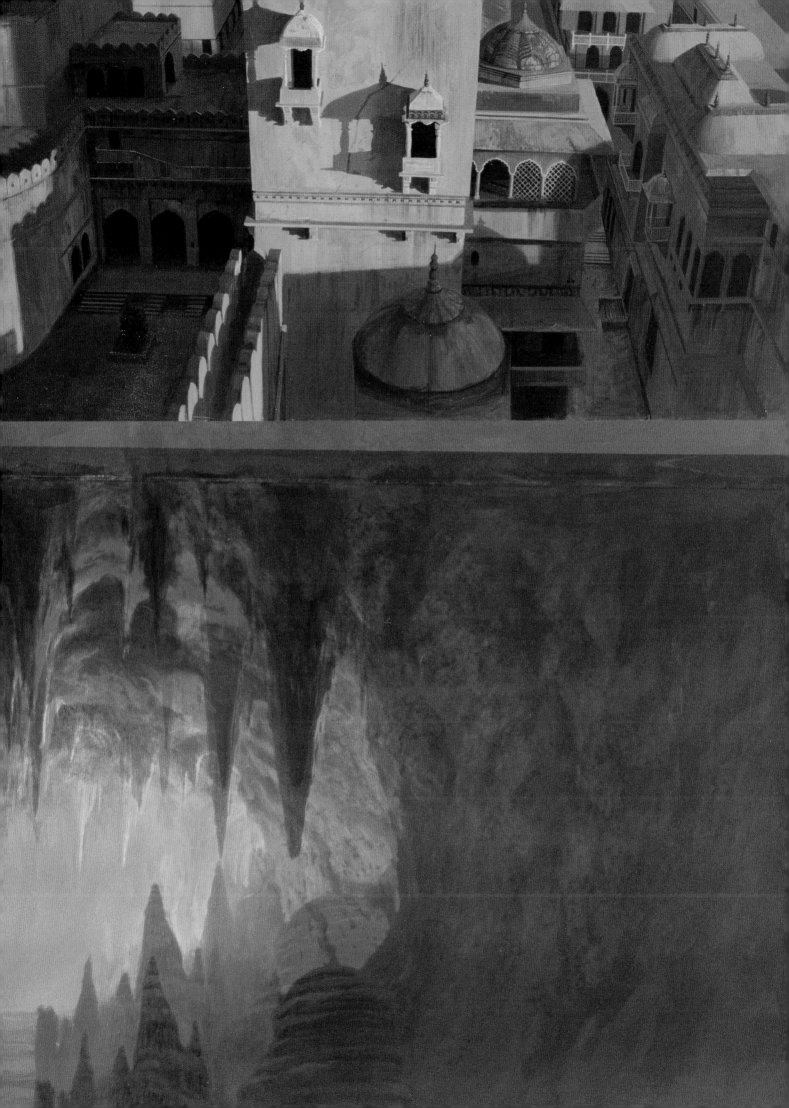

TEMPLE OF DOOM

The dark secret of the palace is how the evil Mola Ram, a high priest of the Thuggee cult, controls the young Maharajah and has enslaved the village children to work in his underground mines.

A mine car chase scene was conceived with Spielberg sketches and finalized as detailed storyboards. ILM's miniature mine car work, which had to perfectly match the live action scenes it would be intercutting with, required more than fifty feet of miniature set, with Tom St. Amand providing stop-motion animation for puppets of Indy, Willie, and Short Round. The size of the set dictated that creature maker Phil Tippett and his crew scale the puppet figures to no more than eight to ten inches tall. "It was such a grueling shot," Tippett recalls. "Tom St. Amand and Mike McAlister had to stop-motion and shoot the entire sequence frame by frame in a cold bay with the set fogged up for atmosphere—it took months to complete."

The full evil of the Temple of Doom is revealed earlier when Ram conducts a bloody sacrifice to the goddess Kali.

For Mola's evil ceremony, actor Amrish Puri was outfitted with a horned headdress, complete with a shrunken head in its crown that was made from latex. The torture rack used to lower the slave was created both as a full-scale prop for the live-action shots and as a three-foot miniature to secure a three-foot-tall slave puppet. Although the puppet and miniature would have typically been shot bluescreen, with the lava pit produced as a separate element, the desire to avoid any delays in the time-consuming optical compositing process led ILM Visual Effects Supervisor Dennis Muren and his model makers to produce the effect in-camera. The final effect required a thirty-foot-tall lava pit set, with pumps circulating colored and bottom-lit glycerine, into which the miniature puppet was lowered.

Mine car with Thuggee Guard figures, model, 14 x 23 x 25 cm.

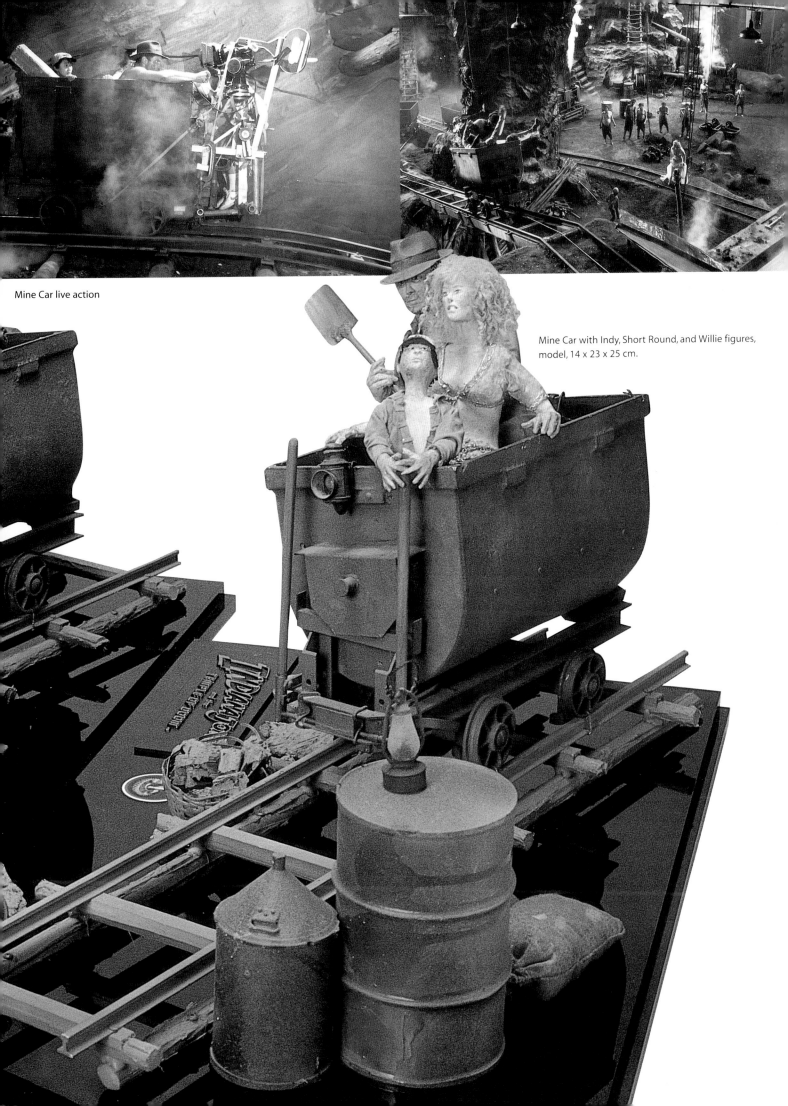

Mine Car live action

Mine Car with Indy, Short Round, and Willie figures,
model, 14 x 23 x 25 cm.

Torture rack, miniature model, 74 x 36 x 15 cm.

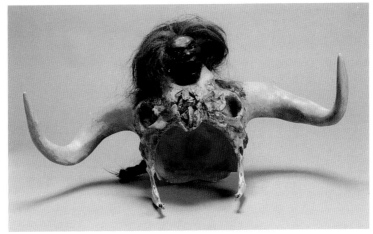

Mola Ram ceremonial headdress, costume, 80 x 33 x 45 cm.

Sacrifice in the Temple of Doom, storyboard sequence

ANGRY UP ANGLE — LAVA LIGHT REFLECTED UNDER STATUE.

.... THE BURNING SKELETON OF CHATTER L'AL.

BURST OF LAVA FOUNTAIN AND FIRE FROM PIT AND CREVASSE. BELIEVERS BACK OFF.

.... AND RIGHT SIDE TOO.

INDY PEEKS OVER THE EDGE OF THE PIT.

MOLA RAM TAKES THE SACRED STONES.

THE GRILL EMERGES FROM UNDER THE LAVA — BRINGING WITH IT....

MOLA RAM EXITS TO THE LEFT AS WE

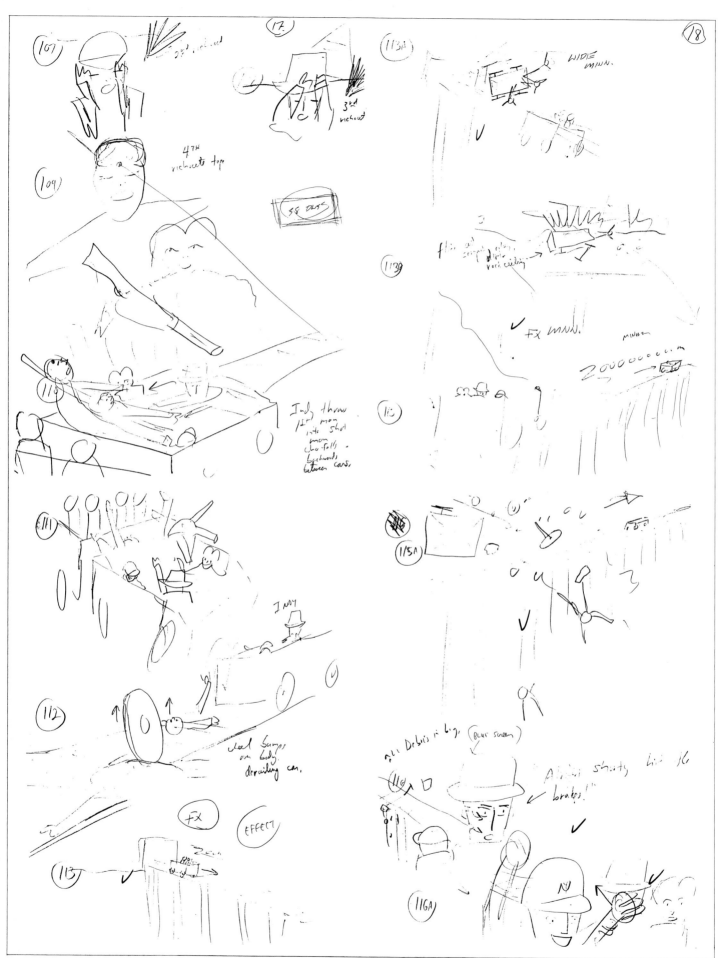

Spielberg sketch for mine chase sequence

INDY II 1983 © STORYBOARD OCT 03 1983

DESCRIPTION: MINE CHASE SEQUENCE

NOTES:
REDUCTION ONLY OPTICAL

ELEMENTS:	STAGE	ANIM	PLATE	MATTE	NON-ILM	ELEMENTS:	STAGE	ANIM	PLATE	MATTE	NON-ILM	SHOT # / SEQUENCE
Stop Motion Miniature	x											MC 31
											FRM COUNT	PAGE #

STORYBOARD OCT 21 1983

DESCRIPTION
MINE CHASE SEQUENCE

© INDY II 1983

NOTES:

ELEMENTS:	STAGE	ANIM	PLATE	MATTE	NON-ILM	ELEMENTS:	STAGE	ANIM	PLATE	MATTE	NON-ILM	SHOT # / SEQUENCE
												MC41

INDY II 1983 © STORYBOARD OCT 21 1983

DESCRIPTION: MINE CHASE SEQUENCE

NOTES:

ELEMENTS:	STAGE	ANIM	PLATE	MATTE	NON-ILM	ELEMENTS:	STAGE	ANIM	PLATE	MATTE	NON-ILM	SHOT # / SEQUENCE
Stop Motion Miniature	x											MC33

INDY II 1983 © STORYBOARD OCT 21 1983

DESCRIPTION: MINE CHASE SEQUENCE

NOTES:

ELEMENTS:	STAGE	ANIM	PLATE	MATTE	NON-ILM	ELEMENTS:	STAGE	ANIM	PLATE	MATTE	NON-ILM	SHOT # / SEQUENCE
High Speed Miniature	x											MC42

INDY II 1983 © STORYBOARD OCT 21 1983

DESCRIPTION: MINE CHASE SEQUENCE

NOTES:

ELEMENTS:	STAGE	ANIM	PLATE	MATTE	NON-ILM	ELEMENTS:	STAGE	ANIM	PLATE	MATTE	NON-ILM	SHOT # / SEQUENCE
Stop Motion Miniature	x											MC35

© INDY II 1983 REVISED SEP 30 1983

DESCRIPTION: MINE CHASE SEQUENCE

NOTES:

ELEMENTS:	STAGE	ANIM	PLATE	MATTE	NON-ILM	ELEMENTS:	STAGE	ANIM	PLATE	MATTE	NON-ILM	SHOT # / SEQUENCE
Go-Motion Figures	x											MC 46
Miniature BG	x											

INDY II 1983 © REVISED OCT 3 1983

DESCRIPTION: MINE CHASE SEQUENCE

NOTES:
REDUCTION ONLY OPTICAL

ELEMENTS:	STAGE	ANIM	PLATE	MATTE	NON-ILM	ELEMENTS:	STAGE	ANIM	PLATE	MATTE	NON-ILM	SHOT # / SEQUENCE
Stop Motion Miniature	x											MC 37

© INDY II 1983 REVISED SEP 30 1983

DESCRIPTION: MINE CHASE SEQUENCE

NOTES:

ELEMENTS:	STAGE	ANIM	PLATE	MATTE	NON-ILM	ELEMENTS:	STAGE	ANIM	PLATE	MATTE	NON-ILM	SHOT # / SEQUENCE
Go-Motion Figures	x											MC 47
Miniature BG	x											
Sparks		x										

FINAL BATTLE AND AFTERMATH

The Sankara Stones, modeled after the linga symbol of the deity Shiva (but realized as plastic props with light bulbs inside for illumination), are finally captured by Indiana, but not before a deadly battle with Thuggee warriors and Mola Ram on a precarious rope bridge.

The rope bridge battle was another complicated sequence requiring intercutting of live-action stunts and effects shots. The principal photography was staged in Sri Lanka, with the production bridging a wide gorge with steel cables covered with rattan ropes. Although safety harnesses and other special precautions were used, Executive Producer Frank Marshall would recall how nervous he was, concerned for complete safety while filming hundreds of feet in the air. At another bridge location shoot in Sri Lanka, Marshall could breathe a little easier since that set, designed for the most dangerous camera angles, was only fifteen feet above ground.

When Indy cuts the rope bridge, sending Ram's henchmen falling into the water of the gorge below, the shots were created at a sixty-foot cliff set in England. Mechanical effects supervisor George Gibbs took ordinary tailor's dummies, made molds of them, and filled the molds with soft foam. Internal pneumatic air cylinders were triggered, causing the dummy limbs to flail about, perfectly simulating human movement.

Although the return of the sacred stones and the kidnapped children

Site for rope bridge, photo collage, location work in Sri Lanka

Rope bridge standoff, story board sequence

CAMERA JUMPS STRAIGHT BACK — INDY SPINS BACK AROUND TO SEE

INDY – TRAPPED AGAIN . . .

(INDY): TO MOLA RAM — "YOU WANT THE STONES — LET THEM GO AND CALL OFF YOUR DOGS !"

Rope bridge shoot, set work

Sankara Stones, props, 8 x 8 x 13 cm.

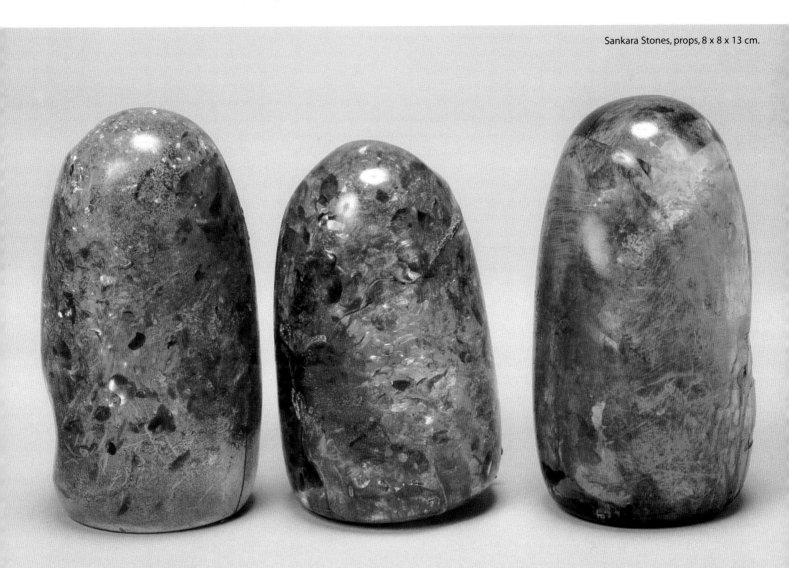

to the village bursts with happy endings—the land flowering in all its fertile glory, Indy and Willie linked in a lingering kiss—the dark themes of the movie troubled some critics and audience members. Some even felt that the shrill Willie Scott character, so different from the tough, tomboyish Marion of *Raiders*, was not the type of female the headstrong likes of Indiana Jones would have cared to be with.

In a 1989 interview with writer Ben Fong-Torres, Lucas admitted there was a conscious decision to make the film much darker than the first. But although Lucas felt *Temple of Doom* was, on balance, no more violent than *Raiders*, he did acknowledge that many fans were dismayed at the kind of violence Indy found in India.

Despite the controversy, it was another success for the Lucas/Spielberg team. Between their creative team-up for the Indiana Jones series, Lucasfilm's *Star Wars* trilogy, and Spielberg's own films, the duo had stature as the most commercially popular filmmakers in the history of the movies.

As planning went into the third installment it was decided to return to the dynamics of the first film. Once again Indy would be racing Nazis to obtain a sacred relic—the Holy Grail, the sacred chalice Jesus Christ used at the Last Supper—but this time with Indiana's father (played by Sean Connery) along for the ride.

Harrison Ford, George Lucas, Steven Spielberg, and Kate Capshaw taking a break

THE FINAL QUEST

INDIANA JONES AND THE LAST CRUSADE

(Lucasfilm/Paramount) 1989

CROSS OF CORONADO

The Last Crusade opens in the time of Indy's boyhood. On an Eagle Scout hike in the rugged wilderness of Utah, the young Indy discovers a group of fortune hunters digging up the Cross of Coronado. Incensed that the artifact is not heading for a museum, Indy swipes the relic and leads the fortune hunters on a wild chase through a circus train.

Although the relic was named after the fifteenth-century Spanish explorer Francisco Vásquez de Coronado, who led his army through present-day Arizona and New Mexico in a fruitless search for the legendary Seven Cities of Gold, the cross itself was a fictional prop.

The circus train chase was storyboarded as a tour de force, with each car presenting some new obstacle to be hurdled. (A pair of giraffes watching the wild chase were me-chanically animated creations.) Maquettes provided a crude, but effective, means for visualizing the three-dimensional look of the circus train, as well as the Cross of Coronado dig site, the Portuguese cargo ship where a full-grown Indy has another fateful encounter with the relic, and an interior for scenes at the college where Indiana lectures.

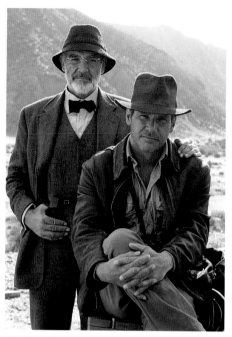

Dr. Henry Jones (Sean Connery) and Dr. Indiana Jones (Harrison Ford), production photo

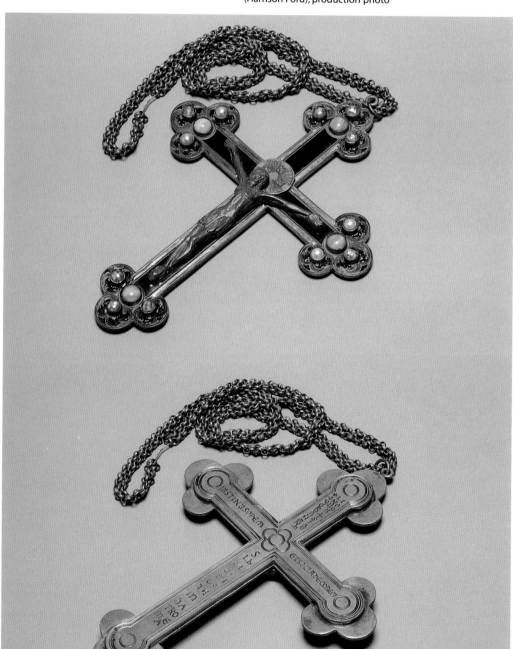

Cross of Coronado, prop, 22 x 17 x 2 cm.

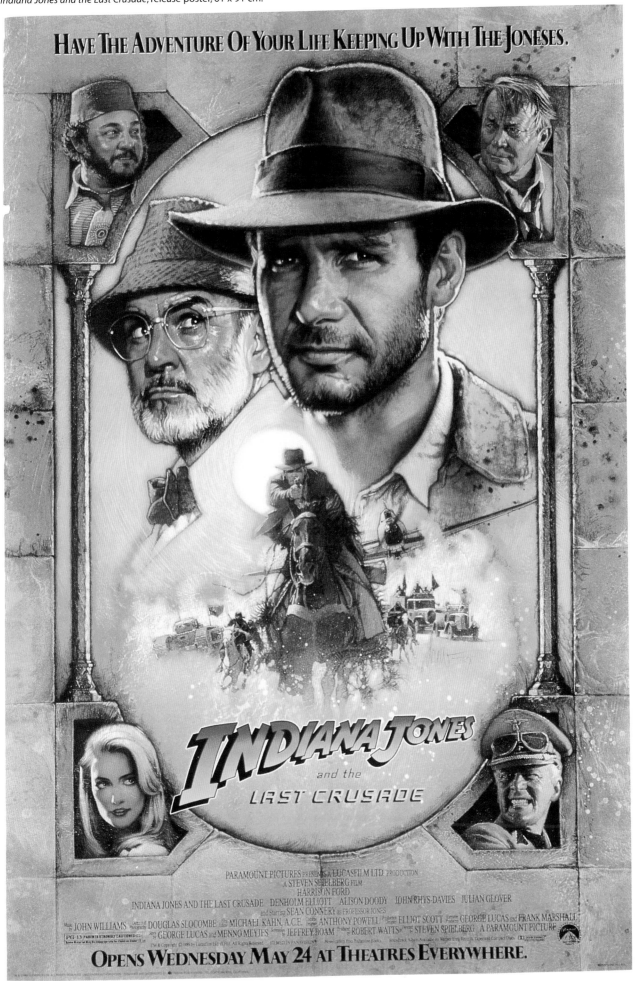

Indiana Jones and the Last Crusade, release poster, 61 x 91 cm.

Young Indy (actor River Phoenix)

Eagle Scout Award, prop, 8 x 9 x 3 cm.

Cross of Coronado dig site, maquette, 27 x 18 x 16 cm.

Circus train, maquette, 6 x 6 x 91 cm.

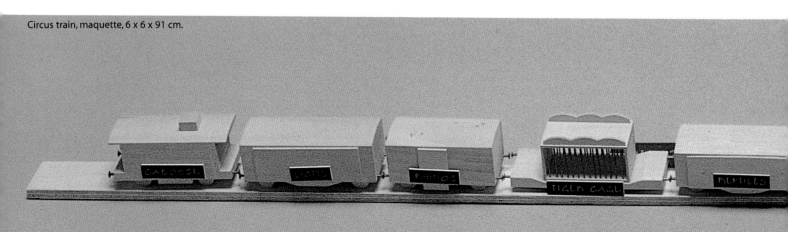

Young Indy and the circus train chase, storyboard sequence

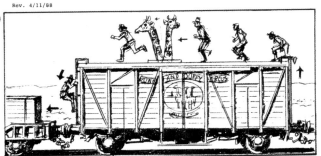

INDY CLIMBS DOWN THE NEXT LADDER, EVERYONE RUNNING PAST THE GIRAFFES WHO TURN THEIR HEADS TO WATCH ---

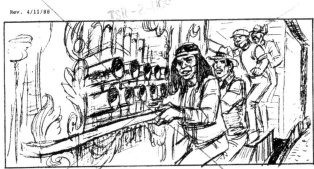

HIS P.O.V. — THE INDIAN IS ALMOST ON HIM, NOW JUST GETTING TO THE ORGAN PIPES, WITH "FEDORA" ON HIS HEELS (CUT TO)

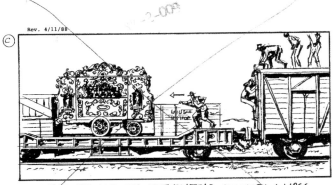

INDY CLIMBS ONTO THE NEXT FLATCAR ALONGSIDE A LARGE CRATE TOWARD A STEAM CALLIOPE AS THE GANG STARTS DOWN THE LADDER --- (CUT TO)

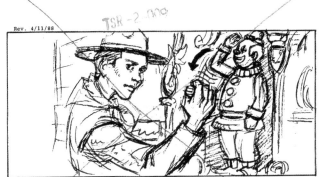

CLOSE ON INDY — HE LOOKS AT THE CLOWN FIGURE MOUNTED ON THE CALLIOPE, PERCEIVES ITS SIGNIFICANCE, AND PULLS DOWN ON THE SALUTING ARM (CUT TO)

REVERSE ON INDY — PAST CALLIOPE PIPES — HE STOPS AT SMALL MECHANICAL CLOWN FIGURE, TURNS BACK TOWARD HIS PURSUERS (CUT TO)

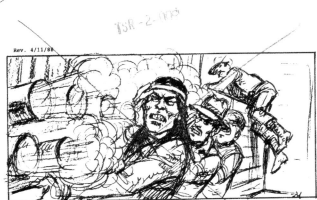

ANGLE ON THE INDIAN AND OTHER THREE — WITH A GREAT BLAST OF STEAM AND A PIERCING SHRIEK, THE CALLIOPE GIVES FORTH, STOPPING THE PURSUERS IN THEIR TRACKS — (CUT TO)

CT 30

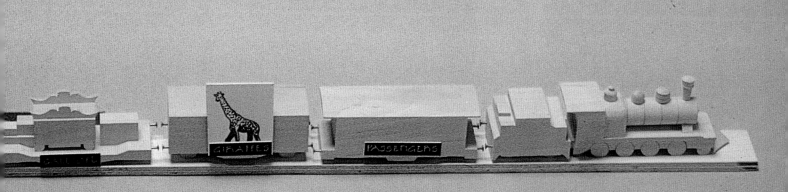

THE GRAIL LEGENDS

As the movie reveals, Dr. Henry Jones's life has been spent in not only a search for the Grail but a humble contemplation of its mysteries. It's also been the obsession that has driven a wedge between himself and the young Indiana. The villain of the piece, the mysterious millionaire Walter Donovan (played by Julian Glover), identified as Chandler in some of the early maquettes of his lavish apartment, has also spent his life indulging a passion for antiquities. But as the Jones boys discover, Donovan (who longs to drink from the Grail and receive its legendary gift of immortal life), is one of the many hydra-heads of Hitler's army.

Henry's 1912 Grail diary, full of clues to the whereabouts of the lost relic, is a particularly inventive prop, full of scribbled notes, sketches, data, all the musings of an intellectual in pursuit of a legend of history. Other props include an ancient book in Donovan's apartment that faithfully recreates an illuminated manuscript from medieval times.

Throughout the movie the Arthurian legends are recalled, particularly those crusading knights whose battles for Christianity included the mystic, and sometimes bloody, quests for

Young Indy's Diary, prop, 11 x 17 x 1 cm.

Grail Diary of Dr. Henry Jones, prop, 11 x 17 x 2 cm.

HENRY'S STUDY COLORADO

Henry's study, set design illustration

Deck of Portuguese cargo ship, maquette, 29 x 24 x 13 cm.

College interior, maquette, 58 x 91 x 8 cm.

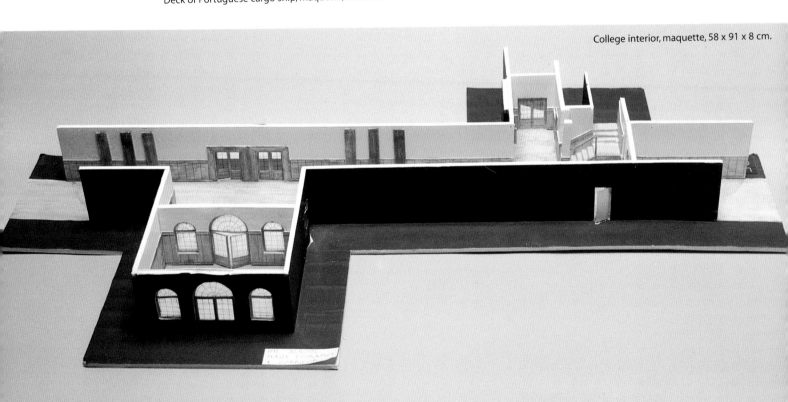

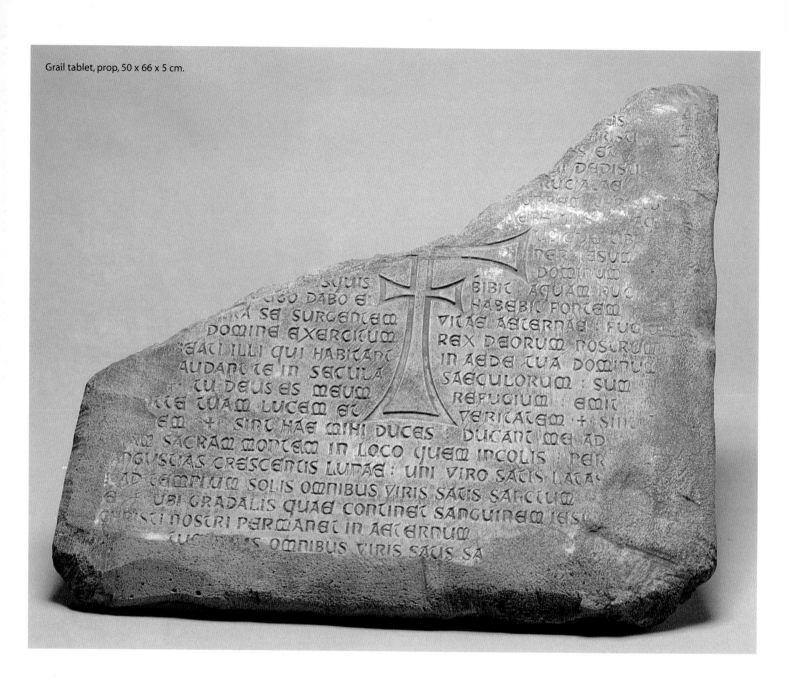

Grail tablet, prop, 50 x 66 x 5 cm.

Brown wrappers, prop, 21 x 25 x 3 cm.

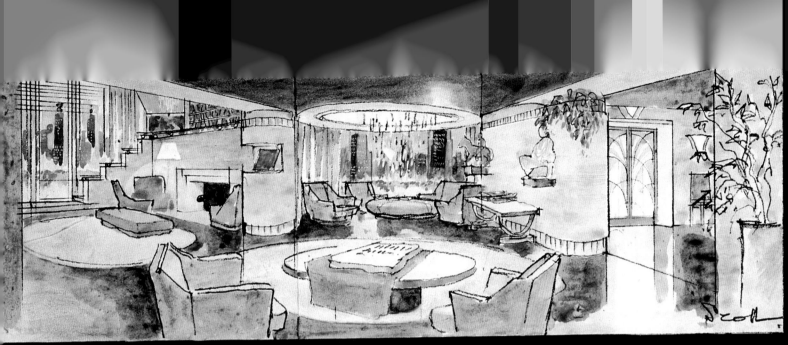

NEW YORK ~ DONOVAN'S APARTMENT

Donovan's apartment, set design illustration

Illuminated manuscript in Donovan's library, prop, 28 x 21 x 5 cm.

Donovan's (identified as "Chandler's") apartment, maquette, 32 x 53 x 10 cm.

Donovan's (identified as "Chandler's") apartment revised , maquette, 44 x 32 x 9 cm.

the lost talismans of their faith. Two props, evocative of religious paintings of the era, show the legend and power of the Grail, from the goblet receiving the blood from Christ's wound as he hung on the cross to the painted vision of a noble knight walking on air to claim the holy chalice.

In the film, Indiana has been drawn into a personal crusade to find not only the holy relic but also his missing father who has vanished in his own search for the Holy Grail.

Photos of Henry and Indy, props,
left: 7 x 10 cm.; middle: 11 x 16 cm.; right: 11 x 16 cm.

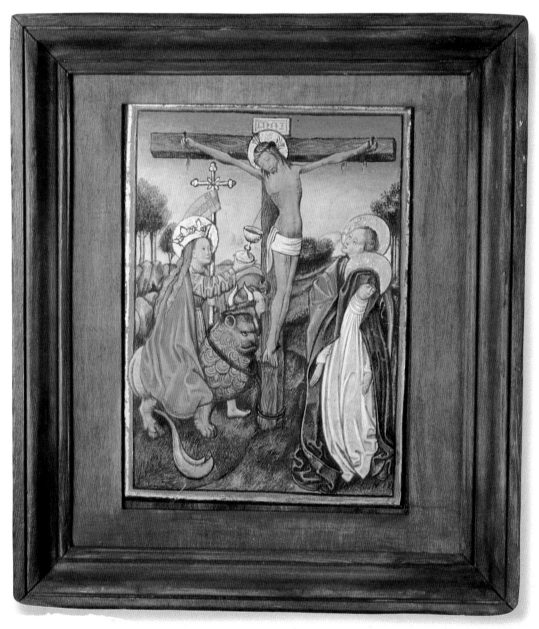

Medieval painting, prop, 40 x 46 x 5 cm.

Professor Jones's house (ransacked), production illustration

Medieval painting, prop, 34 x 46 x 3 cm.

FROM CATACOMB TO CASTLE

Teaming up in Venice, Italy, with Brody (a colleague from the university, played by actor Denholm Elliott), and the mysterious Elsa Schneider (Alison Doody), Indiana searches a library for an entranceway that will lead down into forgotten catacombs and the next clue on the trail to the Grail. The clues, alluded to in Henry's Grail diary, help Indy find the secret entrance floor section. Once in the catacombs Indiana and Elsa have to

Indy suspects that below the library floor is an ancient catacomb (with Elsa and Brody looking on), still from film

Roman numerals on scrap of paper, prop, 8 x 10 cm.

Library in Venice, set design illustration

Henry's Grail Diary, drawings of medieval stained glass
window and Roman numerals, which give clues to
the location of the Grail

Henry's drawings of the position of clues in the Venice library

survive an army of rats and a fire attack from members of a secret brotherhood sworn to protect the sacred relic.

The action leads from the dank, dark world of the catacombs to a motorboat chase on the Venetian waterways and on to a castle in Salzburg, Austria. In the castle, a secret Nazi stronghold, Indiana finds his father imprisoned.

From catacomb to castle the production depended on image illustrations and maquettes to visualize and

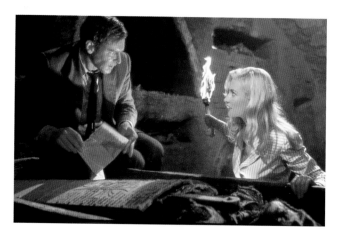

Deep in the catacombs Indy and Elsa discover the next clue in the quest for the Grail, still from film

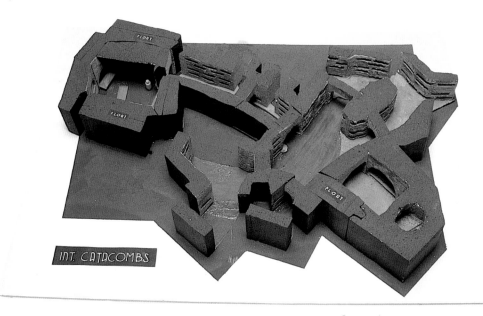

Catacombs, maquette, 55 x 76 x 9 cm.

Catacomb chamber with knight's coffin, set design illustration

Folded Grail rubbings, prop, 41 x 58 cm.

Small Kazim Crosses of the Grail Brotherhood, props, 3 x 4 cm.

Venetian waterways, maquette, 57 x 76 x 3 cm.

plan the final set pieces. The Nazi castle sequence also required exterior shots filmed at a real castle outside Salzburg. The set pieces for the castle interior included the room where Henry Jones is held prisoner, the hidden radio room used by the Nazis, and the baronial hall where the Nazis turn up the heat on the Jones boys.

Escape from the Nazi castle, still from film

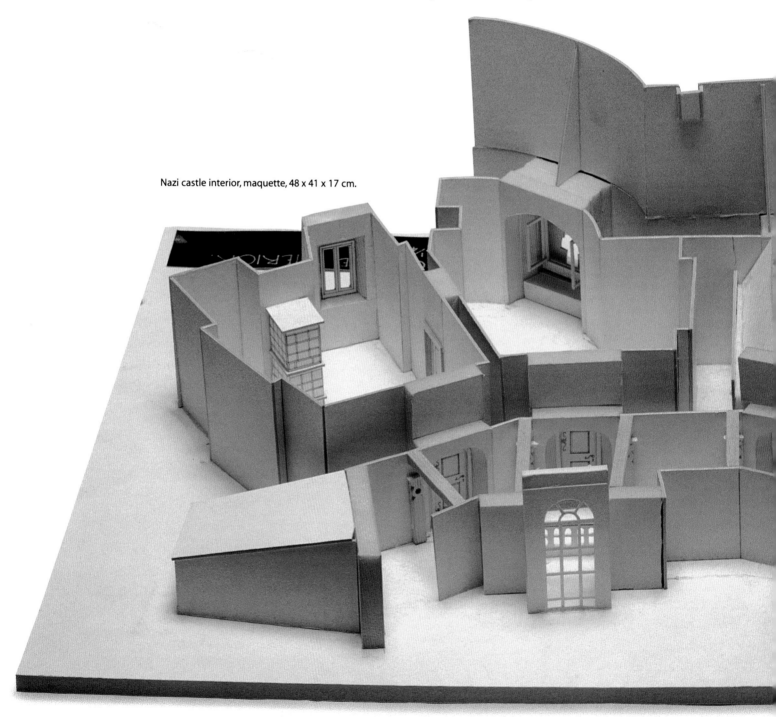

Nazi castle interior, maquette, 48 x 41 x 17 cm.

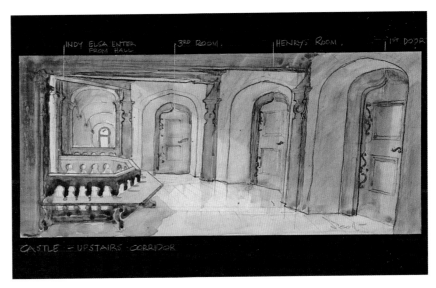

Castle (upstairs corridor), set design illustration

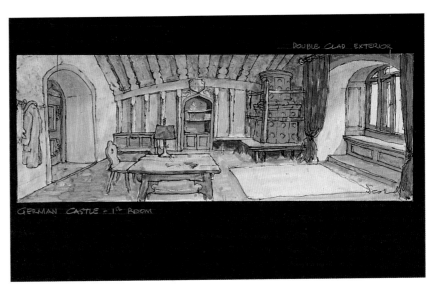

Castle (first room), set design illustration

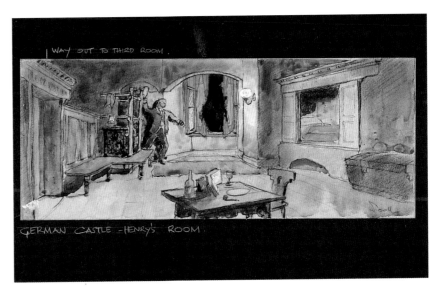

Castle (Henry's room), set design illustration

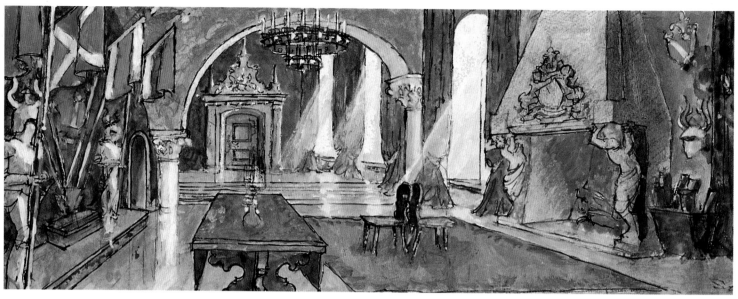

Nazi castle (baronial hall), set design illustration

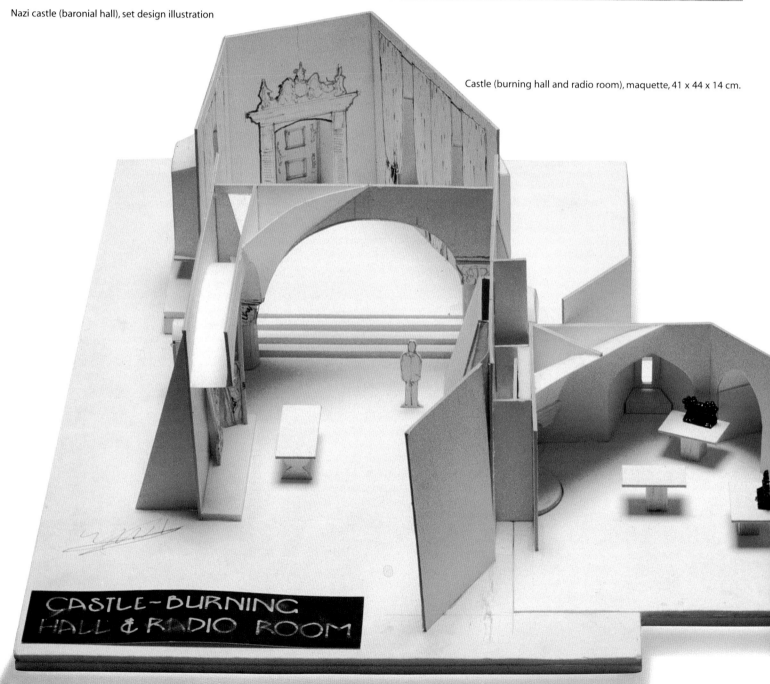

Castle (burning hall and radio room), maquette, 41 x 44 x 14 cm.

CASTLE-BURNING
HALL & RADIO ROOM

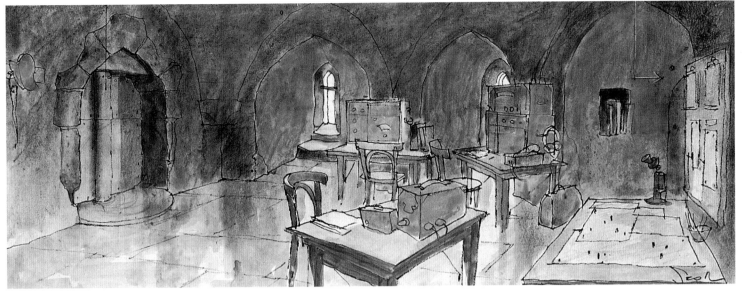

Castle (radio room), set design illustration

Elsa's lighter, prop, 5 x 2 x 6 cm.

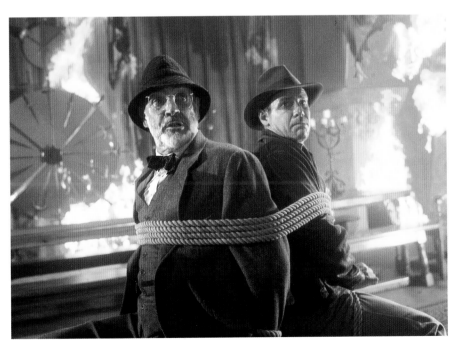

The Jones boys feel the heat, still from film

THE CHASE

It wouldn't be an Indiana Jones movie without a wild chase and *Last Crusade* provides a dandy, if deadly, sequence in which Nazi fighter planes pursue Indy and his father in the air and on the ground. Other than a major set piece of the Berlin air terminal, from where Indy and Henry leave the city in a zeppelin (after retrieving Henry's Grail diary from the slinky Elsa), much of the ensuing action required ILM effects artistry. Although portions of the airship were built as full-scale sets, most of the zeppelin action was created as optical composites, with an eight-foot airship model shot with motion control in front of bluescreen and composited into a sky background plate.

When the zeppelin is called back to Berlin, Indy and Henry make their escape in a biplane they steal from the underside of the airship. For their biplane flying scenes the two actors were filmed against a bluescreen inside a full-scale mock-up.

When the chase leads to ground level, the two swipe a car and are pursued by Nazi fighter planes. The finale, in which the Jones's car enters a tunnel followed by the pursuing plane, which crashes and burns, was a complicated effects sequence that intercut miniature sets and models, bluescreen work, and live-action pyrotechnics.

Nazi zeppelin, model, 38 x 305 x 38 cm.

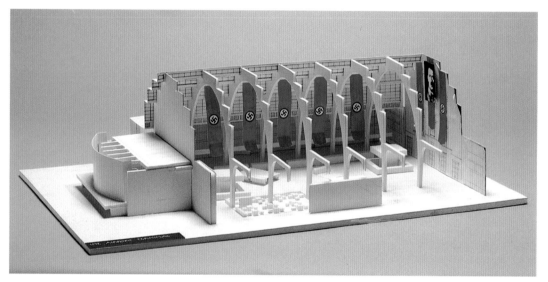

Berlin air terminal, maquette, 76 x 49 x 20 cm.

Berlin air terminal, set design illustration

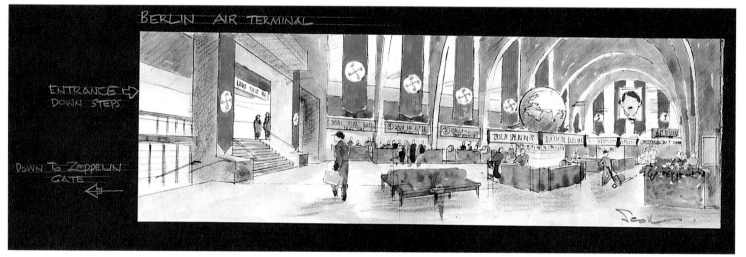

Zeppelin underbelly with two biplanes, storyboard

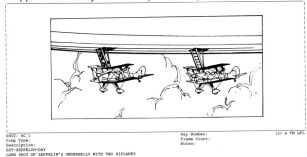

SHOT: AC 1 Key Number: (c) & TM LFL
Comp Type: Frame Count:
Description: Notes:
EXT-ZEPPELIN-DAY
LONG SHOT OF ZEPPELIN'S UNDERBELLY WITH TWO BIPLANES
SUSPENDED FROM CRANES.

ELEMENTS	TYPE	ELEMENTS	-TYPE	ELEMENTS	TYPE
BG sky plate - NO PLANES	plate	Zeppelin	stage	Biplane #1	stage
Biplane #2	stage	Zeppelin G-Matte	animRT	Biplane #1 G-Matte	animRT
Biplane #2 G-Matte	animRT				

(27 Oct 88)
Agreed to and accepted by:_____ Date:_____ SHOT: AC 1

Henry's pocket watch, prop, 10 x 10 x 3 cm.

Henry's umbrella, prop, 90 x 13 x 6 cm.

German biplane, model (with figure), 66 x 53 x 23 cm.

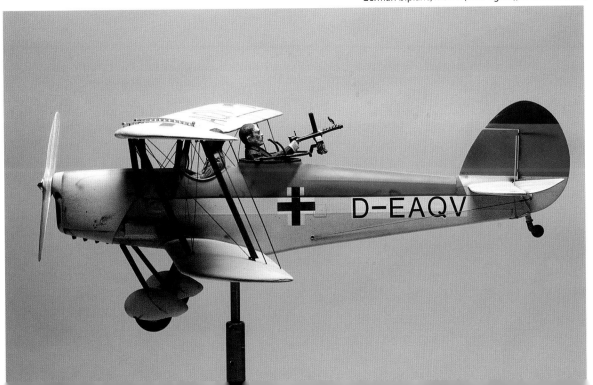

Fighter plane figure, puppet

Tunnel chase, storyboard

SHOT: FT 1
Comp Type:
Description:
EXT. - CAR - DAY
Car screams around camera, panning right as the squibs
run a straight line just behind...Camera pans car...
into tunnel.

ELEMENTS	TYPE	ELEMENTS	TYPE	ELEMENTS	TYPE
8-perf plate with car and tunnel	plate	R/O w/Mirror Image	optical		

(11 Oct 88)
Agreed to and accepted by:_____ Date:_____ SHOT: FT 1

Key Number:
Frame Count:
Notes:
Was AC 63

(c) & TM LFL

SHOT: FT 2
Comp Type:
Description:
EXT. - CAR - DAY
Fighter swings around hill...Camera pans right...
The plane enters the tunnel, but it's wings are
sheared off at the entrance.

Key Number:
Frame Count:
Notes:
Was AC 64.

(c) & TM LFL

SHOT: FT 4
Comp Type:
Description:
INT. - TUNNEL - DAY
Indy's reaction as he turns to look back.

Key Number:
Frame Count:
Notes:
Was AC 66.

(c) & TM LFL

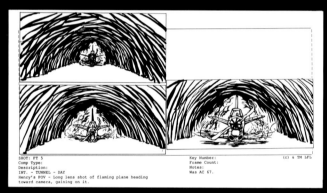

SHOT: FT 5
Comp Type:
Description:
INT. - TUNNEL - DAY
Henry's POV - Long lens shot of flaming plane heading
toward camera, gaining on it.

Key Number:
Frame Count:
Notes:
Was AC 67.

(c) & TM LFL

SHOT: FT 6
Comp Type:
Description:
INT. - TUNNEL - DAY
Indy's reaction as he turns to look back.
Fiery plane is still gaining on them.

Key Number:
Frame Count:
Notes:
Was AC 68.

(c) & TM LFL

SHOT: FT 7
Comp Type:
Description:
INT. - TUNNEL - DAY
Indy's reaction as he turns to look back.
Tunnel opening can be seen approaching.

Key Number:
Frame Count:
Notes:
Was AC 69.

(c) & TM LFL

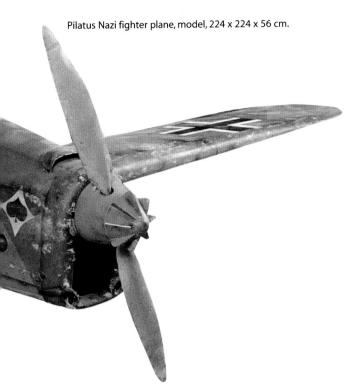

Pilatus Nazi fighter plane, model, 224 x 224 x 56 cm.

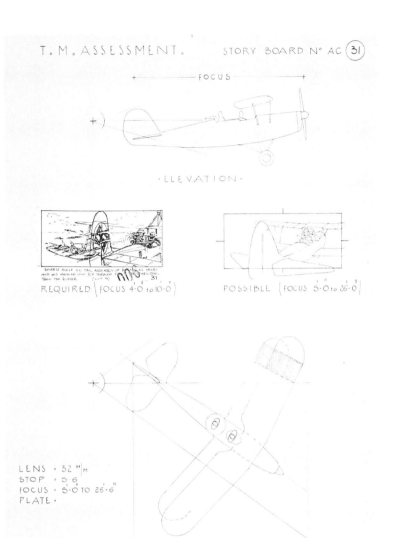

Biplane, storyboard with technical references

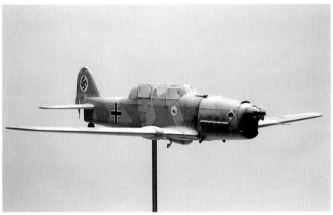

Pilatus Nazi fighter plane, model, 74 x 61 x 15 cm.

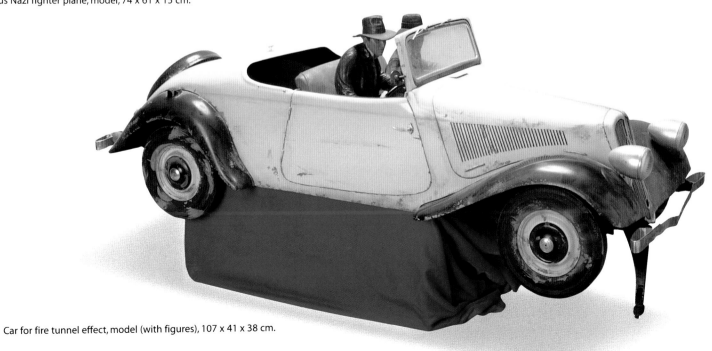

Car for fire tunnel effect, model (with figures), 107 x 41 x 38 cm.

THE DIARY CONTINUES

The Grail diary of Dr. Jones describes the ultimate location of the Holy Grail in a temple hidden deep in the crevices of a valley.

The production exteriors were shot at the location of Petra, a once-lost city in the Jordanian desert. The city, carved out of mountain rock whose sheer walls rise three hundred feet, has been both a stronghold for bandits (who coveted its nearness to caravan routes) and a Roman outpost. The place also has its own legends—it's said that the crevasse in the rock was opened with a strike from the rod of Moses.

Petra, Jordanian desert, photo collage of location shoot

Henry's Grail Diary, prop, 10 x 17 x 3 cm.

Henry's Grail Diary, notes on Prestor John and Grail legends

Henry's Grail notes with "Map of the mountain road"

Henry's sketch of one of the obstacles to the Grail

THE TANK

A tank chase, shot on location in Spain, required the construction of a motorized replica of a Mark 7 German tank from World War I. Only eight such tanks had actually been built for the war, and with the only surviving tank a nonfunctioning museum piece, mechanical effects supervisor George Gibbs and his crew had to construct their full-scale replica from scratch.

A realistic recreation was built, down to the lack of suspension systems characteristic of the original construction. Actual steel was used, ensuring the vehicle would withstand the rugged three weeks of shooting. The final, motorized period reproduction was thirty-six feet long and weighed twenty-nine tons. (A lesser prop played a key role in the tank battle scene: one of Henry's pens blinds a Nazi with ink and allows the good doctor to gain control of the tank's gun.)

Henry's pens, prop, 13 x 2 x 2 cm.

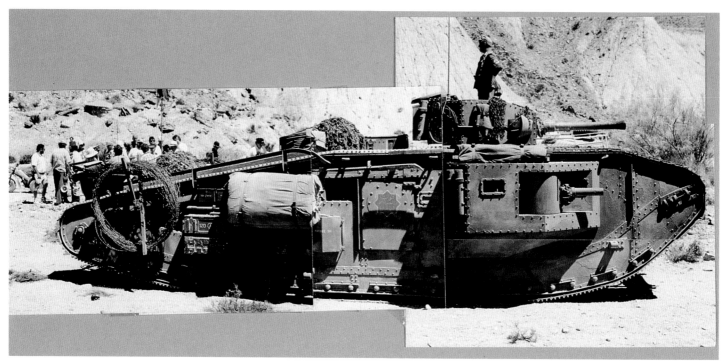

Indy 3 Tank, photo collage

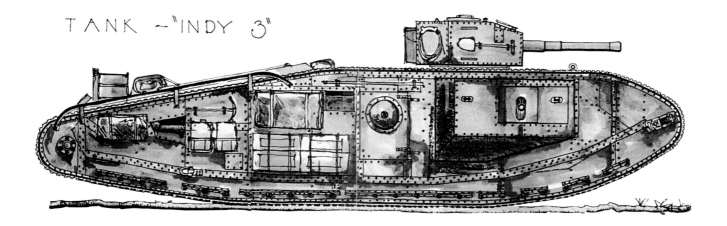

Tank, production illustration

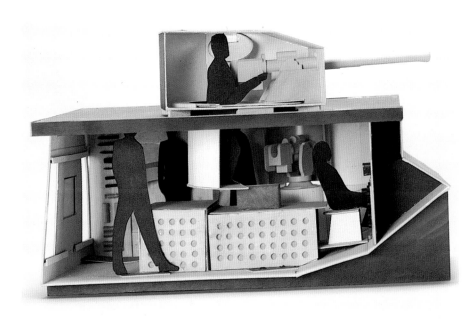

Tank interior, maquette, 38 x 23 x 38 cm.

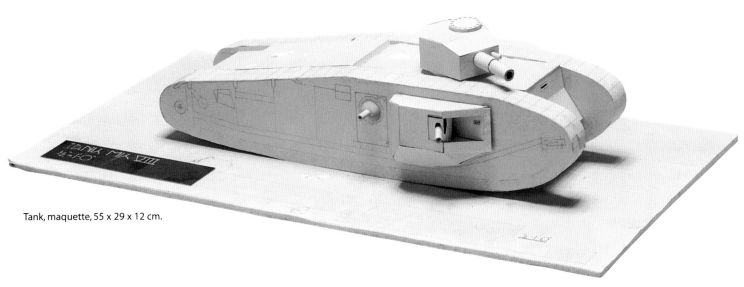

Tank, maquette, 55 x 29 x 12 cm.

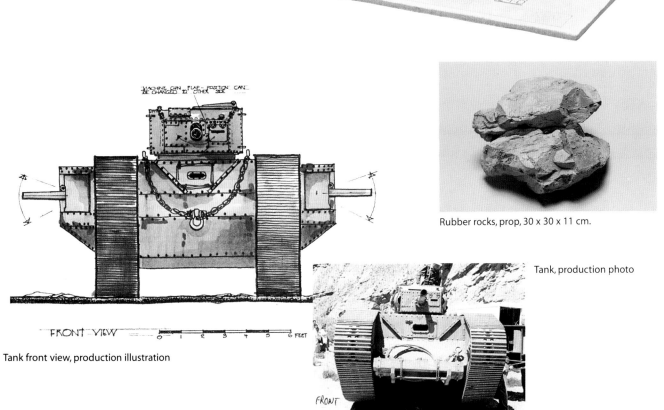

Rubber rocks, prop, 30 x 30 x 11 cm.

Tank, production photo

Tank front view, production illustration

CHAMBER OF THE GRAIL

After penetrating all the obstacles in his path, Indiana arrives at the inner Grail temple where an ancient knight stands guard. But the evil Donovan has also followed Indy into the inner sanctum and, at gunpoint, demands the right to choose the Grail from among an array of chalices.

Donovan picks a glittering gold cup, dips it into a font of water, and drinks. Donovan instantly discovers he has selected the wrong chalice and is blown into eternity as he ages in seconds, his skeletal shape finally exploding into ash. The effect, tagged at ILM as "Donovan's Destruction," marked a technological breakthrough in effects work: it was the first shot completely composited in a computer and scanned back out to film. It also utilized the computer image processing technique of morphing developed for a transformation sequence in Lucasfilm's "Willow".

Spielberg had challenged the ILM effects team to show the scene without the usual cutaways during which an actor's physical transformation is traditionally advanced by makeup or other tricks. To create the effect, ILM created lifesize puppets representing various phases of deterioration. The images were then scanned into a computer where a computer graphics team processed them to seamlessly blend into each other.

Grail Knight's book, prop, 32 x 25 x 6 cm.

Inner Grail Temple, set design illustration

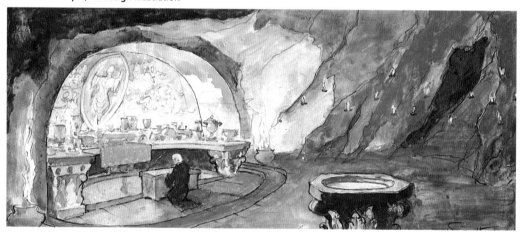

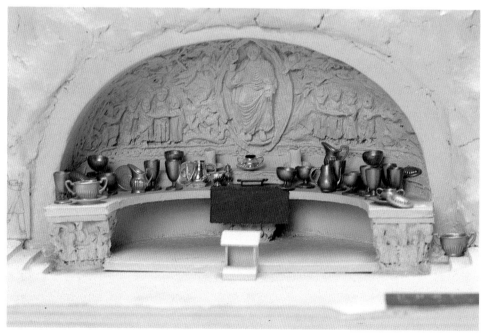

Inner Grail Temple, maquette, 50 x 23 x 38 cm.

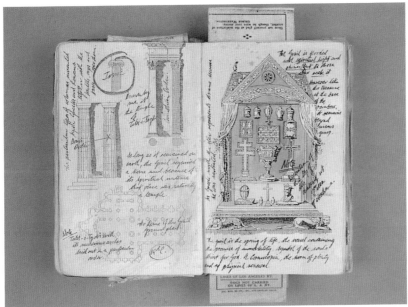

Henry's Grail Diary, speculation on the spiritual
properties of the Grail

Maps and other fragments
of research leading to the Grail

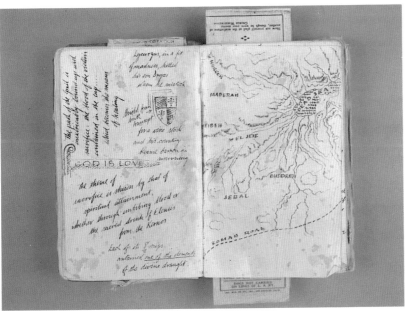

Maps and other fragments
of research leading to the Grail

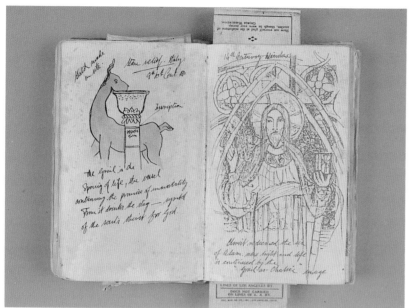

Henry's Grail Diary, research notes
on the Grail's "promise of immortality"

Research notes on the Grail's
history and power

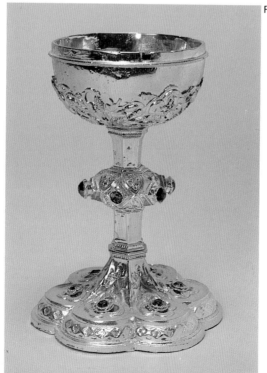

False Grail, prop, 15 x 15 x 21 cm.

Henry's Grail Diary, detailing the final three challanges of the Quest

Henry's Grail Diary, notes on Knights of Maltese tradition

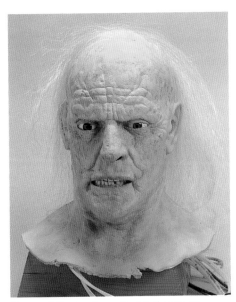

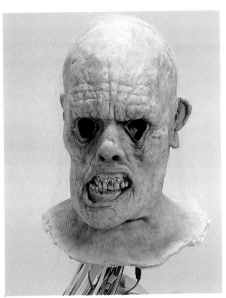

Donovan's Destruction, articulated puppets used in computer image processing sequence, 29 x 28 x 38 cm.

THE GRAIL

Unlike the doomed Donovan, Indy, whose heart and soul have been fortified by his quest for the Grail and his reunion with his father, selects the true Grail: a simple clay cup for the son of a humble carpenter. Indy uses the chalice's holy waters to heal the nearly fatal gunshot wound Henry has suffered from the Nazis. But Elsa, seduced by the magic of the Grail, tries to take it out of the temple confines against the warning of the guardian knight, causing the entire temple to shake and collapse.

At the movie's end Indiana and his father mount horses and ride off into the sunset, closing the third installment of the Indiana Jones trilogy. At the time of its release, the film was billed as the final Indiana Jones adventure that would be produced by the team of Lucas, Spielberg, and Ford. Only time will tell if Indiana Jones will ride again.

The Temple collapses, still from film

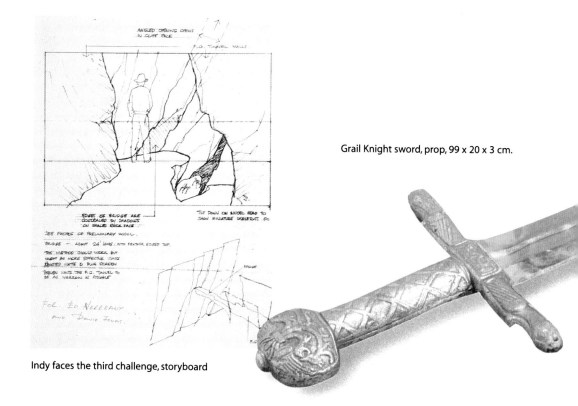

Indy faces the third challenge, storyboard

Grail Knight sword, prop, 99 x 20 x 3 cm.

Henry's Grail Diary, additional maps and clues to the location of the Grail

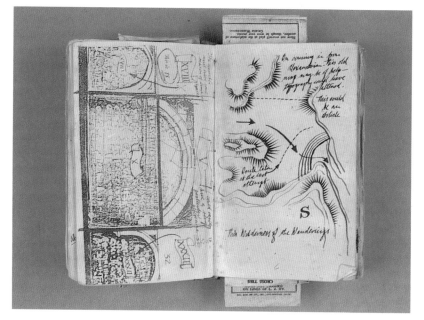

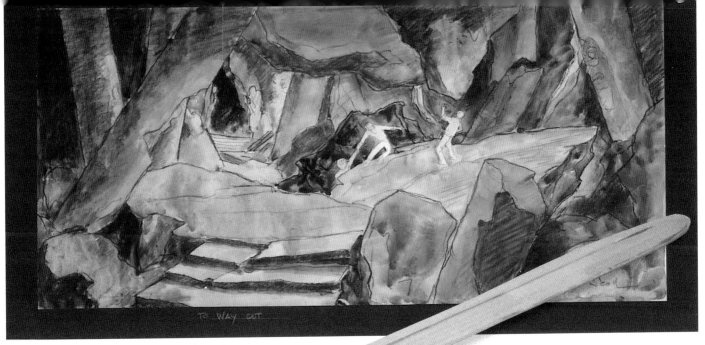

Outer Grail Temple collapsing, production illustration

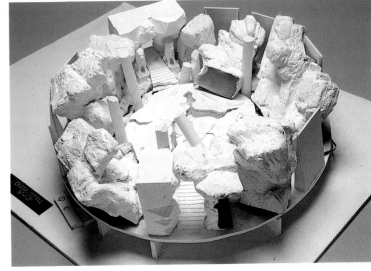

Outer Grail Temple in ruins,
maquette, 76 x 76 x 28 cm.

Henry's Grail Diary, information on the knight
who guards the Grail

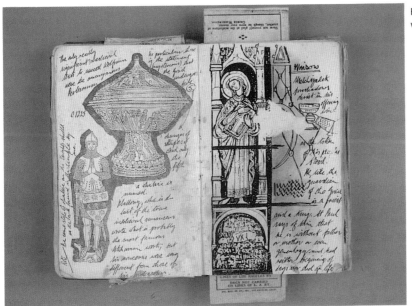

Holy Grail, prop, 11 x 11 x 15 cm.

FUTURE DREAMS

By 1989, when Indiana Jones was on his *Last Crusade*, the first ripples of the coming wave of computer image processing and graphics animation began to arrive.

Today at ILM, digital technologies have already replaced brush-and-oil matte painting and photochemical compositing. Traditional model making and creature work have lost a significant chunk of business to synthetically produced models, props, and creatures. There is even serious acknowledgment that celluloid film itself is coming to the end of its life span perhaps to be replaced by digital data.

For nearly a century moviemaking has been a machine-age craft, its production means involving machined tools, gears and sprockets, physical materials, photochemical processes. When Lucas named his ILM effects company in the mid-1970s he was acknowledging the "Industrial" realities. But two decades later, the digital era has dawned. In 1993, during a restructuring of his company, Lucas reorganized ILM under a new division—Lucas Digital Ltd.

The treasures in the Lucas Archives represent precious artifacts that document crafts that are vanishing or have been diminished. The Lucas Archives do hold a rare physical prop from the computer-image process: the turtle-to-lion transformation puppets of *Willow* that were filmed for use in the breakthrough computer-image processing technique of "morphing," the effect used in the Donovan's Destruction scene in *The Last Crusade*.

The digital breakthroughs have, in fact, made it possible for Lucas to resume the telling of the next *Star Wars* chapters, unencumbered by the expense and physical limits of the old industrial arts of moviemaking. But for fans of the movies there is pleasure in seeing the tangible artifacts that have been blown up bigger

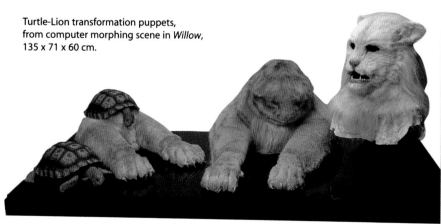

Turtle-Lion transformation puppets, from computer morphing scene in *Willow*, 135 x 71 x 60 cm.

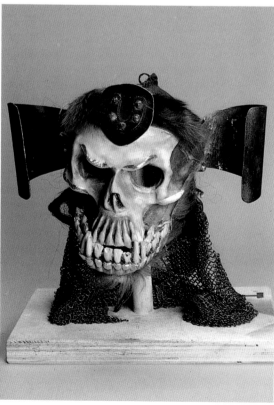

General Kael, costume headgear for *Willow*, 51 x 33 x 42 cm.

than life on thousands of movie screens. They are the collective product of hundreds of movie makers, each skilled in creating the stuff of movie magic. These treasures of Lucasfilm stored in the Archives helped build Lucas's success, helped him realize his dream of Skywalker Ranch.

The ranch has prospered since the closing of the *Star Wars* and Indiana Jones trilogies, with Lucas buying two more adjoining ranches, expanding his holding to more than 4,700 acres. The ranch has developed as a nearly self-contained community with its own fire department, security, and other services. It contains a small vineyard, a vegetable garden, and a few head of cattle graze in the fields. The buildings, which house everything from administrative offices to state-of-the-art sound recording facilities, are nestled out of sight from the main road. The buildings, each with its own name and period design, were built as if Lucas had renovated the existing structures of a century-old ranch. The Main House at Skywalker Ranch is a masterpiece of Victorian architecture. A flight up a central staircase, Lucas has his office. It is a work place, a dream chamber.

Howard's planet, matte painting from *Howard the Duck*, 191 x 119 cm.

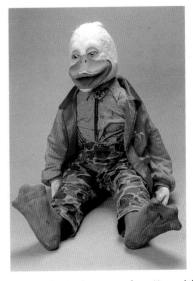

Howard the Duck, costume from *Howard the Duck*, 38 x 36 x 109 cm.

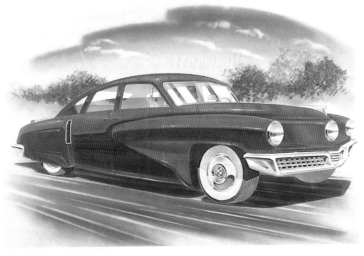

Tucker Torpedo, production illustration from *Tucker: The Man and his Dreams*

From Skywalker Ranch, Lucas's native Modesto is only a few hours drive away, but it seems farther. In the harvesting of the years Lucas has created his own mythology and reinvented the way movies are made. Along the road he's kept his feet on the earth and his mind in the stars. As Steven Spielberg has observed: "Like his creation Luke Skywalker, George Lucas continues to look into the future and dream."

Main House, Skywalker Ranch, Marin County, California